Hooked On Painting!

Illustrated Lessons & Exercises
for Grades 4 and Up

Sandy Brooke

PRENTICE HALL

Library of Congress Cataloging-in-Publication Data

Brooke Sandy.
 Hooked on painting : illustrated lessons and exercises
 for grades 4 and up / Sandy Brooke.
 p. cm.
 ISBN 0-13-918152-0
 1. Painting—Technique. I. Title.
 ND1473.B76 1998
 751.4'071—dc21 98-41859
 CIP

10 9 8 7 6 5 4 3 2 1

ISBN 0-13-918152-0

Acquisitions Editor: *Susan Kolwicz*
Production Editor: *Mariann Hutlak*
Interior Design/Formatting: *Dee Coroneos*

ATTENTION: CORPORATIONS AND SCHOOLS

Prentice Hall books are available at quantity discounts with bulk purchase for educational, business, or sales promotional use. For information, please write to: Prentice Hall Direct, Special Sales, 240 Frisch Court, Paramus, NJ 07652. Please supply: title of book, ISBN number, quantity, how the book will be used, date needed.

 PRENTICE HALL
Paramus, NJ 07652

A Simon & Schuster Company

On the World Wide Web at http://www.phdirect.com

Prentice Hall International (UK) Limited, *London*
Prentice Hall of Australia Pty. Limited, *Sydney*
Prentice Hall Canada, Inc., *Toronto*
Prentice Hall Hispanoamericana, S.A., *Mexico*
Prentice Hall of India Private Limited, *New Delhi*
Prentice Hall of Japan, Inc., *Tokyo*
Simon & Schuster Asia Pte. Ltd., *Singapore*
Editora Prentice Hall do Brasil, Ltda., *Rio de Janeiro*

DEDICATION

For Christen, Rob, John and Sydney

Art was and still is a big part of our three children's lives: Christen
is an interior architect . . . Rob is a photographer . . . and John
is a potter. It will also be there for Sydney who at age two
has just started mark-making.

ACKNOWLEDGMENTS

This author wishes to acknowledge the many students that she has had the pleasure to teach and work with over the years. Special thanks go to my students at:

Cloverridge School, Albany, Oregon

Foster School, Sweet Home, Oregon

Holley School, Sweet Home, Oregon,

Corvallis Art Center, Corvallis, Oregon

Harding School, Corvallis, Oregon

Oregon State University, Corvallis, Oregon

Wilson School, Corvallis, Oregon

We wish to thank the following for permission to use their artwork:

The Art Institute of Chicago

Georges Braque, *Collage*

Julio Gonzalez, *Screaming Head*

Claude Monet, *Caricature of a Man with a Large Nose*

Vincent van Gogh, *Corner of a Park at Arles*

The Metropolitan Museum of Art

Vincent van Gogh, *Self Portrait*

Muscarelle Museum of Art

Marco Rico, *Caricature of Bandits*

Museum of Fine Arts, Boston

Vincent van Gogh, *Lullaby*

Philadelphia Museum of Art

Vassily Kandinsky, *Little Painting with Yellow*

Vincent van Gogh, *Haystacks*

Scala/Art Resource, N.Y.

Leonardo da Vinci, *The Vitruvian Man*

Steinbaum Krauss Gallery

Beverly Buchanan, *Kingsland, Georgia*

Jaune Quick-To-See Smith, *Tongass Trade Canoe*

San Francisco Museum of Modern Art

Georges Braque, *Vase, Palette and Mandolin*

Richard Diebenkorn, *Untitled*

We wish to acknowledge the Artists Rights Socieity (ARS) for permission to reproduce the following:

Georges Braque, *Collage*

Georges Braque, *Vase, Palette and Mandolin*

Julio Gonzalez, *Screaming Head*

Vassily Kandinsky, *Little Painting with Yellow*

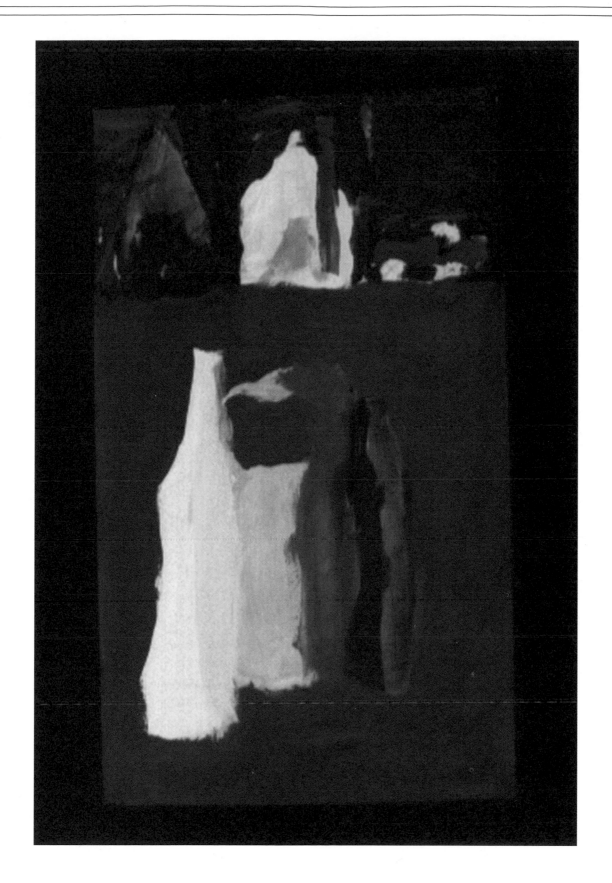

Sean Sweet, Grade 5

ABOUT THE AUTHOR

Sandy Brooke has a Master of Fine Arts in painting and a Bachelor of Fine Arts in painting and drawing from the University of Oregon. She has taught painting and drawing for 20 years. It is through her experiences with students in grades K through 12 that she developed the projects and exercises for this book. The 17 years she spent working with students in the Artist-in-Education program were particularly formative. She worked with students all over the state of Oregon, not only teaching painting and drawing, but also developing large mural projects. In addition to teaching at the K-12 levels, she has been an instructor at Central Oregon Community College, Oregon State University, and the University of Oregon.

She has been a studio artist for 27 years and shows regularly in Oregon and the Western states. Her paintings are abstract, referencing space of trees, water and people.

INTRODUCTION

Painting seems to be one of the harder art subjects for teachers to work into their curriculums. Just the technical problems of getting the paints out and setting up the room can be overwhelming. This is completely understandable. It is with this in mind that I have designed and written *Hooked on Painting*.

At the same time, painting is one of the things that students love to do. It has tremendous appeal, and the painter may be one of our last romantic images. The painter, an individual struggling to create, perhaps a rebel, definitely a nonconformist in society, a person of strong character, and high morals, searching for the truth. Although somewhat Hollywood, those aren't entirely bad ideals to reach for in terms of becoming a productive adult. The value of art is that it encourages and develops students to be independent thinkers. People capable of coming up with new ideas, inventing something new and capable of determining what the next job should be after they finish the first one, are exactly what most business people will tell you they are looking for in an employee. The Arts provide a means to develop strong critical-thinking abilities in students. Developing creative reasoning and thinking skills strengthens a student's ability to learn across the curriculum.

Making art involves skills that can be learned; you don't have to have natural talent. In doing art work the students learn to accept themselves because art work is personal and distinctive to each individual. By accepting that we all make different products in art and each is an acceptable solution, we learn to accept ourselves as individuals and to respect differences. Sometimes it takes an experience to make people understand a concept. Students also learn to follow their own voice in making art.

Making art is hard work and the student who sticks with it learns perseverance. Practice is what makes the product better. The most important part of an art project is the process. The product will often be a surprise.

In the process the materials of art can seduce us. The texture of the paper, the smell of the paint, the feeling of the brush, or the coldness of the clay. We often respond to art materials in an intensely personal way. It is said of Pablo Casals that he knew as a child the cello was his instrument from the first moment he heard it.

The materials have potential that—when coupled with a student's active participation—can be turned into art. What counts in making art is the connection of the contents of your head and the qualities of your materials. The knowledge you need to make that fit comes from noticing what really happens as you work—the way the materials respond will suggest new ideas to you.

What's really needed to make art is nothing more than the courage to start, a general idea to work from and some technique and fundamentals of how the materials function. An artist must dismiss what might seem to be a mistake and take advantage of any accidents that come his or her way. Simply put, to make art, we must take chances. It can be unpredictable; uncertainty lurks at every turn, shadowing the initial vision and the desire to make art. A tolerance for chaos and uncertainty is a prerequisite to completing any art project. Success is in the mind of the artist and the viewer. What better way to prepare students for the trials and tribulations of life?

I have approached the study of painting from the simplest beginnings in both the choice of medium and the type of exercise. There is a progression from the simple to more complicated exercises while constantly developing better skills and more expertise in painting. The book is organized with the foundation exercises in the first section followed by simple to complicated exercises in each

focus area. This allows the teacher to move from a still life exercise to a landscape study or to a perspective study after completing the first section and the introductory exercises in each section.

I wrote a book before this one called *Hooked on Drawing*. It has in-depth exercises in the study of modeling, shading, perspective, texture, space, and composition. In some of the lessons in this book I have given brief instructions where necessary to help the students draw their compositions, but if they need further instruction, refer to *Hooked on Drawing*.

The illustrations were drawn by students in classes that I taught. They are not in the talented and gifted program nor are they the "classroom artist." Painting can be a great equalizer in a classroom. All students are equal in their ability to paint because painting is a learned skill. We learn to paint just as we learned to walk. It takes practice and a good number of failures before we feel we are getting on the right track. Through failures and successes students recognize that this is a long-term study, not something we start and finish in one day.

A lesson can be done more than once. Each experience will increase the students' awareness and skills. It is a rare occasion where at the end of a painting the artist feels totally satisfied. Most painters will tell you that they never like their work. It's never good enough, they always know they could have done better, and the final piece is usually not the vision they had at all! This is a normal reaction. It is actually a good reaction because it is the driving force in the student or the painter to make another painting that will be better. If you make a masterpiece, there would be nothing left to strive for—you will stop painting because you're done.

There is something magical about paint. It is a great seducer of the human spirit. It can be totally engrossing and exciting to work with. That's why some students will load their paintings with paint—they are just so excited about watching the changes happen

that they keep adding more and more paint. Try to let this happen especially in the beginning because watching the work change is a tremendous and unequaled teacher. Painting teaches itself in the doing.

As the painter Milton Resnick said, "You have to let the Master Paint tell you what to do!" He also reminded me that the value of art is to create creative thinkers in society. People with vision see, reason and debate intelligently. We all don't have to be painters but what we take from the experience is invaluable in forming personal strength and character.

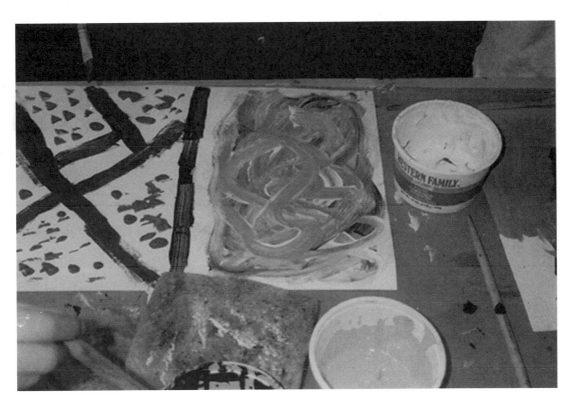

Students at Foster School experimenting with paint

CONTENTS

Section 3 STILL LIFE 51

Students' paintings of geometric compositions at Holley School

Student mixing paint on a plastic palette at Holley School

xiii

Students painting rhythm and repetition compositions at Holley School

Chris Buckingham, oil on canvas, Painting 1, Oregon State University

xvia

Section 1

METHODS, MEDIUMS, AND FOUNDATIONS

GETTING READY TO PAINT: CHOOSING PAINT

- Watercolor

- Acrylics

- Tempera Paint

Watercolor is one of the cleanest and easiest paints to use. It comes in hard pans or tubes. If the tube color is placed in a sectioned palette like an ice cube tray or muffin tin, it will dry into a block of color when the student is finished. The beauty of watercolor is that it will reconstitute by adding water to the hard pan. Water dissolves the watercolor in the pan into a liquid state ready for painting. The more water that is added to the pan, the lighter the color will be.

Watercolor is not an intense pigment since it is more transparent than opaque. Watercolor is discussed in its own section of this book.

Acrylics are expensive and so usually schools are unable to purchase them. There is a student-grade acrylic that is often sold in gallon containers. The same setup with individual containers for each color that is described here for tempera paints can be used with acrylics. Acrylics and temperas are very similar. Neither can be reconstituted once they dry up. It is important to keep the containers they are stored in tightly closed. In addition, some water must be added to the containers over time to keep them wet. Acrylics have higher quality pigment than temperas, are transparent, mix well, and retain high color vibrancy. Although they are water-based, they are permanent and will stain.

Tempera is an inexpensive water-based paint. The liquid tempera is the easiest to use as opposed to dry tempera, which must be mixed with water. The drawback to tempera is its low pigment quality which can sometimes result in dulled colors or muddy-looking mixes. Tempera does not have the range of colors available in either acrylics or watercolors, but it is still excellent to start with.

Dry tempera must be mixed with water to make a liquid. The powder must be completely dissolved. Mixing tempera paints and getting the tempera to dissolve in the water is difficult and takes a good deal of time. Use a blender to make mixing easier. One of the drawbacks to liquid tempera is

it will often crack and fall off the paper when dried. To prevent this, acrylic matte or gloss medium can be added to all colors. Acrylic medium can be purchased in gallon amounts from between $12 and $18 from Nova Color in California, the most reasonable supplier I have found. Nova Color's address and phone numbers are:

Artex Manufacturing Co.
5894 Blackwelder Street
Culver City, CA 90232-7304

(213) 870-6000
Fax (310) 838-2094

Catalog: #204 Matte Medium
 #205 Matte Varnish (glossy)

Table Set up for group painting

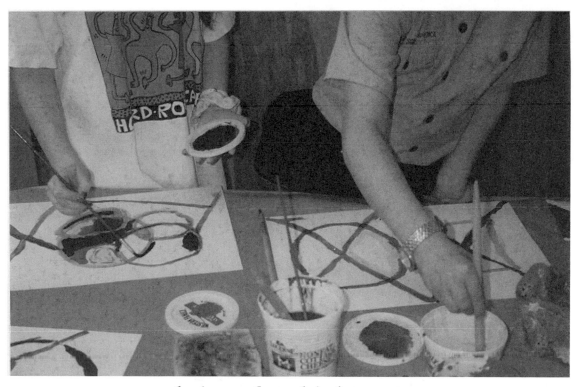

Students at Foster School painting

USING AND STORING TEMPERA PAINTS

Using Tempera Paints

Tempera paint is sold in 8- to 16-ounce plastic jars and gallons. There are a couple of ways to distribute and use the paints. All painters need a palette to hold their paints. As the tempera is liquid rather than paste, the palette may be several individual containers. One of the most available containers is a 16-ounce margarine or cottage cheese plastic container with a lid.

Each color to be used needs a separate container. If you start with only the primaries—red, blue, and yellow—plus the extra shade and tint colors, black, and white, you will need a minimum of 50 containers for a class of 30 students. I recommend black should be held back until the first color mixing lesson is over as the students tend to put it in the mix which creates a series of browns and grays instead of the secondary colors you want them to mix.

The containers should be filled no more than one-quarter to one-half full of color. White and yellow tend to get contaminated by dirty brushes more easily than other colors. If there is a small amount of paint in the container, there is less paint to toss out or you can save it for landscape painting later.

Water, paint containers, and sponge

Another choice for a palette is an ice cube tray or a muffin tin. Both have separate sections in which to separate one color from another. When using trays or tins, the students should have their own palette if possible because some painters are very careful and some are not about contaminating the paints. It is best with these smaller amounts of paint for the students to control their own paints. To save this paint, cover it tightly with plastic wrap; it will often last overnight.

Tempera is also sold in hard square pans that work very well. The amount of water added to the cake will determine the strength of the color. Water lightens the color, whereas if more pigment from the cake is worked into the water it will strengthen the color, enriching it. Once the students have the cake releasing the pigment, they should be careful about adding water. Often just dipping the brush in water and adding that amount of water to the pool on top of the cake will be enough to continue painting and maintain the strength of the color.

Adding Acrylic Medium

Add approximately 1/4 cup of liquid matte or gloss medium to 1 cup of tempera color and stir. Once you add acrylic medium, the tempera becomes an acrylic paint. Acrylic paints dry quickly and are much more flexible on the paper. They will not chip or crack off. Adding the medium will also give the painting a richer surface when it dries. Straight tempera tends to look dry and chalky.

Storing Paints

The paints can be stored in covered containers for months. To extend their life (if they have not been used for several weeks), take off all the lids and use a spray bottle or mister to mist a layer of water on top of each color. The paints dry up as the water in them evaporates so adding a little water to each color prevents them from drying up.

Some colors will mildew. Black is particularly prone to mildewing. Just toss it out when that happens. The odor from the paint will alert you that it's bad. To avoid mildew, open the paints once a week and air them out.

SETTING UP THE ROOM TO PAINT

Students can work together and share supplies by arranging four desks in a circle around an empty desk in the middle. The table in the middle will hold the paints, the water, the brushes, the palettes, and the sponges. The students should stand up to paint. At first each group should get one container of red, one of yellow, one of blue, and one of white. After the first exercises in color mixing, purple, orange, green, and black can be added to the palette.

In a class of 28 students, for example, there would be seven separate setups. Seven setups mean 7 sets of paint, 7 water containers, 14 to 21 sponges, and 4 to 8 plastic lids. This is why 50 empty plastic containers come in handy. There would be a total of 7 containers of red, 7 of yellow, 7 of blue, 7 of white, and 7 of black. Plus, if you are adding the premixed secondary colors, you would need 7 containers each of orange, green and purple.

The students whose desks are placed in the middle will need a place to work. They can be moved to one long table or several smaller tables placed together. Often a room will have a utility table in the back of the room for student projects. That table is perfect if it happens to be clear.

Handling Paint and Water

Some teachers place newspaper under the paints to keep the drips to a minimum. The paint does wipe off Formica® and linoleum easily. Carpet is the only surface I have ever had trouble getting spilled paint out of, and in 20 years of working in classrooms it has only happened three times. To the students' credit, one of those times was completely my fault! Don't rush when cleaning up and ask the students to be careful carrying paint across the room.

Water cans should be only one-half to two-thirds full to avoid splashing and spilling the water from the sink to the table. Acrylics can coat the water pipes, so be sure to run hot water and add soap when cleaning brushes and dumping any dirty water down the drain.

BASIC TECHNICAL INSTRUCTIONS

Start with a Damp Brush

When the students start painting, they should dip the brush first in the water and then wipe the water out on a rag, a paper towel, or a sponge.

Dip the brush in the first color up to and not over the ferrule. The brush has three sections: the bristles, the ferrule, and the handle. To paint, the students dip the bristles in the paint, avoiding getting paint on the ferrule. A brush is constructed with the bristles bound by glue inside the ferrule, so to save the brushes, it is best not to get paint up inside the silver ferrule; if the paint dries inside the ferrule, it is impossible to clean it out. The paint will then harden inside and the brush will get stiff. It is also not a good idea to leave brushes soaking in water while you are painting or waiting for someone to clean them. Water can loosen the glue holding the bristles and cause the bristles to fall apart.

Painting

If students intend to use the same color again, then they may continue dipping the brush back in the paint and putting the paint on the paper. To change colors, rinse the brush out in the water and wipe the water out on the sponge or in a rag. The painters will need to do this a couple of times to get their brushes clean. When the brushes are clean, the students may select a second color to add to their painting.

The reason white and yellow should be put out in small amounts is that students will sometimes forget to clean their brushes between colors. After a while these light colors are so contaminated that they muddy any mix to which they are added. At that point they need to be replaced. Save this muddy yellow or mixed white in a jar with a lid and use it later in landscape painting when students need a wider range of tints and shades. Colors don't need to have perfect clarity to be of use.

The paint will stay clean longer by only dipping the bristles in the paint without stirring the brush around in the paint container.

Dipping as opposed to scooping out paint also keeps the brush cleaner, making it easier to clean the paint out of it at the end of the lesson. For example, if a brush has yellow on it and is then wiped out in a rag, it could be dipped back in blue or red without affecting the color as long as it isn't used to stir the paint. After washing a brush out be sure to wipe the water out on a sponge. Dipping a dripping-wet brush in the paint will dilute the color.

Cleaning the Brush

While painting, there is no need to swirl the brush in the water to get it clean. Simply press the bristles against the bottom of the can back and forth a few times to work the paint out, and then wipe the water out of the brush on a large sponge or into a rag. Students also like to tap the brush on the top edge of the can to flick the water out; however, ask them not to do this because it flips water all over the table and other students' paintings. They should wipe the excess water out, *not* flick it out.

Changing Brushes

If students wish to change brushes, they should clean out the first brush, wipe the water out of it, and lay it on the table. Don't leave the brushes in the water can soaking or in the paint containers. This is also a way to share brushes and provides students the opportunity to use a range of brush sizes from small to large.

Paint Shirts

Men's dress shirts work best. Men's T-shirts are not heavy enough, so paint can bleed through onto the student's shirt or pants. The 50/50 cotton-and-poly dress shirts are heavier and easy to put on. Putting them on backwards with the buttons placed along the student's back seems most effective.

THE IN'S AND OUT'S OF COLOR MIXING

Primary and Secondary Colors

The three primary colors are red, blue, and yellow. They are primary because they cannot be mixed by combining any other colors. They are the foundation of the Color Wheel. When you combine any two primary colors, you get the secondary colors of green, purple, and orange. If three primaries are mixed together, one of three browns results. Mixing red and yellow makes orange, mixing red and blue makes purple, and mixing blue and yellow makes green. With tempera paints, add a little white to red and blue to make a lighter purple.

Tertiary colors are degrees of orange, green, and purple that are made by mixing a primary with a secondary color. By mixing red with orange, red-orange results; by mixing yellow with orange, the result is yellow-orange. In addition, blue-green and yellow-green can be mixed along with red-purple and blue-purple.

Mixing Colors

The safest way to mix colors in order to maintain control of the mixture is to start with the light color first and add the darker color a little at a time. Plates, bowls, and plastic lids make good palettes. The plastic lids from margarine containers work nicely as mixing palettes. To avoid large unusable mixtures of paint, a small palette and a teaspoon *or* less of each color will be enough to start mixing a color.

Clean-up

To clean the lids, partially fill a 5-gallon bucket with water and—using an old sponge—rinse the lids off in the water. Add hot water and soap to the water going down the drain to prevent any of the acrylic from sticking to the pipes.

PAINTING WITH PRIMARIES AND SECONDARIES

OVERVIEW

This exercise is simple and provides an opportunity for the teacher to work on teaching painting, while establishing the process of getting ready to paint. Painting may involve a little rearranging of the room, so if everyone is aware of what needs to be done, the amount of time it will take to set up and break down can be reduced. In addition, the students will learn how to help. Once the process of painting is established—setting out the paints, water, and sponges—the students can spend more time on their paintings.

The students should stand up to paint. Standing is helpful in avoiding painting disasters of reaching over paints, catching them on a sleeve, and knocking them on the floor. Painting is easier when the student's painting arm is free to reach the entire piece of paper. The purpose of this exercise is to practice mixing paint. Once students start painting, they should stay with the same piece of paper all the way to the end. Don't give students a second piece of paper because they don't like what they've started. It is better to have them wipe off the paint and paint over the area. The students can practice painting with no pressure to create anything. They should first learn to control the paints and brushes, then later they can worry about what to paint.

Planning and Set Up

The day before you want to paint, have the students make up the paints. Set out the number of paint containers you will need. If your counter space is limited, mix one color at a time. Fill them one-fourth to one-half full and add the acrylic medium, stir, and put on the lids. Save them for the next day.

Use 18" × 24" tagboard if there is enough working space; 12" × 18" if not. This first day is to experiment with color only and to practice mixing any two colors together. After, students mix the secondaries of green, orange, and purple. They can mix all three primaries together to make browns.

Arrange the room with the desks in groups of five. Place one desk in the middle and four around it, each on one side of the center desk. Move the students whose desks are in the center to another work area.

Place three primaries and white, the can of water, and two sponges on the center table. The students will stand to paint. Put on the paint shirts if you need to, and give each student one piece of paper. Place all the brushes up in a can and send a student around the room to each station, letting each student pick one or two brushes. Each table should have a selection of small and large brushes.

Supplies

1. 12" × 18" tagboard
2. tempera paints: primary colors (red, blue and yellow)
3. assorted available brushes (1/4", 1/2", 3/4" or 1")
4. water and containers
5. sponges
6. paint shirts
7. rags

The Exercise

This exercise relies on chance and intuition rather than the precise direction for composition. The students will place the paint on their papers by impulse and whim. The goal is to practice mixing any two primary colors to make a secondary color. Mixing red and blue will make purple, but since it is a very dark purple, adding a little white will improve it.

Mix red with yellow, and blue with yellow one at a time. Students should cover the paper with abstract shapes or areas of color using both the primaries and the secondaries. Remind the students to clean out their brushes when changing colors and not to put a dirty brush in a new color.

The students should sign their paintings at the bottom. It is sometimes helpful if they write their names on the back of the tagboard in pencil before they start painting since the entire surface can be covered with paint. The color areas may end up side by side or some may overlap. Both are fine because the composition doesn't matter. The goal is to experiment and learn to combine primary colors to make secondary colors.

Save all the paintings for the Layering Exercise in abstract painting.

Ways to Mix Paints

1. Wet into wet: First paint an area, for example, yellow. Clean out the brush and add red into the wet yellow on the paper.
2. Use the lids to the containers as palettes. Place a teaspoon of red on the plastic lid, then clean out the brush and add a small amount of blue. Mix the two colors together on the lid.
3. Vary the proportions of each color in each mixture. Try 75% of one and 25% of the other.

Goals

- Students build technical skills in using the tools of painting.
- Students practice mixing primaries to get secondaries.
- Students learn by doing.

Students from Foster School painting

12a

WHAT IS A TINT AND WHAT IS A SHADE?

What Is a Tint?

White is not considered a color because, when added to other colors, it will only lighten the value of the color.

White does not make a new color; it changes the value. Value is the light and dark of one color. For example, the range in blue goes from light blue (also called baby blue) to sky blue to medium blue or cobalt blue. Ultramarine blue is like the blue of the ocean or a lake, and there are dark blues like night blue, navy, or prussian blue.

Light red is also known as pink, medium red is like fire engine red, and dark red is crimson. Yellow goes from light or pale yellow to medium or daffodil yellow to dark yellow, which might seem like an ochre or copper shade.

What Is a Shade?

Black is not a color for the same reasons white is not a color. When black is added to a color, it darkens the value of the color. When adding black to another color, add it slowly and in small amounts.

Another way to darken a primary color is to add its complement. An important point to remember is to keep the amounts of paint small when experimenting with mixing; once it goes to mud, you just have to throw it out and start over.

The complement is a color's opposite. Red and green are complementary colors; they are opposites. When opposites are placed side by side, they create a visual vibration between themselves. Blue and orange are complements; yellow and purple are complements.

When the complement is added to its opposite, the color is said to have been grayed. Adding a little purple to yellow will darken yellow, better than if black is used to darken yellow.

A range of grays that can be mixed by using a primary, its complement and white. First, mix a little green into a little red, then add a little white. If the color looks too green, add a little more red; if it looks too red, add a little more green. At a mid-point the mixture will turn gray. This can be done with yellow and purple, as well as blue and orange.

An interesting visual experiment for the students in understanding color and opposites is to have them stare at a red surface for one minute and then close their eyes. They should see green dots with their eyes closed after looking at the red. This is because the eyes become starved for the opposite color if they are forced to stare at one alone for very long. The opposite color actually rests the eyes and creates relief.

Painting with opposites or complements can create vibrant and active paintings. Vincent van Gogh often used purple shadows on a field of yellow straw. When the complements are not mixed but placed side by side in a painting, they are visually vibrant.

When all three primaries are mixed together, brown results. There are three browns: one is more red like burnt sienna, one is more yellow like raw sienna, and one is more blue which is closer to burnt umber. The shade of brown mixed is determined by the amount of each primary in the mix. Blue, being the darkest color, should be used in the smallest amounts. Mix brown in stages, starting with yellow and adding red to it. Then add blue a little at a time, watching as the color changes.

Students are fascinated by mixing colors and will probably make a few "globs" and large combinations before they settle into the science of controlled mixing. That's to be expected and just part of the excitement of painting. Remember, tempera paints are pretty cheap so it's no great loss when students make a glob of brown. The depth and new understanding of color that comes from experimenting with color is tremendous compared to the loss of paint in terms of monetary value.

USING TINTS AND SHADES

A Tint Lightens the Value of a Color

1. Divide a piece of 12″ × 18″ tag board into twelve squares.

2. Draw a circle or an oval in each square. Paint the first circle yellow. While it is wet, paint white over the top half of the yellow circle.

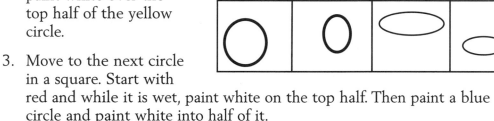

3. Move to the next circle in a square. Start with red and while it is wet, paint white on the top half. Then paint a blue circle and paint white into half of it.

4. Next use yellow as a tinting color. Paint a red, blue and black circle and use yellow to lighten the top or one side.

A Shade Darkens the Value

1. You may continue painting in the above grid. This time paint a circle red and while it is still wet, cover the bottom half of the circle with a little black.

Continue painting circles of yellow and blue to which black is added.

2. As an option, draw two circles like the above center square, paint the top one a primary color with a dark color on the bottom half of the circle. Then paint the other circle black. This should create the illusion that the circle is floating.

Using the Complement to Shade

Paint a circle red and add green to shade one side or the bottom. Paint a circle yellow and use purple to shade half of the circle while the paint is still wet. On a blue circle paint orange for the shade. Make a new grid to hold these new mixes or add them to the original grid.

UNDERPAINTING

The first color on the surface of the painting affects the value and thus the perception of the color. A white piece of paper is the most reflective surface for color and will best represent the pure color. The reds are bright, the yellows are clean and clear, the blues are rich and deep. When color is applied on a dark piece of paper or over a dark value or dark color, the value of the color applied is reduced and the color will appear subdued, not bright.

A dark blue, green, or black ground will alter the perception of red, yellow, or white when they are painted on top of the dark ground. Acrylics and tempera paints are slightly and often completely transparent, allowing the eye to see through them. Yellow on black will look more green than yellow. Red on white will look scarlet, while red on black will appear crimson.

Wet and Dry Surfaces

If paint is applied into a wet surface when changing color, it will mix with the under color to create a third and new color or value change.

To cover up an area, it must be dry. To avoid interference from the underpainting, paint the area white first, **let it dry,** and then paint over it with red, blue, orange, or whatever.

Some of the best colors and richest surfaces occur from painting one color into another wet color or painting over a dry color.

To experiment with colors, make a color chart following the guidelines on the next page. Test as many combinations as the students can think of. Paint on dry as well as wet surfaces. Label each test.

A VALUE STUDY: DARK ON LIGHT/LIGHT ON DARK

STEP 1: Wet on Dry

Make eight 4-inch boxes on the paper. Paint the first color shown below and **let them dry.**

STEP 1: Paint this one White	Paint this one Yellow	**STEP 2:** Paint Yellow on White	**STEP 2:** Paint Blue on Yellow
Paint this one Blue	Paint this one Black	**STEP 2:** Paint Yellow on Blue	**STEP 2:** Paint Red on Black

STEP 2: Dry on Dry

When the colors are dry, paint a second color over the first. It will make a difference how much paint is used in the second coat. A heavy coat will block more color than a thin coat.

STEP 3: Wet into Wet

Make another page of 4-inch square boxes while waiting for the first ones to dry. Make another study. Pick a color and paint one of the new boxes red, for example. While it is still wet, pick a second color, such as yellow, and paint it into the wet color. Continue trying one color into another in the other boxes. Make as many boxes as you have time or room. Try to keep the combinations at two colors only.

First paint the box Red—add Yellow to the wet Red	Start with Yellow—add Blue while wet	Start with Yellow—add Red while wet	Paint the box Green—add Blue
First paint the box Blue—add Yellow into wet Blue	Paint the box Red—add Blue while wet	Paint the box Red—add Blue and a little Whilte	Paint the box Purple—add Red while wet

THE COLOR WHEEL

OVERVIEW

Making a traditional color wheel can be tedious and even boring for students. To keep it interesting, offer a choice of formats. The color star, the spiral, wheels of color, or boxes of color may be more interesting to paint.

This exercise covers the mixing of primary colors—red, blue, and yellow—to create the secondary colors of green, orange, and purple. Any format can be used as long as all the mixtures of red and yellow are placed between red and yellow in the format.

When mixing colors, the amount of each color used in the mix will control the resulting color. For example, when mixing red and yellow to make orange, the more red in the mixture, the closer it will be placed to the red side; the more yellow in the mix, the closer it is placed to the yellow side. The same is true when mixing red and blue to get purple and when mixing blue and yellow to get green.

In addition to the secondary colors of orange, green, and purple, the students will make a series of tertiary colors that are degrees of secondary colors. Tertiary mixtures depend on the amount of each color used in the mix. When mixing red and yellow, the secondary color is orange. To get the tertiary colors of red-orange and yellow-orange, mix the red and orange. Then mix the yellow and some orange. Repeat for blue with yellow and with red. The students should try to create three different mixes by controlling the amount of the primary used in the mixture. Start with the secondary color and slowly add small amounts of the primary, watching the tertiary color develop.

COLOR WHEEL

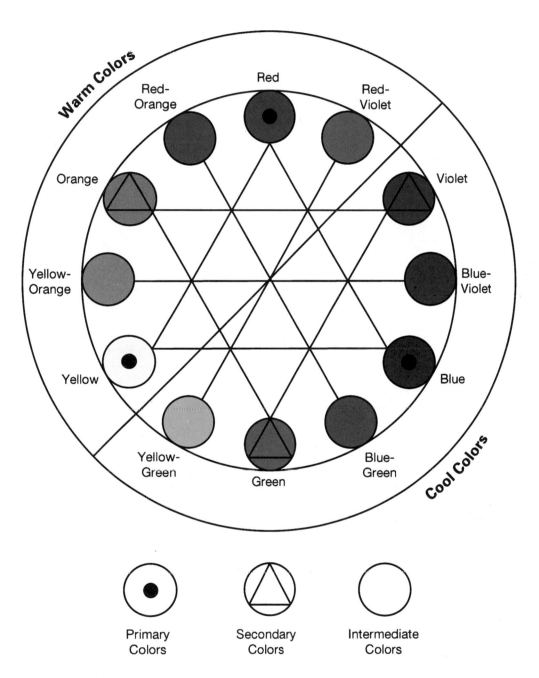

Color Wheel from Multicultural Art Activities Kit by Dwila Bloom (1994, C.A.R.E)

18a

Setting Up

In Section One, ways to distribute liquid tempera and to set up a room to paint are described. If you don't already have a favorite method for setting up to paint, this section will help.

Supplies

1. 12″ × 18″ or 12″ × 12″ white tagboard, tempera paint (red, blue, yellow, and white)
2. assorted 1/4″ or 1/2″ flat bristle brushes
3. pencils
4. water, sponges, or rags
5. plastic lids for palettes
6. paint shirts

The Exercise

The students will work with the primaries—red, blue, and yellow—plus white. The white is listed for mixing red and blue tempera paint to make purple. The purple can be too dark—by adding white the purple is more exciting to use.

To start, the students should decide on a format in which to place the primary, secondary, and tertiary colors. Several examples are suggested in the overview. Using a pencil, the students should lightly sketch out the format, whether it is a circle or a grid. The sections need to be at least two inches wide. If the sections are too small, it is difficult to fill in the area with a color.

Place the primaries of red, blue, and yellow on the chart, leaving a minimum of three empty spaces between each primary.

Next, the students mix two primaries to create a secondary color. Mixing red and yellow will make orange. Paint the orange on the color chart midway between red and yellow, leaving one space between the orange and the red and a space between the yellow and orange.

To make the tertiary mixes, take a little of the secondary mixture of orange and place it on a palette. Add more red to it and paint that mixture in the empty space next to red. Place a teaspoon of the orange on another spot of the palette and add more yellow to it. Paint this second mixture in the empty space next to yellow. Continue this process to mix red with blue for purple, which might need a small amount of white added to bring out the purple color in tempera paint. Then mix the blue and yellow together to create green and two tertiary colors of green between the blue and the yellow.

To control the mixing process, it helps to start with a small amount of color and add it slowly while watching the color change. Placing the colors side by side helps to control the mixing process. Since it is hard to say how much color it will take to alter another color or mixture, it is better to add slowly, using small amounts of paint, and watch the color change.

There is one more mixture students can make. Have the students draw another circle or place these new colors in the center of their color wheel or they can add one more circle around the outside of the first wheel to place these mixtures. Don't tell them about these next mixtures until after they have completed the first combinations.

Mix red, blue, and yellow together to get brown. Once again, the amount of each color in the mix will determine the brown they make. To control this, start with yellow, adding a little red to it, and then add a little blue.

If you were measuring the proportions of paint, it would go 1/2 yellow to 1/4 red, and 1/8 blue. Then reverse the red and yellow amounts for a second mixture, using more red than yellow; in the third mixture, use a little more blue than the other two. Blue can be added sparingly as it is overwhelming and changes the mixture very quickly. It is best to add dark colors slowly, at the end and a little at a time. By controlling the balance of pigments in the mix, the students should have three different browns.

Goals

- Students increase their technical knowledge of color mixing.
- Students learn to use the brushes and to set up the room to paint.
- Students are given a foundation for other lessons that are more complicated.

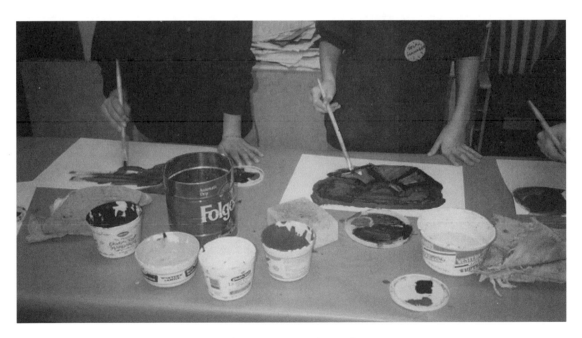

Students from Foster School painting

Section 2

BEGINNING TO PAINT BY EXPERIMENTING AND PRACTICING

1. Brushstrokes: Applying Paint
 and Using a Brush

2. Painting Techniques: Splatter, Stencil,
 Squish, and Play

3. Painting Techniques: Layering Wash,
 Stencil, and Resist

4. Working Wet on Wet

5. Working Wet on Dry

6. Details in Painting Nature: Clouds,
 Foliage, Fields, and Atmosphere

7. Painting with Complementary Colors:
 A High Contrast Painting

BRUSHSTROKES: APPLYING PAINT AND USING A BRUSH

To Pick Up Paint with the Brush

Dip the brush in the paint, covering only the bottom one-half of the bristles. Try to keep paint off the ferrule. The ferrule is the metal band that holds the bristles to the handle. Once paint gets up inside the ferrule, it is impossible to clean out and it will ruin the brush.

Paint Can Be Blended with the Brush While Painting

Apply color to the light side of the form, then clean out the brush and pick up a dark color for the dark side of the form. Paint the dark side of the form leaving 1/2" to 1/4" of blank paper between the two colors. With a clean brush, wipe the brush into the light color, then work the light color across the blank space into the dark color. After one or two strokes wipe the brush off on a paper towel and continue mixing the two areas together. Blending light and dark creates a medium value between the light and dark sides.

Wiping the paint out on a rag helps to control the mixing. Once the brush is full of mixed paint, the mix will get darker and darker and it gets hard to create light and medium blends.

Paint Can Be Applied One Stroke at a Time

Colors can be laid down side by side and not mixed together.

Pressure Is Important in Brushing on Paint

Light pressure gently mixes areas together. Firm pressure mixes the paint layers together. Try different pressures. With light pressure, paint can be laid on wet paint without mixing the two together.

Painting Light to Dark Background to Foreground

Start with a thin light color: yellow, orange, or *thin* red wash. Paint the entire paper and let it dry. Come back over the ground with strokes and dots of paint, allowing the under painting to show through here and there. Stack light blue paint strokes for the sky. White strokes can be painted over the wet blue to create clouds.

Student Painting Techniques: Strokes, stacking, marking dots, and dashes

PAINTING TECHNIQUES: SPLAT-TER, STENCIL, SQUISH, AND PLAY

OVERVIEW

Some paintings are planned, others are not. This one is not planned. It is mark making and experimenting. In this exercise students learn by doing. Painting often teaches itself; while students may understand the mechanics of painting, what the paint *can do* is easier to learn by painting.

Sometimes it is difficult to talk about how you make a painting. The automatic response side of the brain can work in conjunction with the hand to make a painting without using either logic or reason. When you are painting, you make decisions depending on what is happening at the moment. Parts of the act of painting are not planned. They are outside of the logic and reason side of the brain. "I don't know, I just did it," is a perfectly acceptable reason for painting.

After 30 years of painting, I'm not sure I understand today just exactly how I paint. You have to pick up the brush and trust that it will work out when you are done. Painting is an act of faith.

The Exercise

The goal is to cover the paper with a series of experiments with the brushes. It is best to have a pool of paint to dip the brush into. If you are using hard pan watercolors, add a teaspoon of water to the pan and mix the paint and the water together before starting. Start with the last color mixed since the paint is now in the brush.

Otherwise, dip the end of the brush in the paint without getting paint up to the ferrule (the silver band above the bristles) and make as long a mark across the paper as the paint in the brush will allow.

Alternating the brushes, follow up with:

- Thin lines, thick lines, squiggles, dots, and dashes.

- Change the pressure on the brush. Start by pressing it lightly into the paper, then increase the pressure. Make a series of marks rotating between light and heavy pressures. The marks may look like a series of small to large blobs.

- Twist and turn the brush on the paper more gently than roughly, as rough handling will ruin the brush. The bristles can fall out.

- Set the end or tip of the brush on the paper and make a small stroke lifting the brush up at the end of the stroke. Make a line or two of these strokes side by side.

- Using a watercolor brush or soft-pointed brush, try to make a line. Start with light pressure, then press down a little to widen the line, then let up to thin the line. Continue the line until the brush runs out of paint.

- Make spirals, loops, circles, and other gestures.

Supplies

1. assorted available brushes (square bristles, flat, pointed)
2. toothbrushes
3. paper
4. black felt-tip pens
5. container of water
6. paper towels or sponges
7. tempera paint and watercolors (any available color)
8. small dishes, jars, containers for paint
9. glue

SPLATTERING

First put newspaper down to cover the table or the desk where students will be working. Splattering is very messy, and tempera paints and watercolors can stain clothing so a paint shirt or cover up is a good idea. Murphy's® oil soap is good for getting out paint stains. Rub it into the fabric on the painted area and let it sit for a few hours to overnight, then rinse it out with water and wash.

Place a white piece of paper on the newsprint. Tempera paint can be used right out of the bottle or thinned with acrylic medium and a little water. The paint should be liquid but not runny and thin. Too much water will dilute the color, leaving the splattering thin and washed out. Dip the brush in the paint and flick the paint at the paper. You can use your hand as a bridge and gently hit the brush handle against the end of the hand or across your finger to increase the splatter and control it somewhat. Runny paint will drip off the brush. Try gestures of flicking or shaking. Hold the brush, bristles up, loaded with paint, and with a flick of the wrist toss a line of spattered paint down on the paper.

Rinse the brush and wipe the water out on the paper towels, then change to another color. Long-hair soft and floppy brushes are easier to use than short, square, bristle brushes. The soft brushes will hold and release the paint better. Cover the paper with multi-colored splatters. If it's nice outside, you could do this outside.

A toothbrush may be dipped in paint and—by pulling the bristles back and aiming it at the paper—the paint will splatter onto the paper. Hold the brush near the surface of the paper. Wearing plastic gloves protects the hands. Students can also run the brush across their fingers to spray the paint on the paper.

THE NEXT STEP: FINDING THE FORM IN THE PAINT

1. Have the students look at the pages of marks they made. Ask them if the marks look like anything. . . . Reptiles, animals, insects? Using black felt pens, have the students add some eyes, legs, arms, heads, whatever they can to convert them into animal shapes. Now, rather than planning to draw an animal, they are finding and creating them out of their abstract painting marks.

2. Let the students draw on the splatter page with a pencil, creating shapes to cut out. Have the students cut out shapes and reassemble them into a picture. Add line to the shapes with a felt-tip pen. They can cut out mountains, clouds, houses, dogs, and airplanes. Let the students exchange painted papers with other students to see what they can cut out.

3. Splatter pages will vary by students with different colors and different patterns. They could also add solid pieces of colored construction paper for some of the areas. Glue the pieces to a solid color sheet of railroad board or construction paper to make a collaged picture.

Goals

- Students practice painting which will improve their skills.

- Students develop hand-eye coordination and increase the concentration and focus of their eyes.

- Students are given a no-stress, no-fail activity in which everyone succeeds and learns something by doing.

Criteria for Evaluation

FOR AN A

1. The student covered the page with experimental marks. The student experimented with all available brushes (two at least). The student expanded the abstract mark into something else.

2. The student splattered a piece of paper with at least three colors. The student cut and pasted a composition of splattered paper shapes on construction paper, and added line.

 The student used the found and reshaped marks of animals, reptiles, or insects in a collage.

FOR A B

80% of above

FOR A C

50% of above

NOTE: These could be two separate exercises done on two separate occasions, which would also divide the criteria.

Reference Lessons

See Section One for "Getting Ready to Paint" and "Using and Storing Tempera Paints."

PAINTING TECHNIQUES: LAYERING WASH, STENCIL, AND RESIST

OVERVIEW

This exercise serves two purposes. First, it's practice in using and understanding wash techniques. Secondly, the painting can be used later as a prepared ground for the exercise "Working Wet on Dry" in which the students need a previously painted dry ground on which to work.

Once the papers are dry, stack them up and save them until you are ready to work again. This exercise covers many different ways to put paint on paper. It may be something to stretch out over a week or several weeks.

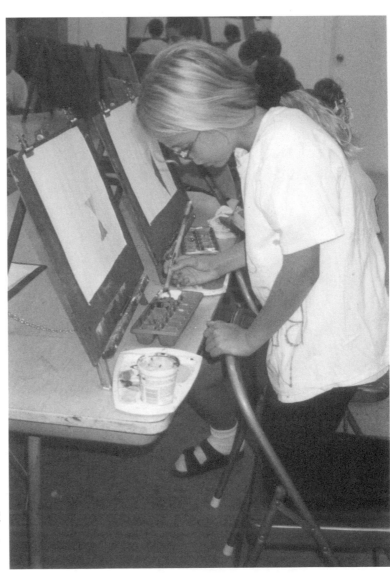

Student at Corvallis Art Center painting shapes

Student Painting Techniques: Layering wash, stencil, and resist

30a

Shapes and Wash

Working with wet layers on paper will cause the paper to wrinkle and curl. To avoid this, first tape the paper to a board or desk top. The paper tape that you have to moisten is the best. If you can't find it or don't have paper tape, use wide masking tape. If you only have 1/2-inch tape, use two strips overlapped at the edge on each side of the paper to hold it down.

In little cups, dishes or jars, mix the

paint and the water diluting the paint to a wash. Mix by dipping the tip of the brush in the jar of full-strength paint and then stir the paint into the water. Test the color on a scrap piece of paper. If the color is too dark, add more water to lighten it up. A hint of blue, red, or yellow is all you'll need. Make up dishes of red, blue, and yellow for the students to share.

The paper tape needs to be dry before you start. Use the 1-inch flat soft bristle brush and paint a shape like a circle, a square, or a triangle on the paper. The shape should take up one-fourth to one-third of the paper. Select another color and paint another shape on the paper, but don't let them touch. Add a third shape.

Making shapes and grounds with wash

When the first shape is dry, use a smaller quill or flat brush, dip into the wash and paint half of the shape with the same color again. Rinse out the brush and repeat on the other two shapes. Add more paint and water to the wash. When this second layer dries, add a third layer of wash over the bottom of all the forms. Use the same color to build up the color on each shape.

CREATE BACKGROUND AND FOREGROUND

While waiting for the shapes to dry, use a 1/2-inch brush and put a wash of different color behind the forms on the top half of the paper. Change the color and put a second wash on the bottom half of the paper behind and around the shape.

ADD SHADOWS

Mix up the complements: green from blue and yellow, orange from red and yellow, and purple from red and blue. Dilute them in separate dishes. Use the complements to create shadows, such as green on a red form. Paint over the one side and the bottom of the red form with a green wash. Then put orange on blue and purple on yellow. Continue and paint a shadow under the form in the complement. The shadow should be painted over the dry foreground color added earlier, which helps to darken it.

SECOND PAINTING—THE FLAT WASH

These washes need to dry between layers. Work on two paintings at once. If you have room, tape another piece of paper to a board, table, or the floor. The paper can be painted without taping it down, but it will wrinkle a bit which is okay. When it dries, the painting can be placed under a pile of books to flatten out the wrinkles.

Use the large flat 1-inch brush and dip the brush in the color wash. Paint a horizontal line of color across the top of the entire paper.

Keep dipping the brush in the paint and continue adding horizontal strokes one over the edge of the next all the way down the paper, filling it entirely with one wash color. Let it dry.

WASH #2 AND PAPER #2

Dip the large flat brush in a color, make a thick stroke of blue, for example, across the top of the paper. Wet the brush by dipping the bristles in the water and wash the color down the paper, pushing it with only a wet brush.

WASH #3 AND PAPER #3

Dampen the entire piece of paper with a wet brush. Dip the brush in red and paint a stroke of red on the side. Watch the paint spread into the wet and move across the paper.

WASH #4 AND PAPER #4: USE A SPONGE

To make a large wash all over the paper, first tape the paper down. Dip a small round or square piece of sponge in the color wash and wipe it across the paper one row at a time from top to bottom or side to side. You can change direction if you want to experiment with the ground. Wipe horizontally, then vertically, then diagonally across the paper.

WASH #5 AND PAPER #5

Making washes is a delicate operation and usually looks best with a minimal amount of brushing. Place a stroke of blue at the top of the paper. Then with a clean but wet brush paint into it, pushing the color down the paper. This will thin the color out. Clean the brush and dip it in magenta or red wash, then add strokes of this wash to the middle of the paper over the blue. Clean out the brush. Dip it in yellow and paint the yellow over the bottom third of the paper. This should give you a hint of green at the bottom and a little purple in the middle. Let it dry.

ADD A STENCIL DESIGN

While the ground dries, use scraps of tagboard or construction paper to make a stencil. Cut shapes out leaving two inches of paper around the hole for the shape as a frame. The students can cut out geometric shapes, or shapes from nature like trees, lightning bolts, clouds, or flowers.

Place the stencil on the dry painted ground. Adhere the outside edges with light masking tape and spatter the opening with full-strength tempera paint. Or use a flat brush dipped on the tip in full-strength tempera and paint carefully over the stencil. Don't paint back against the edge of the opening. Change the direction of the brush painting from the paper frame into the stencil shape until the middle where you stop and go to another side. Try to cover the area in as few strokes as possible; the paper stencil cannot be painted on very long before it will disintegrate. The paint should not be too watery.

One way to extend the life of a stencil is to paint over it with either matte or glossy acrylic medium. If you have added acrylic medium to your paint, the stencil will dry stiff and be water resistant. After the first coat has been applied, let the stencil dry. They you can reuse the stencil and students can share stencils.

Use a paper towel to blot off any extra or unwanted paint in the stencil outline. Blotting can also let the under color show through better.

RESIST

Make a crayon drawing on the tagboard first, using any color of crayon. Put a light wash over it. Let the wash dry. Add more crayon to the picture. Add a second wash. The students may for the first wash choose one color at the top of the paper for the sky and another wash color at the bottom for the ground. They may alternate areas of the painting with different color washes if they like. Continue adding wash over wash and crayon. Then crayon on wash until the picture is done.

Rubber cement is a wonderful resist. (CAUTION: Use rubber cement in a well-ventilated room.) Paint rubber cement on the paper using a stroke in the sky for wind; on the ground wipe strokes unevenly for grass or on a tree trunk for texture. Let it dry. Paint over it with a medium-colored wash. Let it dry and then rub off the rubber cement.

After a colorerd ground has been applied to paper with either the brush or the sponge, students may color with crayon on the ground and then add wash over the crayon. They should push firmly on the crayon. If it's too lightly applied, it fades away.

Goals

- Students practice painting and improve their skills to develop a greater knowledge of the possibilities of painting.

- Practicing painting improves hand-eye coordination and increases the concentration and focus of the student's eyes.

- Students are given a no-stress, no-fail activity in which everyone succeeds and learns something by doing.

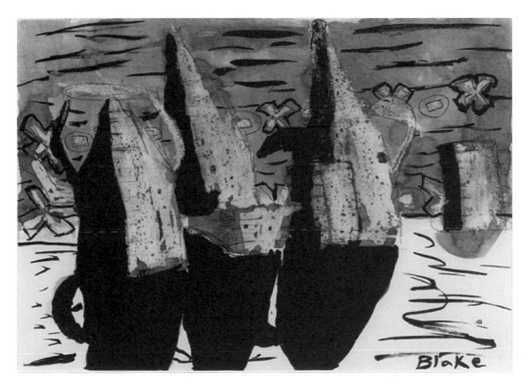

Blake Shaw-Phillips, Grade 5, wax resist and ink drawing

WORKING WET ON WET

OVERVIEW

Mixing colors while they are wet lets them run together or marry. This process is more chance than planning. The art work generated in this exercise may also be used in the next, "Working Wet on Dry." By saving this work you don't need to repeat the exercise; instead, you can extend these paintings one step further.

If you can obtain painting boards in maple plywood or Masonite™, they will help students complete these lessons. Taping the paper to a board allows the students to manipulate the paint by tilting and turning the board. It will also help in storing the papers while they dry as you can leave them on the boards and stand them against a wall a few inches apart to dry.

The Exercise

Tape the paper to the desk or a board before starting. A wet paper will warp and wrinkle more if not taped down making it difficult to work on, but it can be done. If the paper buckles, wait for it to dry and then paint on it again.

Supplies

1. 80-lb white drawing paper
2. paper tape or masking tape
3. tempera or watercolor
4. jars or dishes to hold paint in
5. flat and quill brushes
6. water
7. rags, paper towels

Mix the tempera paint with a little water in a small dish or cup. For watercolors, add water to the pan of watercolors in the center of the hard pan and mix the paint with the water. By creating a small pool of color, the students can dip the brush in to paint.

PAPER #1

Paint a large yellow shape on the paper. Clean the brush in water and wipe the water out of the brush on the paper towels. Dip the brush in red and touch the end of the brush into the wet yellow and let it run into the yellow.

As this first color spreads, add more red by dipping back in the pool and touching the end of the brush a second time into the yellow. Don't brush the color together, just let it run together.

Try another shape and while it is wet, add a second and third color to it.

A third approach is to paint a red area and while it is still wet, dip the brush in yellow, then lightly brush the two together with a clean brush.

PAPER #2

If the paper is on a board, wash on a color in a couple of big strokes with a large flat brush across the top. While it is still wet lift up the board and let the color run down the paper. Lay the paper down and brush several rows of another color over the top edge and then pick it up and let it run again. Let it dry. If the paper is not taped to a board, hold it up by hand to make the paint run and pin it on all four corners to a wall to dry.

PAPER #3

Dampen the entire sheet of paper. Paint a large thick stroke of red across the top. Using a damp to wet brush, paint into the first red stroke, pushing it down the page. Add a little more red if it gets too light. Clean out the brush.

Pick up yellow as a second color and brush it into the paper from the middle of the paper to the bottom. Clean the brush, blot out the water in the brush.

Finally, dip a clean brush into the blue wash and start at the bottom of the paper, brushing it over the two previous washes while wet. Move up the paper a line at a time but only brush the bottom fourth of the paper.

These three layered and overlapped colors are a ground for a landscape painting with the color moving from light to dark down the page. (The following wet-on-dry exercise deals with using these grounds.)

PAPER #4

Dampen the entire paper with a wet brush or damp sponge. Paint a line of color, perhaps blue, across the top and watch it spread. Pick up another color, perhaps green or red, and lay a line of color under the first blue stroke. Repeat, moving down the paper adding one row of wet paint after another. It will run together with fuzzy edges.

Hint:

If you work the paint over the paper too much, it will turn muddy. Watercolor muddies quicker than tempera, and tempera mixed with acrylic medium lasts longer than both.

Goals

- Students practice painting and improve their skills to develop a greater knowledge of the possibilities of painting.

- This practice improves the student's hand-eye coordination and increases the concentration and focus of their eyes.

- Students are given a no-stress, no-fail activity in which everyone succeeds and learns something by doing.

Criteria for Evaluation

For an A:

1. The student painted four papers, with four different wash techniques.

2. The student experimented with all available brushes.

3. The student covered the entire page with a wash.

For a B:

80% of above

For a C:

50% of above

NOTE: This lesson could be done on three separate occasions.

WORKING WET ON DRY

OVERVIEW

Use the papers from the wash or wet-on-wet exercises in the previous lesson. For the following first exercise, students need a previously painted, dry ground to paint on.

Drawing or painting boards are very handy to have because the students can tape their paintings to a board that can then be set against the wall to dry. In addition, they can tilt, tap, and run paint easier. Lumber yards can cut a 1/4" to 1/2" piece of plywood or maple into 20" × 18" boards for probably under $5 a piece. You can also use Masonite™, which is cheaper at about $2 a board.

THE TYPE OF GROUND YOU BUILD ON MAKES A DIFFERENCE WHEN ADDING A SECOND COAT

1. **Tempera mixed with acrylic** is water-based but permanent and will dry hard. You can paint on top of this ground and the under layers will not mix with the top layers.

2. **Tempera alone** is water-based. If the second coat is too wet or brushed too long on top of it, the ground will dissolve and mix with the second coat.

3. **Watercolor** is water-based and will fade together with top layers if the students brush the surface heavily. The second coat should be planned and placed on the ground with a few strokes of paint.

The Exercise

Select one of the previously painted papers. Using a pencil, *lightly* draw the outline of trees, mountains, clouds, and cars for a landscape or roof lines for a cityscape. The choice for the drawing is up to you and your students; these are just suggestions. Keep the drawing simple.

To paint, use a wash by reducing the amount of water and increasing the amount of tempera in the painting mixture. Have the students paint their drawn images over the ground. The original light pencil lines outlining areas will reinforce the edge of a shape. For a strong and bold outline use felt-tip pens to outline forms first on top of the wash. The ground will show through the colors applied if the second color is thin and not too thick or dark. Short brush strokes will prevent the undercoat of watercolor or tempera from loosening up and mixing with the new second coat. Try to stack and add brush strokes to change areas as opposed to brushing over and over one area.

Supplies

1. prepainted paper
2. heavy white paper (80-120 lb)
3. paper tape or masking tape
4. tempera or watercolor
5. colored pencils, crayons
6. jars or dishes to hold paint
7. flat and quill brushes
8. water, rags
9. a Masonite™ or plywood board (optional)

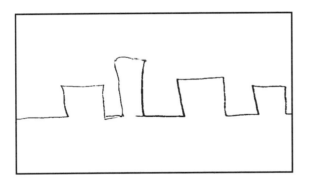

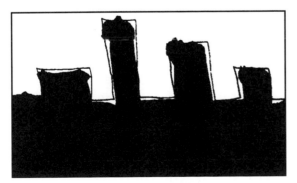

The water method

THE WATER METHOD

Use a fresh sheet of white paper. Draw a skyline of building tops across the middle of the paper. A skyline is just a line drawn vertically then horizontally to establish the top of a line of buildings. Dip the brush in clean water and dampen the paper in the area for the buildings and to receive the wash. Dip the brush in a gray wash and paint into the wet area across from the edge of the paper up into the buildings. Turn the paper upside down to dry, letting the pools of paint flow back into the wash. The paint will not flow over the drawn edge where the paper is dry.

USING COLORED PENCILS

The students can also draw with colored pencils on the dry wash and then fill in with layers of color pencils and wash colors over the pencil.

To combine materials, draw the outline of an animal in colored pencil on a dry wash. The wash will make a ground for any texture such as an animal's coat. By using hatching strokes in colored pencil, a texture of hair can be created over the wash. The wash will show through, increasing the effect.

CRAYON

Crayons can be used with wash. The crayon will resist the wash, creating a texture in the wash.

To create a texture of fur use a tan crayon on the animal's body by rubbing a light layer of crayon over a yellow or orange wash where the fur will be placed and then paint over the crayon with a thin wash of brown or red. Use a few strokes; overbrushing muddies the effect. To darken use a little green in the red or purple in yellow or a little blue. Use the darkened mix to paint over the underside of the animal and back of the legs.

Add another wash around the animal to change the sky colors.

Make light and dark marks on the ground for rocks or grass with different colored crayons. Paint a wash over the ground marks. Paint lightly, both in terms of pressure and value to preserve the crayon marks.

A CROSS-CURRICULUM LESSON

Once the students have created the wash grounds, they will need a subject for the focus of their painting. The painting could focus on an aspect of a history or geography lesson you are currently studying. Each student could make a picture about what most sticks out in their mind from the lesson. When they create a scene out of history that they choose on their own, they reinforce the lesson in their memory. It works best if they pick what to paint rather than being assigned a person or object. That way they must make decisions about what they know and what impressed them. They have practiced and learned the art techniques they need to use to create an illustration of their subject. By combining techniques with critical thinking they create a personal artwork.

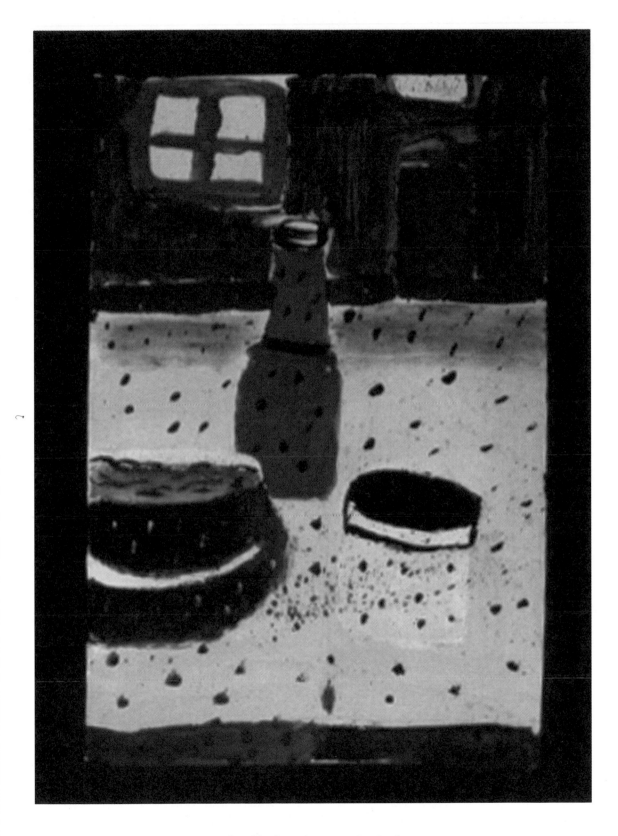

Molly Van Meter, Grade 6

MURAL PROJECT

Working with the students, select a time in history and plan the entire scene. Make a list of the images the scene will need for completion and assign each student to create one image or part of the scene. Use a piece of paper with a wash ground to draw the subjects and then cut them out. On a large piece of poster or butcher paper compose the drawings to create the narrative. Paint a wash on the paper for the sky and the ground before gluing the individual sections over the ground.

Goals

- Students practice painting and improve their skills to develop a greater knowledge of the possibilities of painting.
- By practicing they improve their hand-eye coordination, and increase the concentration and focus of their eyes.
- Students are given a no-stress, no-fail activity in which everyone succeeds and learns something by doing.
- Art is tied to the curriculum with both subjects retaining their personal integrity; neither becoming second to the other.

Criteria for Evaluation

FOR AN A IN EACH PROJECT

1. The student painted forms over the washes.
2. On a second paper the student covered half the page with a wash ground, separating wet from dry with a skyline. The paper was dampened and a wash added.
3. The student used a wash with a colored pencil drawing.
4. The student made a multi-layered pencil, crayon, and wash painting consisting of three applications of line areas or crayon and at least four washes.

FOR A B:

80% of above

FOR A C:

50% of above

NOTE: This could be three separate exercises done on three separate occasions which would also divide the criteria.

Reference Lessons

See Section One for "Getting Ready to Paint" and "Using and Storing Tempera Paints."

DETAILS IN PAINTING NATURE: CLOUDS, FOLIAGE, FIELDS, AND ATMOSPHERE

OVERVIEW

There are many ways to apply paint and remove paint depending on what you want to achieve. Cut up a large sheet of paper or tagboard into approximately 6″ × 9″ pieces to make small studies with the following techniques.

I haven't included any evaluation criteria as this is all practice and skill building. Practicing and fooling around with paint is a tremendous learning tool. Not only can this exercise increase the students' skill level, it can also build the students' interest. As the students watch the paint go on the paper and as they move it from here to there, they will increase their hand-eye coordination which has been found to also improve their reading skills. When they improve their skill level in painting, it also helps build their self-confidence. Playing with paint is magical and intriguing.

The Exercises

LIFTING OUT: CIRRUS CLOUDS

Dilute blue tempera paint in a dish or jar with water to make a wash. Lay a flat wash across one of the papers with a large flat brush or mop (brush). While the wash is wet take a piece of tissue or a dry sponge and wipe a streak through the blue. These streaks can overlap, go diagonally, or vertically. Ask the students to think of cirrus clouds in the sky.

CUMULUS CLOUDS

Paint one of the papers light yellow and let it dry. Add a second wash over the dry yellow of red. Then while it is still wet, use a crumpled piece of tissue with a dabbing motion to pick up some of the color. Dab in a semi-circular motion. As the tissue gets saturated, pick up another tissue to remove more paint, carving out a large cumulus cloud.

Hint: You can lift out dry paint. A small quantity of gum arabic can be added to the paint water to give the paint extra body. Because it is soluble in water, it makes the paint easier to lift out when dry. Gum arabic is sold in art stores.

FOLIAGE, FIELDS AND HILLSIDES

When layering washes, start with a *light* wash. Layering and lifting out color can make surprisingly complex effects of multicolored grounds. For a hillside, lay an orange wash down first. Let it dry and wash green over it, wiping and dabbing some of the color off. Let it dry and wash red over it, wiping and dabbing some of the color off. Let it dry. For foliage, start with a yellow wash and let it dry. Wash orange and red over it and dab out spots. Let it dry. Then go back with a small brush and add spots of dark paint to create the underside of the leaf where it is turned away from the light.

ATMOSPHERIC EFFECTS

Paint a darker color on one of the papers and, while it is still wet, dip a toothbrush in water. Hold the bristle over the wet ground and spray the ground with the water. Spatter the water off the brush holding the bristles upward by drawing your thumb across it. Water flicked onto damp or wet paint will produce irregular small shapes.

MASKING FLUID OR RUBBER CEMENT

Rubber cement can be spattered much the same way on the white paper. The drops will protect the paper from the wash of watercolor. When the wash is dry, rub off the masking fluid or rubber cement. This technique results in a winter snowstorm effect. (CAUTION: Be sure to put paper down everywhere as masking fluid is hard to get off wood and floors and it can spray a long distance. Also use these products in a well-ventilated room.)

WHITE SPATTER

White spattering can be used in the final stage of a painting. Dip a toothbrush in white tempera and use your thumb to spray the surface. This effect might be used as ocean spray, or as snow on top of the sky, rocks, or hills. The thicker the paint, the easier it is to control.

Hold the toothbrush a few inches from the paper, running your thumb or the handle of another paint brush quickly along the bristles. Put the white spattering over a wash base. Create a scene to be spattered with snow or an ocean with waves crashing.

SPATTERING COLOR

Paint a little landscape with a beach and a few rocks. Paint the sand a light gray wash or light yellow-orange wash. Use a toothbrush dipped in the color you painted with and make a wash to spatter the area. The approach and process to use for this type of spattering is to hold the handle of a paintbrush over the area to be spattered and pull your thumb across the bristles to release the paint in drops. Globs that are too big can be lifted out with a cotton swab or ball. You can use the same paint for both wash and spatter because the spatter will be slightly darker as it is a second layer of paint. You may add different colors over the wash to create the effect of pebbles on the sand or a multi-colored ground.

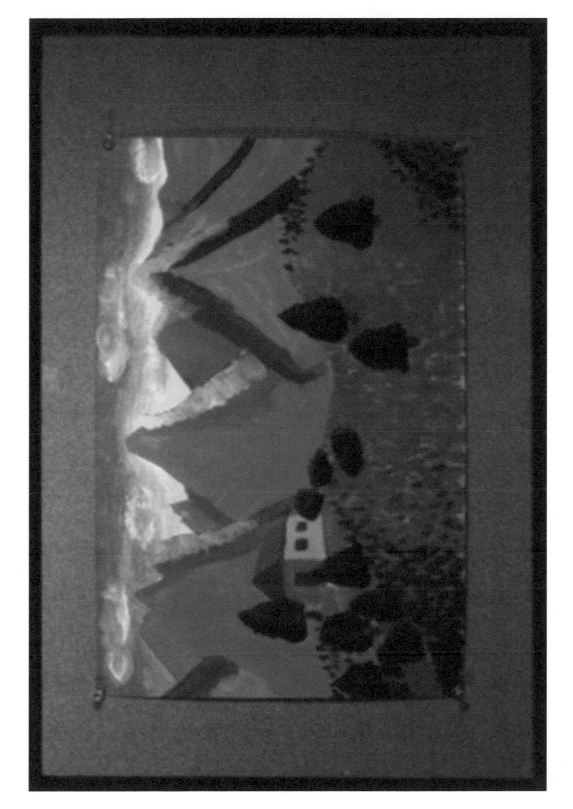

Meagan Macke, landscape, tempera on paper, Art for Teachers, Oregon State University

46a

The spattering will go everywhere. To protect parts of the painting that you do not want to spatter, cover them with a paper mask cut out of scraps. Lay the paper scraps over the areas to be protected. Wax paper works nicely as you can see through it so you can lay it down and trace the shape to be protected and then cut out the outline.

Spattering can be used in decorative patterns. Spatter the ground wash in either a wet or dry state. Let it dry. Paint the lines of the design on top and around the spattering. You can draw a design with a black felt-tip pen also on top of the dry washes and spattering. A wax or rubber cement resist can be painted first as a design, and then spattered. Rub the resist off, leaving a white line design in and around the spattered colors.

DRY BRUSH

In dry brush painting you work with a small amount of paint on the brush. The rougher the paper surface, the better this technique will work. A soft flat brush works best; a camel hair or a soft nylon will also work.

Using previously painted surface, dip the brush tip in the paint and drag the brush across the paper in the areas to be textured. Be sure the underpainting is dry. This works well for creating the effect of fur, hair or grasses or a hazy effect between the trees and the sky.

One way to apply the paint is to hold the brush right above the bristles and splay them out by holding all of them between your fingers and then brush over the area. To insure you don't put too much paint on the brush, wipe or dab it off lightly on a paper towel before painting. The dry brush technique is designed to go over other washes or painted areas to create a final texture. Dry brushing applies an uneven fragmented layer of paint with the undercoat showing through.

PAINTING WITH COMPLEMEN-TARY COLORS: A HIGH CONTRAST PAINTING

OVERVIEW

Vincent van Gogh often used violet for the shadows against the yellow of his wheat fields, the reason being that complementary colors create a visual vibration when placed together. They react to each other to create a visual "push and pull."

Complements may also be used to darken each other. For example, if you are painting a red vase and want to darken one side or the bottom, where the form is in shadow, add a little green to the red to create a darker shade of red.

If you mix red and green together, add a little white and a gray will result. Depending on the amount of white added to the red and green mixture, the gray will be dark or light. This gray mixture can be added to either red or green to lighten or darken the value of the color while not losing the sense that it is red or green. Blue and orange are complements, and yellow and purple are complements. Any one of the three primary and secondary sets will make gray when mixed together.

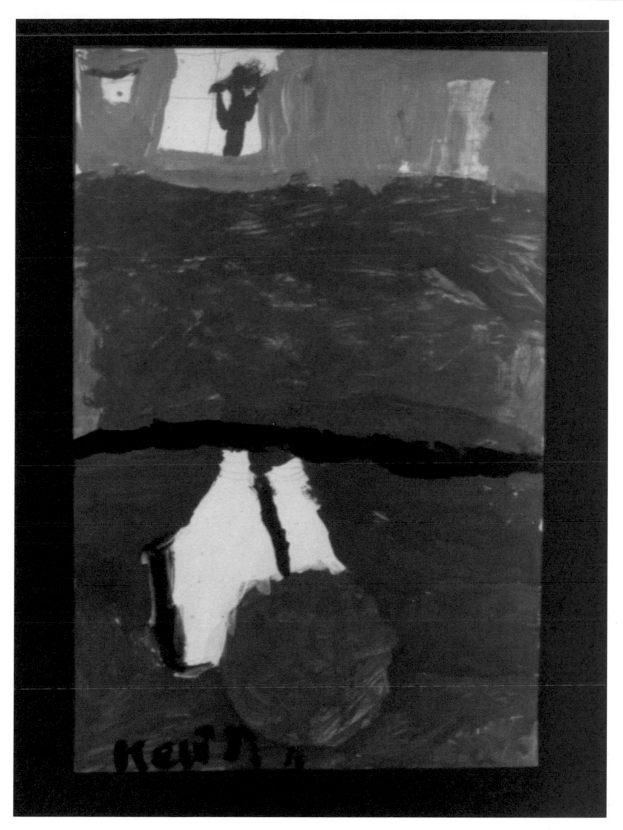

Kevin Prather, Grade 6, a still life painting with complementary colors

The Exercise

Use blue and orange complementary colors to paint a landscape. First paint the sky over half of the paper. Start at the horizon in the middle of the paper and paint it orange from the horizon halfway up the paper. Add red to the top quarter of the orange, painting the red over the orange. Next add a band of purple from the red moving up to the top of the paper. Don't overlap the red-orange with the purple as that will make brown; instead, place them side by side.

Pink follows purple to the top of the page. Use blue for the mountains. Paint a range of mountains over the orange across the middle of the paper. Mix a little orange and blue together to make a gray. Add white to see if the mixture turns gray. If it looks too orange, add a little blue; if it looks too blue, add a little orange until it turns gray. Use the gray to darken one side of the mountains.

You may add the gray to the blue initially or paint the gray directly into wet blue on the paper. Add some of the light gray mixture to some orange. Draw the shape of the hills across the paper in front of the mountains and paint it the orange tinted with gray.

Draw a road wide at the corner weaving back across the page, getting narrower as it goes back. Paint it dark gray in the front and light gray back toward the mountains.

Now paint the front corner yellow and the middle space purple. Have the students add other images over the yellow and purple grounds. Now they can see how the colors work together and how to alter them from light to dark.

Goals

- Students learn to move the value of color from light to dark by using the complement of the color.

- Students plan a landscape and improve their skill with the brush.

- Students learn to interpret what they see in nature in paint.

Supplies

1. tagboard
2. tempera paint (red, blue, yellow, orange, green, purple, and white)
3. brushes
4. water
5. rags

49

Section 3

STILL LIFE

1. Chiaroscuro: Single-Object Value Study

2. Cylinders and an Imaginary Bowl of Fruit

3. Monochrome Painting

4. Black, White, and Gray Study

5. Adding Color over a Black and White Value Study

6. Overlapping Shapes Create Space

7. Still Life: A Cubistic Approach

8. Working from a Small Still Life

9. Working from a Large Still Life

10. Drapery

CHIAROSCURO: SINGLE-OBJECT VALUE STUDY

OVERVIEW

This lesson is directed at understanding color values. Value is the light and dark range of a single color. There are light greens and dark greens and greens in between. Some values have names. Light red, for example, is called pink and dark red is often referred to as maroon. Color manufacturers also name colors. Azure would be a sea blue; hunter green, a forest color. Colors may be referred to by the mineral or metal they come from. Cadmium Red, Titanium White, Zinc White, and Cadmium Yellow are examples.

In the following exercises, students are shown a process to practice creating light and dark values. They can then implement the process by themselves in a painting.

Choosing a value to use in a painting is directly related to light. The way light falls on forms and in a room determines how the painter chooses to place light and dark. The Italian term for light on dark is *chiaroscuro, chiaro* meaning "light" and *oscuro* meaning "dark." By changing color from light to dark, the painter creates space, volume, and depth in the painting.

The subject of this painting is an imaginary ball. The students will use one color and its complement. They will work from light to dark. Red and green are opposites or complements, yellow and purple are complements, and blue is the complement of orange. The students can mix the secondary colors or use a premixed color from the manufacturer. Tempera mixes may be a little muddy and inconsistent because it is impossible to control the amount of each primary used to make the secondary. The premixed secondaries of orange, green and purple are sometimes better to use.

The Exercise

The students can work at their desks since they are making up the compositions, or their desks can be grouped together in fours with an empty desk in the middle to hold the paints, water, and sponges if they need to share supplies. Each student picks one primary and its complement.

Use the pencil to lightly draw a circle in the middle of the paper (Diagram I). Each student selects the direction the light is falling on their circle, and lightly circles the spot on the circle where the light hits first. That's the hot spot and the lightest place in the painting. Ask the students to leave that spot white on the paper in the beginning. It is helpful to lightly circle the area with a pencil line (Diagram II).

Supplies

1. 12″ × 18″ tagboard
2. tempera paint (red, blue and yellow)
3. tempera paint (purple, green and orange)
4. small and large brushes
5. plastic lids for palettes
6. containers to hold paints
7. rags or sponges
8. water cans
9. pencils

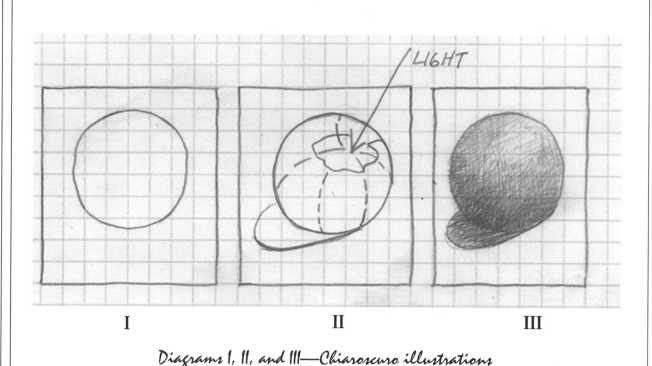

I II III

Diagrams I, II, and III—Chiaroscuro illustrations

53

Select a primary color, for example, red. Paint the top quarter of the ball red. Then add a little yellow into the red, mixing it in while the red is still wet. Use only enough yellow to lighten the red, but *not* so much that you make orange. With a clean brush pick up a little white and work it in over the pencil outline holding the hot spot. As the brush runs out of white, continue working the little that is left in the brush into the wet red and yellow color on top of the circle.

Return to the red and paint the ball red across the middle and on the bottom half of the ball. With a clean brush pick up a small amount of green and add it to the very bottom point of circle. Continue painting the green into the red using a criss-crossing stroke. As the green is running out, move up the ball a little so the bottom quarter of the ball has been darkened by the green. There should only be a very slight change at the middle of the ball with a darker value at the bottom of the ball.

Draw a shadow off the bottom of the ball opposite the side of the ball on which the highlight was first placed. Paint the shadow a mixture of red and green (Diagram III).

Using the pencil draw a horizon line behind the ball either near the top or at the middle of the paper. This line separates the foreground from the background. The foreground can be seen as a table top with a table cloth, or it could be a dirt ground with grass and mountains in the background. The background can be a wall with a window or a wall with a door or a mountain. The background can become a vista behind the foreground of a desert or plain. Ask the students to choose a foreground and a background to paint.

The students should try and imagine where it might be light and where it might be dark on the background and the foreground. Choose light and dark colors or values accordingly.

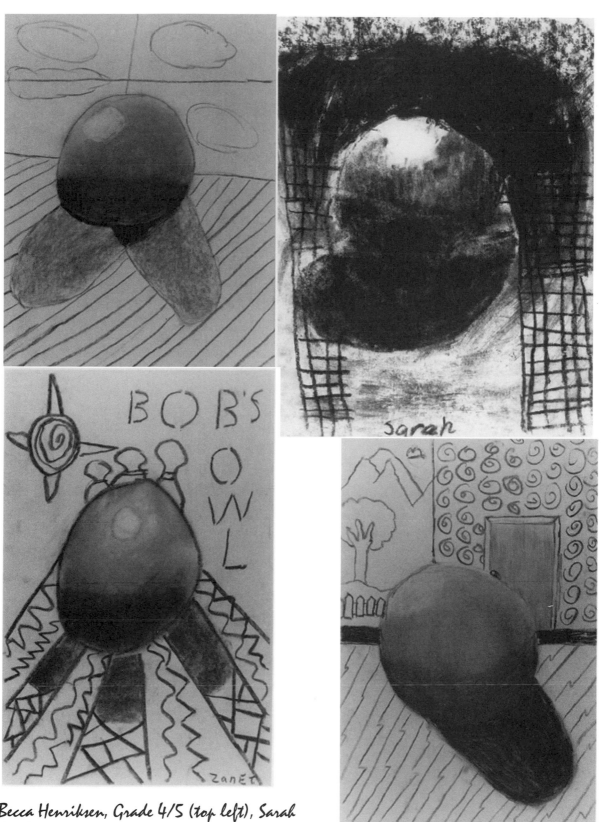

Becca Henriksen, Grade 4/5 (top left), Sarah Freilich, Grade 3 (top right), Zane Trueblood, Grade 4/5 (bottom left), Dave Sahr, Grade 5 (bottom right)

Goals

- Students begin to understand the relationship between light and value. Changing value translates the light to create volume.

- Students' technical skills are improved in color mixing.

- Students' sensitivity and intuitive thinking processes are developed in regard to judging the amounts of color needed to change the value of a color and how to mix paint.

- Students improve their skills in controlling and manipulating the brush over their painting.

- Students are developing decision-making skills.

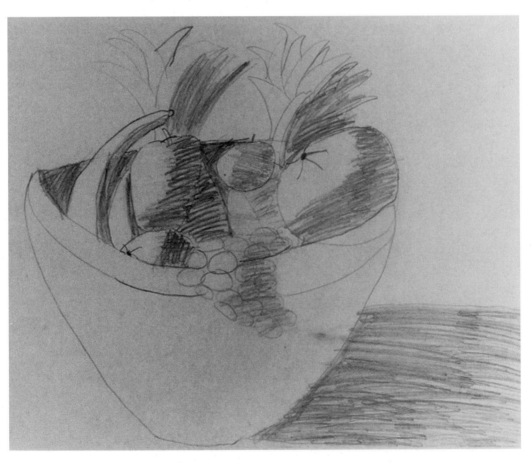

Kathleen Eide, Harding School, Grade 3, imaginary bowl of fruit, still life with hatching

CYLINDERS AND AN IMAGINARY BOWL OF FRUIT

OVERVIEW

This exercise has two parts. The students will first draw. They will practice making cylinders from the inside out rather than struggling with an outline. Then based on what they learned in the drawing exercise, they will create a composition from their imaginations. This exercise can span two days. It is actually very productive for the students to spend 30 to 40 minutes making cylinders out of ellipses.

In doing this exercise the students will improve their hand-eye coordination and their sense of form. They are transforming a two-dimensional surface into a three-dimensional object.

When they are drawing, ask them to keep their drawing arm free. They should not lean on their elbows or wrists as this will limit their ability to draw. If the drawing arm is restricted, the drawing will look restricted and often distorted.

Standing to draw or kneeling on a chair turned backwards to the table are two positions that allow them to lean on the nondrawing arm and keep the drawing hand and arm loose.

Boy drawing with charcoal making a chiaroscuro study.

The Exercise: Part 1

Give each student a pencil and a white piece of paper to practice drawing. The cylinder is a constant component of still life paintings. It's the cup, the glass, the bottle, the bowl, the vase, and the pitcher. When you look at the opening of a cup straight on, the opening is a circle, but when the cup is turned and placed on a table, that circle is changed to the form of an ellipse.

Supplies

1. pencils
2. 12″ × 18″ white paper
3. 12″ × 18″ white tagboard
4. tempera paint (red, blue, yellow, black, and white)
5. small containers to hold paints
6. plastic lids for palettes
7. brushes, small to large
8. rags and sponges
9. paint shirts
10. water
11. bucket of water to rinse out palettes

To start, practice making ellipses. The ellipse is like an oval. The curve for the front and back of the ellipse should be the same and the ends should be round, not curved or pointed. This exercise is covered extensively in *Hooked on Drawing*.

First make a row of ellipses one after the other down the paper all the same size. Next make a column of ellipses in sets of two that are the same diameter. Each ellipse should have a twin. These ellipses can be any size, but there must be two the same size stacked on top of each other. Make another column of ellipses where four are small and the same size, followed by four larger but all the same size, then followed by two small ones.

Now connect any two ellipses that are the same size in the column with a vertical line. Connect any two small ellipses to the larger ellipses below them with a diagonal line. Chose combinations to connect together on the rest of the page. By now the students should see the cylinders forming on their pages (Diagram I).

With this method they have constructed a cylinder from the inside out, rather than trying to draw an outline of the outside edge.

The Exercise: Part 2

To create a bowl, draw a large ellipse at least 6 to 7 inches long at the top of the paper, find the center, and mark it. From the center, drop down the page 5 inches and make a small ellipse about 3 inches long. With a curved diagonal line, connect the outside of the large top ellipse to the outside edge of the bottom ellipse. To make a lip on the bowl, double the top curve on the front half of the bowl and double the line inside the curve on the back half of the bowl.

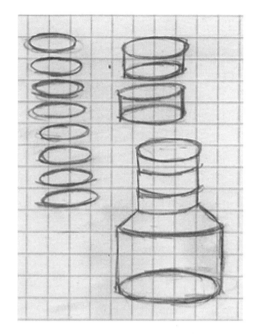

Diagram I—Cylinder illustration

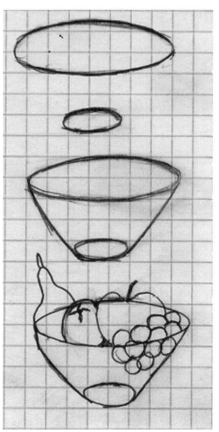

Diagram II—Imaginary bowl with fruit

Fill the bowl with forms resembling fruit. Draw the fruit starting from the front edge of the bowl and moving to the back. An orange is a circle. Grapes are made by connecting small circles in a triangular format and letting some circles overlap others. An apple is like the letter M with a stem in the middle (Diagram II).

Add a horizontal line midway across the paper at the midpoint on the bowl. This line divides the foreground from the background. Ask the students to select a direction for a light source. Using the pencil, lightly map out the lightest area from the darkest area. Add a shadow under the bowl.

Paint the bowl and fruit following the guidelines in the first lesson, "Chiaroscuro: Single-Object Value Study." Have the students compose both the foreground and the background. Create a pattern for a cloth under the bowl in the foreground. Simply use light and dark values behind the bowl or add background images (Diagram III). A background can be a wall, a window, a door, a curtained window, and so forth.

Goals

- Students develop an understanding of three-dimensional form on a two-dimensional surface without using the rules of perspective.

- Students are given the foundation of modeling form.

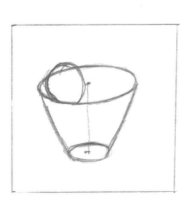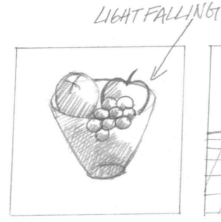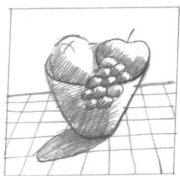

LIGHT FALLING

Diagram III—Illustrations for constructing a bowl with fruit

MONOCHROME PAINTING

OVERVIEW

Students tend to be literal when they are looking at a still life to paint. They have a difficult time at first translating the actual or local color of an object into any other color. If the object is red, they want to paint it red. I realized this when I used a series of copper pots in a still life setup; to my surprise, the students began asking me how to mix copper and bronze colors. I had expected them to use the other colors, but they hadn't thought of using the other colors to substitute for metal.

To avoid this confusion, paint objects to be used in the still life with spray paint colors such as blue, red, yellow or orange. Glass is especially difficult to deal with because clear glass has no real color; it reflects whatever colors are on the forms around it. If you cover glass bottles with paint they become easy forms to work from.

Good objects for a still life can be obtained very cheaply from thrift stores. Vases, jars, bottles, pottery crocks, watering cans, gas cans, and other basic household items are excellent to use in a still life. It is easiest to begin with objects that don't have handles or spouts. (However, there is a short lesson on drawing handles and spouts in Appendix II at the end of this book.)

Sara Nidiffer, monochrome painting, oil on paper, Painting 1, Oregon State University

The Exercise

For this exercise pick objects that are all the same color. Use either a primary color or a secondary color. The objects can be different values of one color. Thus, there can be light and dark blue or different greens and the objects can be various sizes and shapes. The objects to be used in the still life can be painted the same color with spray paint or selected because they are all one color.

Arrange the objects in a line on a table with a patterned cloth of the same color behind them tacked to the wall. The students need to be within 4 to 5 feet of the still-life setup. If they are too far away, they will miniaturize the objects and draw them too small to paint.

One room arrangement is to place a row of objects on a table with a white paper underneath, against a side wall. Then make a semicircle of student desks around the still life. Often seven or eight desks will fit around the still life. Another option is to place two small tables at either end of the room for the still-life setup and then circle it with student desks within 5 feet. Place a narrow cardboard box in the middle of the table for a surface over which to drape a piece of patterned cloth.

Give the students the primary color of the still life (red, blue, or yellow) and then give them the secondary color green for red, orange for blue, or purple for yellow to shade the forms. They may also use white and black.

Supplies

1. pencils
2. 12″ × 18″ tagboard
3. tempera paint (red, blue, yellow, black, white, green, orange, and purple)
4. brushes
5. water
6. sponges and rags
7. plastic lids for palettes
8. still-life objects in one color

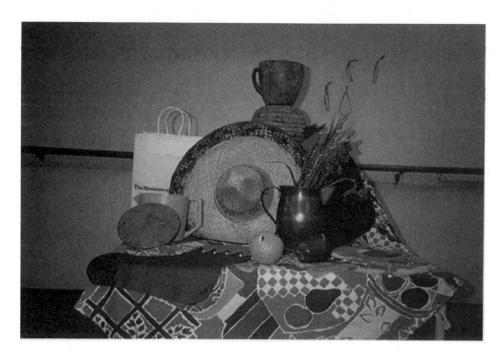

Still life setup

Students will need several brushes—one small, one large, access to a water can to rinse out the brush, and a sponge or a rag to wipe the water out of the brush. Paint shirts are always a good idea.

Manipulating the light in the room will help the students determine value changes. Try turning off one or two of the overhead banks of light, or set up the still life by the window, which forces more light on one side of the objects, or place a light on one side of the still life: a clip-on light attached to a chair or desk, a table lamp with the shade off, or a flood light will work. Arrange the objects in a row, trying to avoid placing one in front of the other. Leave space among the objects so they are easy to see.

To draw the still-life objects, refer to the previous lesson. Using the process for creating cylinders out of ellipses, ask the students to draw three to four of the objects from the still life onto their paper. Each object should be drawn as large as their hand and no smaller than their fist. They should fill the paper with the objects from top to bottom.

After they draw the vases and bottles, take the pencils and map out three basic areas of light on the surface of each object. Ask the students to draw a line where they think the lightest value ends and where the darkest value begins. Locate the shadow under the form and outline it with the pencil.

To paint the drawing of the objects, on the light side of the object use the main color either thinned with water, which will lighten it, or add white to the base color. For the middle value between the light and dark sides of the object, just use the color straight. For the dark side of the object, add the complement to the color: add green to red, purple to yellow, and orange to blue. Black can be used instead of the compliment to darken the color, but it is harder to control the value change.

The goal is to maintain a sense of the local color at its lightest and darkest values. If the main or local color is red, for example, they should have what looks like a light red and a dark red on the jar. They only need to add small amounts of paint to the red to change it.

For the shadows, use a mixture of the main color and black or the main color and its complement. Paint the patterned cloth in the background manipulating light and dark values.

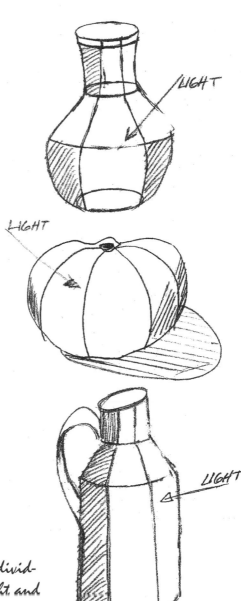

Illustrations for dividing form into light and dark sections

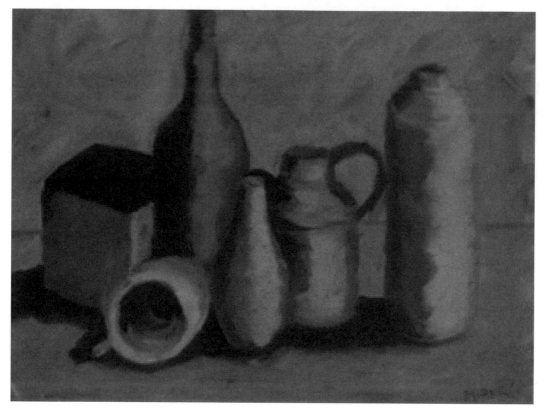

Adele Wilson, black and gray and white value study, oil on canvas, Painting 1, Oregon State University

Goals

- Working with restrictions, students focus and feel they are working with some direction.

- Students are challenged to create value change without being too overwhelmed.

- Students direct decisions at an established goal.

- Students build confidence in their abilities to paint when, at the end, they can see how changing the value created a sense of a three-dimensional design.

BLACK, WHITE, AND GRAY STUDY

OVERVIEW

Use a still life of bottles, jars, and vases for this study, because it is easy to control what the students see. Let the students practice looking at something instead of drawing out of their heads. In this exercise the students learn to model forms by interpreting light and dark values of paint. Modeling creates the sense of volume in two dimensions. In this study they practice blending paint and using painting materials.

It is helpful to have black and white objects to draw and paint. Glass bottles can be painted with black and white spray paint to use as still-life subjects. Arrange three to four bottles on a table. The students can put their desks in a circle around the table, placing them about 4 feet from the still life. Select a light source by placing the table with the objects next to the window, or by turning off a bank of overhead lights, or by placing a spotlight on the still life. If all else fails, make up the direction of the light and instruct the students to think of the light coming from one side. In a class of 24 students, you may need three of these setups in order to fit the students around the still life at 4 to 5 feet.

Doing the chiaroscuro and the cylinder study exercises before this one will prepare the students.

The Exercise

Use the pencil to make a light line outline of the bottles, filling the paper as much as possible top to bottom. Draw with the paper vertically to fit the subject. Start by mapping out the light and dark areas. Start with the light side and draw a line where the light seems to change to gray. Draw another line for the dark side of the form. Sometimes it is hard to actually see these light changes, so as the artists the students can make them up. Simply choose where the light side should end and become gray and when the gray ends and turns to black. Add the shadows under the forms.

Paint both the light side of the form white and the area to be gray. Then clean the brush by wiping the white out on a rag and dip the tip of the brush in the black. Brush the black into the wet white where you want it to turn gray. Be sure to leave the white side area. As long as you don't stir the brush in the black, you won't contaminate it with the small amount of white left in the brush. Using a slightly dirty brush will help blend the gray. For the black side, clean the brush in the water and wipe the water out on a rag or paper towel. Dip the brush in the black and work from the black edge in towards the gray edge. It is easier to control the paint and the blending as the brush runs out of paint. Work the black into the edge of the gray.

To blend the divisions together, you can use a clean brush to push the paint together at the edges of the value change.

Use the black across the bottom of the bottles, darkening the base, and then paint the shadows. Ask the students to consider the foreground (the table space) which includes the shadows and any tablecloth pattern. Choose a light to medium value next to the shadows on the table surface. Draw a line behind the bottles to indicate the back of the table and select light and dark values for the area behind the bottles.

Goal

- Students practice painting techniques and develop an understanding of modeling.

Supplies

1. 12″ × 18″ or 9″ × 12″ tagboard
2. brushes
3. pencils
4. rags
5. water
6. black and white tempera paint with or without acrylic medium

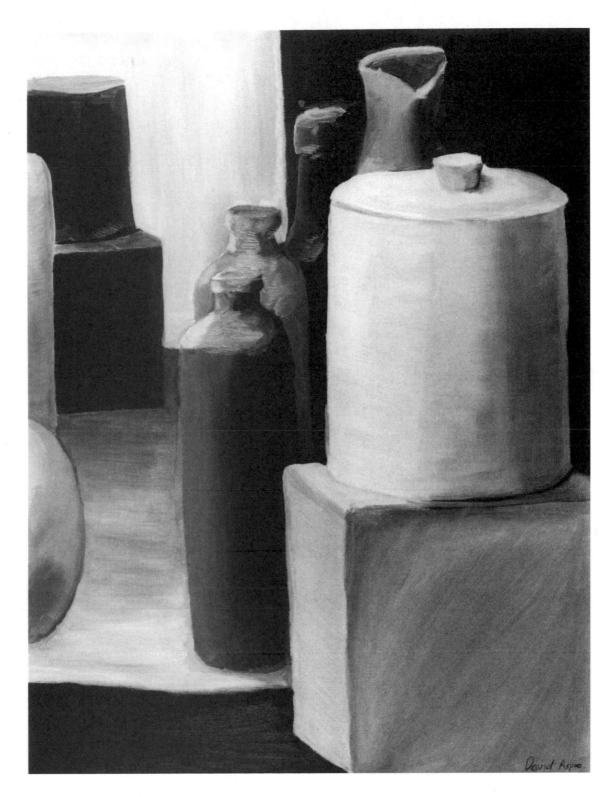

Jay Foley, black and white value study, oil on paper, Painting I, Oregon State University

ADDING COLOR OVER A BLACK AND WHITE VALUE STUDY

OVERVIEW

The cylinder study and the chiaroscuro lessons will prepare the students for this exercise. You can use the dry painting from the Black, White, and Gray study or paint another black, white, and gray painting in which the students create a number of grays ranging from light to dark based on their interpretation of light falling on the form. The more value changes they use across the surface, the richer the modeling will look on the form under the layers of color.

The process of underpainting, in which the painter creates a value study in black and white, is as old as the Renaissance. It is a painting technique that artists used before oil paints were available. The subject is painted in gradations of black and white. By first interpreting the surface in black, white, and gray. A foundation is laid for the color layers. When the ground is dry, color is applied in thin glaze layers over the ground to build up the color. The top color responds and reflects the underpainting, changing from light to dark, depending on the value of the ground underneath.

The Exercise

Have the students make a black, white, and gray study of a still life. The more change in the gray values they can paint, the richer the painting will be. When it is dry, select a light tempera color like yellow, red, or orange and paint a thin coat over the black, white and gray forms. Continue painting all the forms with a thin coat. Dark blue and dark purple are hard to use; lighter colors show the underpainting effects best.

Let it dry and then add a second coat on the forms where the color is too thin or it needs to be richer or darker. Keep the layers thin. You can start with a yellow layer and then add a red layer or an orange layer to build color. Build color from light to dark. Then try it in reverse, putting the green or red on first and then adding a layer of yellow to the dark base.

The original value study alters the top color. The color changes from light to dark according to what value it is painted over. White—when added to the top color—tends to reduce the transparency of the color.

Paint the entire composition from the foreground to the background using single or layers of color on each form and surface.

Goal

- Students practice a painting process and develop skills in developing a composition by planning the light changes in advance of the color. It may help students understand how light changes from light to dark. All shadows are not black; rather they are a change of the value of the color they darken.

Supplies

1. 12″ × 18″ or 9″ × 12″ tagboard
2. brushes
3. pencils
4. rags
5. water
6. black and white tempera paint with acrylic medium
7. red, yellow, orange, and green tempera with acrylic mixed in

OVERLAPPING SHAPES CREATE SPACE

OVERVIEW

Drawing overlapping shapes in a painting creates a sense of three-dimensional space on a two-dimensional surface. It is the beginning of understanding perspective. Arrange a still life in which the smaller forms are in front or way in the back, like a cup tucked behind a larger vase or pitcher. To set up a still life, place the still-life objects on a table in irregular rows from front to back. You can use one large table in the middle of the room with objects on both sides and the ends. That way the students' desks can be placed in a large circle around this one table.

Have the students draw with their paper vertical. The drawing is made from front to back on the paper. The first form is drawn in outline on the left or right side of their paper and 1 to 2 inches from the bottom of the paper. The next object is drawn by how it relates to the first object. Look at the base of the object and locate where it intersects the first object. Draw a base line on the paper, then look at the top of the object and draw a line on the paper where the top will be. Fit the second object between the marks.

The next object is drawn the same way. First find the base, and then the height. The base of each object should be placed a little further up the page from the one in front of it.

Add a horizontal line behind the objects to separate the background and the foreground. For more instruction there is a complete exercise in drawing overlapping shapes in the perspective section of *Hooked on Drawing*.

Maria Larson, still life, oil on canvas, Painting I, Oregon State University

72a

The Exercise

After the students have drawn a still-life outline on their papers, they select the first color for the first object which is the one in the front. They can paint it the color it is—which is referred to as "local color"—or they can make up the color. Paint the objects in the space of the paper from front to back. Each color choice must be balanced against the color of the object next to the one being painted. Students need to change the color on each object in order to distinguish it in the still life. An orange form next to an orange form, for example, flattens the composition.

Let the students make all the decisions in painting their composition within a few guidelines.

Supplies

1. 12″ × 18″ tagboard
2. brushes
3. tempera paint (red, blue, yellow, black, white; green, orange, and purple are optional)
4. acrylic medium (optional)
5. palette (ice cube trays or plastic containers)
6. water
7. rags or sponges
8. pencils

Ice cube tray as a palette

73

Include painting the foreground which is the tabletop with the pattern and shadows on it. The background is the wall behind the objects and can be all one color or may change in value from light to dark.

Goals

- Students begin to understand perspective and interpret space by color and placement.

- Students interpret three-dimensional forms onto a two-dimensional surface. In so doing they can begin to understand how to arrange two-dimensional space.

- Students increase their level of visual perception, which directly relates to increasing their focus and can be directly related to improving their reading and math skills.

Evaluation

For a student evaluation, display the finished paintings and stand back. Ask the students which painting looks most like the objects sitting on a table top. Which seems to feel like real space? Which seems flat and why? They will understand how color and overlapping the forms create space better by looking at the work from 4 or 5 feet away. Looking and examining also helps the students to better understand how the art process works.

Students drawing overlapping forms at Wilson School

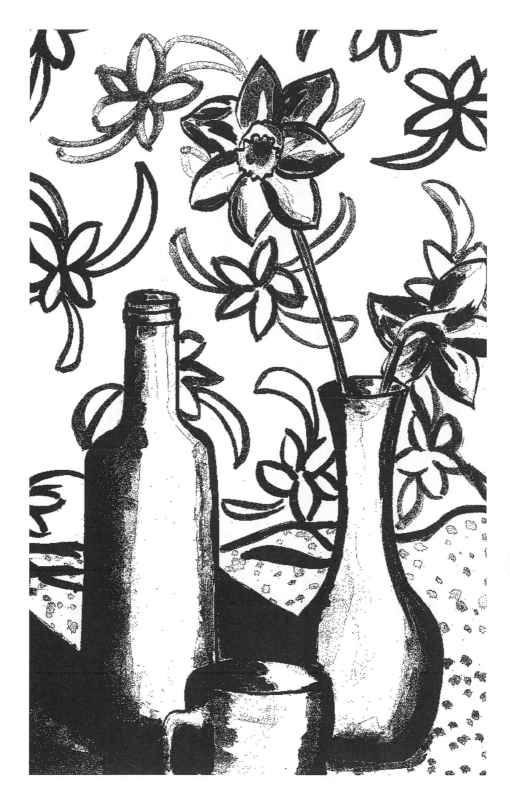

Megan Macke, overlapping forms with value change, Art for Teachers, Oregon State University, Corvallis, OR

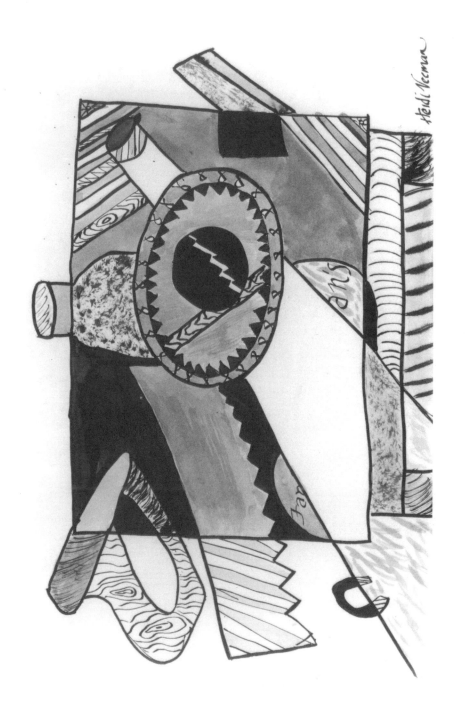

Heidi Veeman, cubist composition, Art for Teachers, Oregon State University, Corvallis, OR

STILL LIFE:
A CUBISTIC APPROACH

OVERVIEW

Pablo Picasso (1881–1973) was a famous cubist painter. There were two other painters who produced equally brilliant cubist's works who should also be mentioned: Georges Braque (1882–1963) and Juan Gris (1887–1927) both worked side by side with Picasso. Cubism altered our vision of space and offered us a new way to think about space without perspective. The traditional perspective was like looking through a window to create the illusion of space.

Cubism was a work of art that was itself a reality and represented the very process of transforming nature into art. Cubism can be a visual contradiction, where a book can be metamorphosed into a table or a hand into a musical instrument. Cubism created a new artistic language interpreting shapes, textures, spaces, and objects. Cubism took the three-dimensional object and flattened it, pulled it apart, inserted textured grounds between the two parts of one form, shifted the outline, then reached around behind the form and placed the back plane side by side with the front plane.

A way to illustrate all this is to take a small cardboard box and draw or paint something on each side or plane, then cut the sides apart so the whole box opens up. With the box flattened we can see the drawings on the bottom and the top and the back all at once. Words, newspapers, music scores, or fabrics were also added to the composition. The entire composition might have an uneven outside edge or fit inside an oval border.

This exercise should be done after students have worked with modeling forms and practiced chiaroscuro, as it offers an opposite way of thinking. Now they take the composition *apart* instead of sculpting it together with modeling. Cubists used modeling but more as an applied texture rather than a device to develop a sense of volume.

The Exercise

Set up a still life of bottles, vases, fruit, plates, and bowls on a table or merely set the objects around the room on tables, desks, counters, or on the floor. Musical instruments like a violin or cello or a guitar are good subjects to draw.

Cut drawing paper into different size pieces (long rectangles, squares, short rectangles). Ask the students to select one object and draw only the outline on one of the papers, filling the paper top to bottom, side to side as much as possible. They should make six to eight drawings of different objects in the room.

Ask the students to paint each object one solid color or outline the object and paint around it.

To compose the artwork have the students draw a rectangle on a piece of tagboard in pencil, which will represent a flat view of a table. Select a piece of fabric, colored paper, or create a pattern on a piece of paper with dots or wood-grain. When the paintings are dry, cut the paintings in half either vertically, horizontally or diagonally.

Rearrange the pieces, separating the two sides of the drawn and painted objects on the tagboard. Include the real or manufactured textures and the other drawings in the composition, interjecting them between the sides of the objects or around or behind the objects.

Stack and overlap the pieces, collaging them together on and over the outline of the table.

Once the composition is to the student's satisfaction, glue it down. Paint the table shape or firmly draw the outline with felt-tip pens.

Goals

- The students' sense of composition is challenged. They must think about what they are doing and try to shift the order. Constructing a collage involves decision making and critical thinking.

- Students are introduced to cultural and historical value of an important art movement.

NOTE: Several books on cubism from the library would be good references for this project.

Benjamin D. Kaiel, cubistic painting, oil on canvas, Painting I, Oregon State University

WORKING FROM
A SMALL STILL LIFE

OVERVIEW

This exercise requires that the distance the students sit from the still life is no more than 4 feet. The closer they are to the subject, the easier it is for them to see the shapes and translate the information. By sitting close to the still life, they can draw the forms larger on their paper. The objects should fill the paper top to bottom.

You will need several still-life arrangements of three to four objects around the room. Depending on the size of the students' desks, you can probably get five or six students around each setup. If you have drawing boards the students can work on their laps using the boards; then you may be able to place more students around one still life.

After you set up the still life against a wall and place the students' desks in a semi-circle around the arrangement, put a piece of white paper under the objects and a patterned cloth behind them.

IDEAS FOR STILL-LIFE COMBINATIONS

1. Two oranges with a lemon stacked on top in a bowl, with a cookie jar behind it all

2. A pitcher with a leaf or large flower in it and a grapefruit

3. Two water bottles (they have blue and green ones) with two red apples

4. Plastic grapes, a pitcher, and a bottle or small pottery bowl

5. An eggplant, a vase, and a pottery jar.

The Exercise

DRAWING

Draw a 1-inch border around the outside of the paper. This frames the space to be painted. Using a pencil, the students make a light outline drawing of the still-life shapes.

Supplies

1. pencils
2. tagboard
3. tempera paints
4. palettes
5. brushes
6. plastic lids or small dishes
7. water
8. rags

Ask the students to keep their heads in the same place as they go back and forth looking at the still life and drawing the shapes. Drawing in perspective means maintaining one view. They should draw the objects as large as their hand and no smaller than their fist. Place the paper in a vertical rather than horizontal position. Start with the object in front of the other still-life objects and draw an outline, placing it on the paper at least two inches from the bottom of the paper.

Once all the objects are drawn and the pattern of the cloth in the background lightly mapped out, add the table line. Have the students look at the objects and hold the pencil horizontally up in front of themselves, leveling it in line with the back of the table. Notice where the line intersects the forms in the still life, then draw a line on the paper at the same point.

Michael Barnes, Grade 5, tempera on paper

PAINTING

The students need to decide in advance which side the light is coming from. Establish one side to be light and one to be dark and the area between them a gray value but in color. The goal is to paint each form with light and dark so that in the end, one side will be light and one side will be dark and there will be a medium value in between.

Place a couple of tablespoons of water on the plastic lid or dish. Dip the tip of the brush in blue, and mix the paint with the water to dilute it. Wipe out the brush, then dip the tip in the blue wash and cover the side of the object to be dark. As the brush runs out of paint, dip the tip in water and cover the area of the form to be the medium value. Paint all the forms, leaving the lightest side of each form the white of the paper.

Use the remaining wash or select another color for the background and the foreground. Put the first wash on these areas. Clean off the palette with a paper towel and pick the color of the object to be painted. For example, if it is an apple, you would pick red or green. Make a wash and paint over the entire form, including the first blue wash. The second wash gives the object color and darkens the area where the first blue wash was placed. A third wash of the object's color will deepen the color. Another approach is to leave a bit of each wash showing and not cover it entirely as you add washes. Use a light color of yellow or white mixed with the green or red on the light side of the form to deepen the color. Purple can be used to darken one side instead of green, if you'd like.

OPTION: INSTEAD OF WORKING FROM DARK TO LIGHT, WORK LIGHT TO DARK

On a piece of tagboard paint the first wash a light thin yellow, followed by an orange wash, and then a red wash. Cover the entire form with each wash. This will build up a color and give it a sense of richness that is different than building with one color alone. To darken, use the complement. For example, on a red form use a little green; on an orange form, use a little blue wash; and on a yellow form, use a little purple wash.

The more water in the mix, the lighter the color; the more pigment in the mix, the darker the color. Ask the students to try and leave a little of every layer showing somewhere on the form.

The students may apply the washes from the right to the left on a form or from the top to the bottom. Add shadows under the forms. Use the complement or black mixed with a color.

Goals

- By working light to dark, the students have time to think and make changes in the composition. A light color is easily covered up by a darker one. By gradually covering the form, the students see the way paint represents light as it moves over the form.

- Working dark to light is a second option in modeling form with paint. Both processes require the students to plan the composition and think ahead. The students' technical competence increases along with their knowledge of space and color. Layering paint takes patience; older students will do more than younger students.

 NOTE: You may want to start the project, lay the foundation colors, and wait until the next day to finish the painting. This project can take as long as two hours.

Reference Lessons

See "Chiaroscuro," "Cylinders and an Imaginary Bowl of Fruit," and "Overlapping Shapes Create Space" in Section Three.

WORKING FROM
A LARGE STILL LIFE

OVERVIEW

The major advantage to this project is that it is easy to set up. Place one long table in the middle of the room. Then place the students' desks in a large semi-circle around the center table. Place objects three deep up and down the table on both sides and at both ends. Have the students select one section of three or four objects to draw. Their view of the table includes whatever is directly in front of them and whatever is behind the front objects on the other side of the table. The students must draw what they see in the order they see it.

This exercise is helpful in building visual literacy and hand-eye coordination. Translating from three dimensions into two dimensions is intellectually challenging while helping to develop concentration and visual literacy.

To paint you may wish to use individual palettes of ice cube trays or flat lid palettes in which the students can go to a paint table, place a teaspoon of paint on their palette to start with, and then add more paint as they need it. They should have practiced painting before they do this exercise. Section One has exercises in mixing paint, tinting, and shading. The lessons focusing on overlapping shapes and chiaroscuro are good to do prior to this lesson.

The Exercise

After you set up a still life and the students are sitting around the center table, start by discussing with the students their personal view of the objects.

To help them make the association between the location of the objects in front of them and where they will place them on their papers, ask them to show you by pointing to the object they will start with and then indicating the side of the paper they will place it on. This focuses them and gives them a clear starting point. Continue the discussion asking them what objects comes next and where will they put it on their paper. What object is it next to?

Having the students point to what they plan to draw and then think about where it will go on the paper increases their visual literacy and understanding of two-dimensional space. This way they begin to understand how to move visually from left to right or right to left.

DRAW FIRST

Ask students to fill their paper side to side with objects drawn no smaller than their fist and as large as their hands. If they draw too small, it is very hard to paint the forms. If they do draw too small, don't erase; just draw over the small drawing, making a larger drawing of the form. The paint will cover the first small drawing. Erasing is a waste of time and tears up the surface of the paper.

> ## Supplies
>
> 1. pencils
> 2. 12″ × 18″ tagboard
> 3. tempera paints (red, blue, yellow, black, and white)
> 4. brushes
> 5. palettes
> 6. water
> 7. rags or paper towels

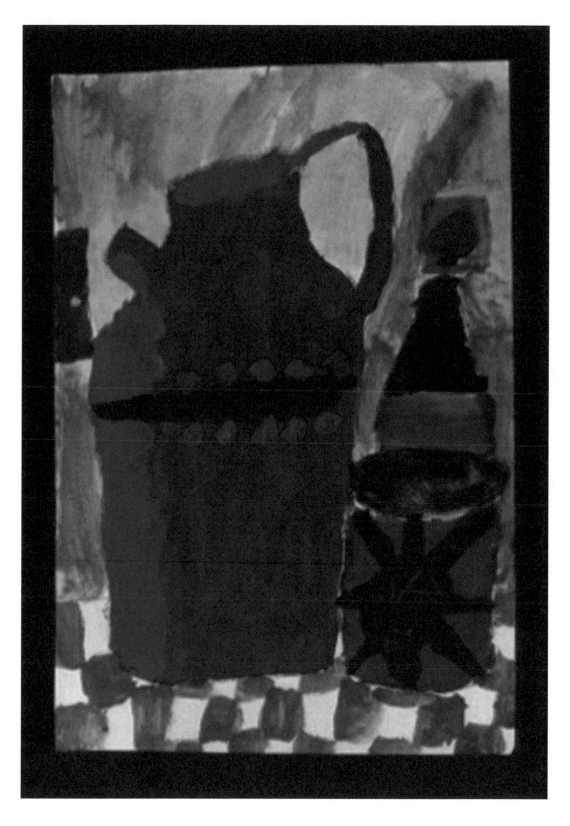

Jared Anable, Grade 5, tempera mixed with acrylic on paper

84a

Painting

By turning off one or two of the overhead lights, a shadow will occur on one side of the objects. You can have the students follow the local color of the objects (the actual color) or they can change the color to one of their choosing. Either way, ask them to paint and build the objects with a light side and a dark side following the rules of chiaroscuro. Modeling the forms from light to dark will result in forms that have a sense of volume.

Students should also choose light and dark values for the background. In the foreground they should paint the shadows over the painted ground color. If the table is painted red, for example, they might use green or blue over the wet red to create a rich-colored shadow.

Goals

- Students build visual literacy and hand-eye coordination.
- Students develop critical thinking and decision-making skills.
- Students are intellectually challenged while developing improved eye concentration and tracking.
- Students improve their painting skills in modeling form and balancing the picture.

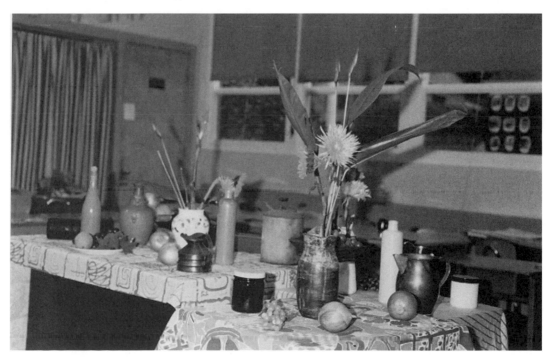

Large still life setup

85

DRAPERY

OVERVIEW

Drapery is difficult to paint because there are no outlines to follow. To paint drapery the students must mentally judge and decide where to divide the flowing or folded surface. This decision is based on an understanding of planes.

The planes of a draped piece of fabric are painted by balancing light, gray, and dark areas across the curves of the fabric. The light areas are on top of the curve or the area of the fabric that curves forward. A gray value is used on the sides of the curve as the drape turns back to the wall or the table it is sitting on. The areas touching the table or the wall are the darkest. Inside a fold will also be a dark value.

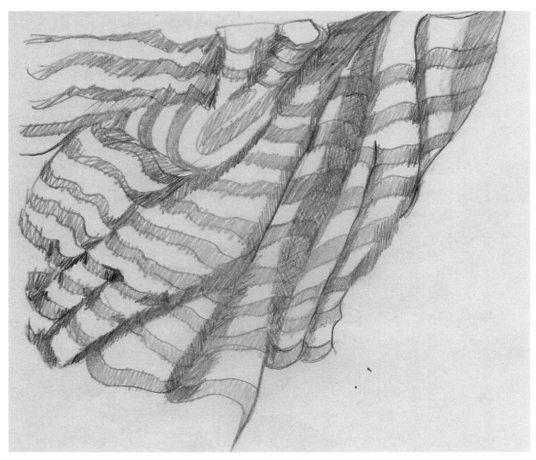

Drawing of a drapery

The Exercise

To understand the planes of the drapery, imagine an ant has walked through ink and is tracking up and down across your drapery. The trail would go up one side and down the other. Where the ant walks on top of the curve it is painted white. As soon as the ant tracks down the other side, it becomes a gray. And when the ant reaches the bottom of the curve and is walking across the table, use a dark value (Diagram I).

Start by drawing an imaginary drapery on a piece of paper. Decide where the top planes and the side planes start and stop. Map out the division first with a pencil outline. Then paint the top plane white or a light value. Mix a gray and paint the side plane gray. Pick a dark value for the back plane, inside the fold. Where the drapery rests on the table or sets against the wall is dark in value (Diagram II).

A color must be lightened and darkened to create a sense of form in drapery. One approach would be to paint the top and the sides white, then paint the dark value in the bottom of the curve. Then with a clean brush blend some of the dark into the white on

Supplies

1. pencils
2. tag board
3. small brushes
4. tempera paint
5. hanging fabric
6. water and rags

Diagram I

Diagram II

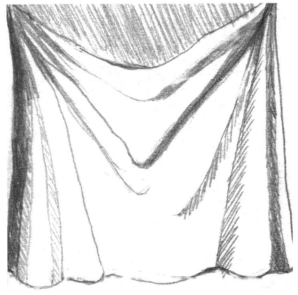

Diagram III

the sides to create the gray value of the sides. Try to keep the paint thick rather than runny.

It helps to hang up the paintings and look at them. A little distance can help the students better visualize the folds (Diagram III).

After practicing, hang up a piece of cloth on the wall to test the students' abilities to translate what they see. Use two pushpins and hang the cloth from two side points. Use additional pushpins to hold the drapery in place to make the setup as easy as possible; try to arrange the drape to have three big obvious folds. Direct a light on the white sheet to accentuate the folds.

Select one color and use its complement to shade. Add white to tint, lightening the color.

Goals

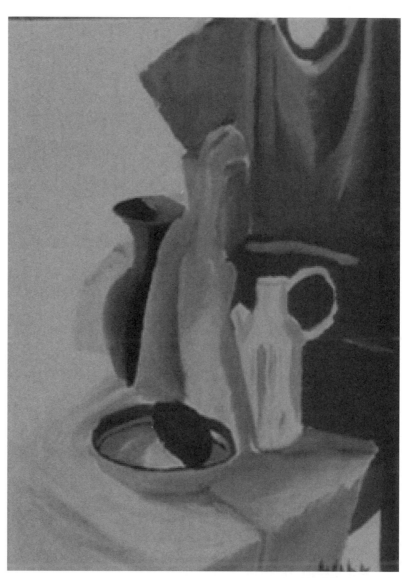

- Students practice painting drapery, a very difficult subject to approach.

- Students develop critical-thinking and decision-making skills.

Wade Mroczko, oil on canvas, Painting I, Oregon State University

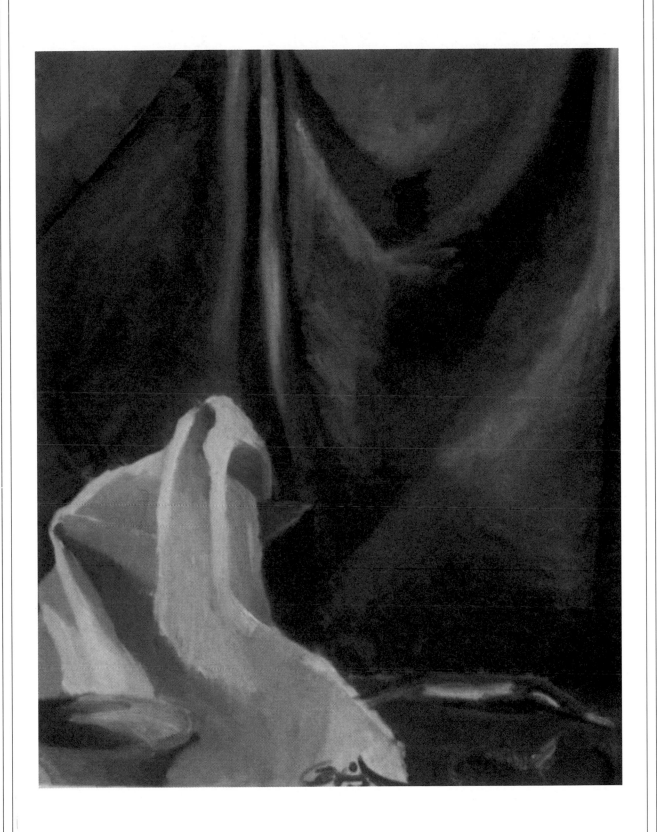

Chris Buckingham, drapery study, oil on canvas, Painting I, Oregon State University

88a

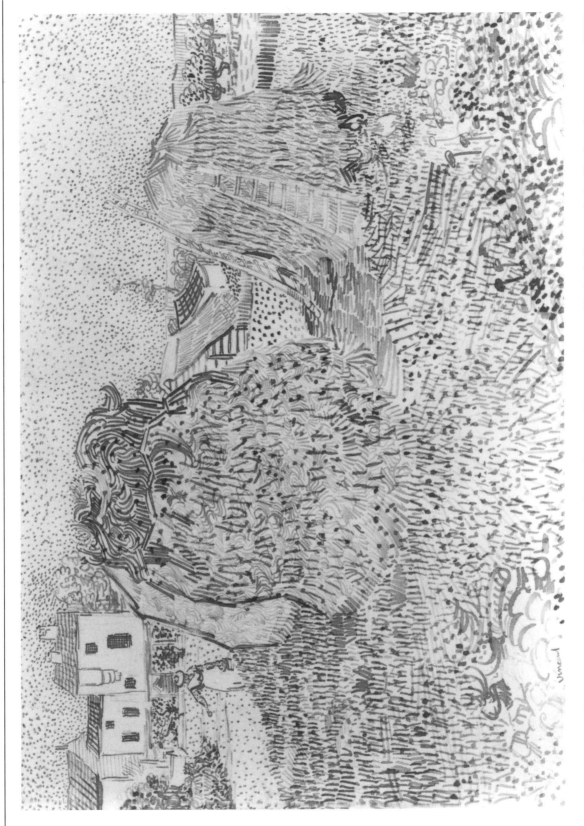

Vincent van Gogh, DUTCH (1853 – 1890) *Haystacks*, reed pen and brown ink over black chalk on pale buff-colored wove paper, 1888, $9\frac{9}{16} \times 12\frac{9}{16}$ in. Philadelphia Museum of Art: The Samuel S. White, 3rd., and Vera White Collection.

Section 4

LANDSCAPE

STARTING PERSPECTIVE

OVERVIEW

This is a very simple exercise that uses a grid and measuring to create a geometric layout for painting. The painting becomes an optical illusion creating depth on a two-dimensional surface.

The Exercise

To Measure

Use the ruler to divide the paper into a 1/2 inch grid. To draw the grid, measure across the top of the paper and make a vertical mark every 1/2 inch. Make the same measurement marks across the bottom edge of the paper. Be sure to start from the same side to mark off the 1/2 inch. Now mark off a 1/2 inch down both sides of the paper, starting from the top edge. Connect the mark at the top of the paper with its corresponding mark at the bottom of the paper with a vertical line. Use *a light line.* The pencil line will be lighter by not pressing hard. Now connect the sides with horizontal lines. The crossing vertical and horizontal lines create a grid to build the boxes in.

If you use 12″ × 18″ paper and the ruler is only twelve inches long, have the students draw the center line in at the 6-inch mark and then mark off this line at 1/2″ intervals all the way down the center line. That way students can draw to the center line from each side creating the horizontal lines.

The next squares may be any size you choose. A 4-inch square is big and easy to paint, but if you have precise painters and small brushes, a 2-inch square can be used.

To make 4″ squares, lightly label the top marks at the edge of the page. Start at 0, measure and mark off 2-, 4-, 6-, 8-, 10-, and 12-inches. Measure a 1/2″ down the verticals under the 2-, 6-, 8- and 12-inch marks. Mark it on each vertical with a small horizontal mark.

Diagram I—Starting the boxes

Diagram II—Forming the first row

Use the ruler to draw a diagonal line from the 0 mark to the 1/2-inch mark on the vertical at 2 inches. Draw a second diagonal line from that mark on the 2″ vertical to the next vertical, which is the 4″ vertical. The line is zigzagging across the top of the page.

Measure 4″ down from the 0-, 4-, 8- and 12-inch marks at the top of the paper. Then measure 4″ from the 1/2″ marks on the 2-, 6- and 10-inch verticals. Mark these points and connect the 4″ measurement on each vertical to the one next to it. This line also zigzags across the paper. See diagram II.

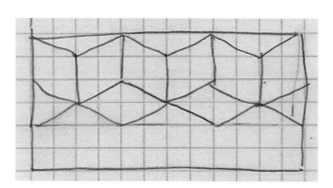

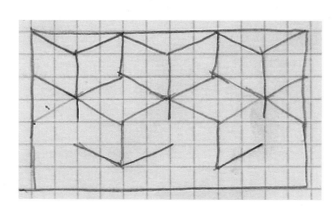

To create the next row of boxes, use the ruler and extend the diagonal line at the bottom of each box as shown in Diagram IV. Now, measure down from each corner 4 inches and make a mark to draw to. Use a diagonal line to connect the new marks. The connecting line will be drawn at the same angle the diagonal line above it was drawn. Continue measuring down the verticals to fill the page with boxes.

Diagram III—First row

Diagram IV—Starting the top of the second row

Diagram V—Drawing row two

TO PAINT

The students should now paint each plane or side of a box. Depending on what they choose, various optical illusions will occur.

Option 1: Select two colors to use for the top planes and alternate them. Select two colors for the sides and alternate them. For example: red on one side, black on the other; yellow on one top, green on the next top plane.

Option 2: Use only black, white, and gray.

Option 3: Paint all tops a light value, one side a dark value, and one side a medium value.

Option 4: Paint all the top planes black and alternate between two colors on the sides.

Goals

- To understand the effects of color when coupled with perspective.

- To create a sense of three dimensions on two dimensions.

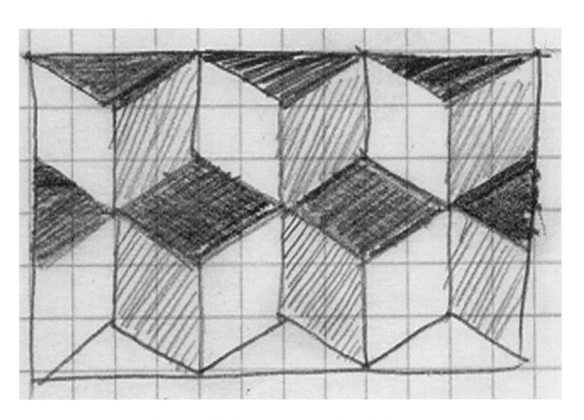

Diagram VI, Painting the sides of the boxes

DRAWING A LANDSCAPE: ONE-POINT PERSPECTIVE

OVERVIEW

Once the students understand the basic rules on perspective, they can expand into more complicated overlapping compositions. Copying a photograph they like is a good way to practice.

In one-point perspective, you start with a horizon line. Draw a line across the middle of the paper to represent the horizon. Somewhere on the horizon is a vanishing point. The vanishing point can be different for different parts of the picture. The road may vanish to a point on the left while the house vanishes to a point further to the right. The vanishing point is established by the direction we look at the road or the house and by the direction it sits in terms of the horizon. Each student will decide in this exercise where the vanishing point will be.

- **Rule #1:** All lines below the horizon vanish up.

- **Rule #2:** All lines above the horizon vanish down.

- **Rule #3:** The lines for either side of a road will vanish to the same vanishing point. Likewise, all the lines forming one side of a house will vanish to a single point on that side, while the lines for the other side of the house will vanish to a single point on the other side.

- **Rule #4:** Things get smaller as they move back in space toward the horizon.

The Exercise

Use the drawing paper to practice drawing a one-point perspective. Then make a drawing on the tagboard to paint.

Start by drawing a horizontal line across the middle of the paper. Place a vanishing point on the horizon in the middle of the paper (indicate that point with a small mark). Draw two diagonal lines from the front edge of the paper to the vanishing point. Leave at least 6 inches between them in the front. Draw two diagonal lines from the top of the paper to the vanishing point directly above the bottom ones. These lines are the top and bottom lines within which the students can construct a row of trees vanishing to the horizon.

TREES

Start at the front of the paper by drawing two vertical lines for the tree's trunk. At the top of the paper draw a curved top for the tree and connect the trunk with branches to the top.

Draw two lines for the next tree 3 or 4 inches up the bottom diagonal. Fit the tree from top to bottom in between the top and bottom diagonals. Draw a horizontal line on which to set the base of the tree. This line dissects the diagonal so the tree will look like it is sitting on the ground. Repeat the drawing of the trees on the other side, fitting the trees between the diagonals.

Supplies

1. drawing paper
2. pencils
3. rulers
4. tagboard
5. tempera paints
6. palettes
7. paint brushes
8. water
9. rags or sponges

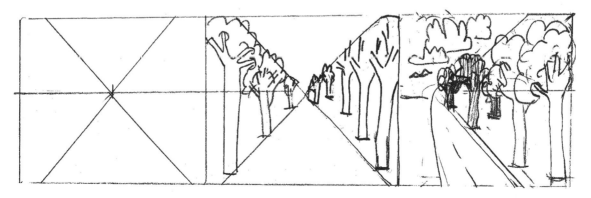

Three drawings constructing a one-point perspective

ROAD

The road can be placed between the trees. Students can start with a road and draw two vanishing lines, one top and one bottom, to draw a row of trees beside the road.

RIVER

A river is drawn the same as the road: wide at the front, narrow at the horizon.

MOUNTAINS

Mountains can be drawn at or above the horizon across the paper in a row. Or, students can draw one large mountain. Pine trees are easily constructed as triangles stacked on each other.

CLOUDS

Clouds are small at the horizon and increase in size as they move up in the sky.

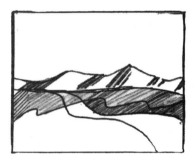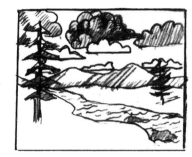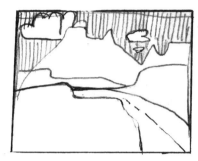

Three illustrations for a road, a river, and mountains and clouds

HOUSE

Draw a horizon on the paper. Put a rectangle below the horizon. Draw a line from two corners of the house to one point on the horizon. Put the roof on. Draw a line from the peak of the roof to the vanishing point. Construct the back of the house by drawing lines between the vanishing lines at the same angle the front lines are. The top and bottom lines for a window on the side of the house are drawn to the vanishing point.

Have the students select the pieces of their landscape and draw them on the tagboard to paint.

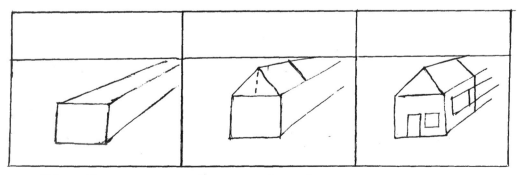

Three illustrations on drawing a house from one-point perspective

Nicole, Grade 4/5, landscape, tempera on paper

98a

To Paint

Paint the landscape from back to front. First paint the sky from the top of the paper to the horizon. The sky can be red, orange, pink, and purple if it is sunrise or sunset. It could also be gray with clouds or blue with clouds. Paint the sky color first and paint the clouds over the sky color. If the paint is wet, the under color will mix a little into the white of the clouds. To control this mixing, use only two or three brush strokes before picking the brush up and wiping the muddied paint off on a rag or paper towel. Continue painting by dipping the bristles in the white and forming the clouds with circular strokes. The clouds may also be painted on a dry sky.

If orange is used in the sunset and the student wants the top of the sky to be blue, paint the sunset, let it dry, and then paint the blue from the top of the paper to the sunset. At the line where the two meet, use a clean brush with a small amount of paint, and brush the two areas together, brushing the blue and white mixture lightly over the edge of the sunset. If you try to do this wet, blue and orange will make brown. If the sky is red, the blue will mix with it to make purple.

Paint the ground next and then the trees and the house over the ground. The students should be reminded of what they learned in the color-mixing exercises. They may want to add texture over the painted ground in the front to show grass or rocks.

You can easily do this exercise over several days. Spend whatever time you have, then hang the paintings to dry. If students painted on a color they later don't like, have them paint over the color. If the color is wet, take a rag and wipe it off, then paint the area again. Painting is never final. Every layer of paint changes the painting.

Goals

- Students develop an understanding of perspective. They learn to translate three-dimensional space into two-dimensional space.

- Students must plan and calculate to draw the composition, which involves critical-thinking skills and decision making. They then translate line drawing into volume and modeled form with paint. Paint changes everything.

- Students must make value adjustments to each plane and area in order to retain the objects in the picture.

Evaluation

FOR AN A

1. The landscape is drawn with the trees drawn between two vanishing lines—one top, one bottom.
2. Roads or rivers vanish to the horizon, decreasing in size.
3. The house is formed with vanishing lines.
4. The landscape is painted completely from back to front.
5. Color is mixed wet on wet as well as on the palette and applied.
6. The color results from decisions by the painter.
7. Textures are added.

FOR A B

1. A row of trees is drawn between the top and bottom vanishing lines.
2. The landscape is painted back to front.
3. There is one other form in perspective (road or house).
4. Small amount of color mixing.
5. Some textures.

FOR A C

1. Trees in the landscape do not vanish to the horizon between two diagonal lines. Trees are drawn short.
2. The landscape is painted by areas not back to front, overlapping.
3. No wet color mixing used.
4. Colors are direct, not mixed.
5. No texture is applied.

Landscape painting with house by Holley School student, tempera on paper

ADDING A HOUSE: TWO-POINT PERSPECTIVE

OVERVIEW

In two-point perspective there will be two points on the horizon to draw to. All the lines on the left of the building will vanish to a point on the left at the horizon, and all the lines forming the right side of the building will vanish to a point on the right. Start with a house drawn below the horizon. All the lines for the house will vanish to the horizon. The second drawing will be a house above the horizon.

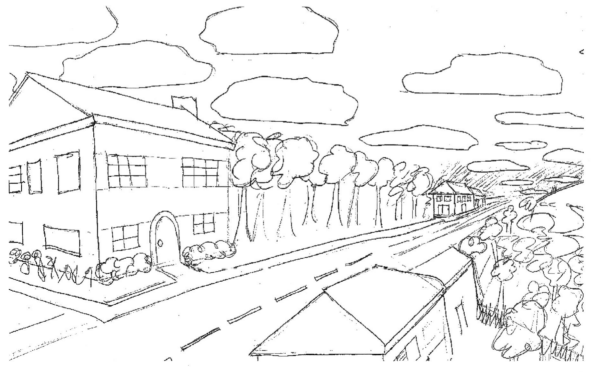

Heidi Veeman, perspective drawing of a street, Art for Teachers, Oregon State University

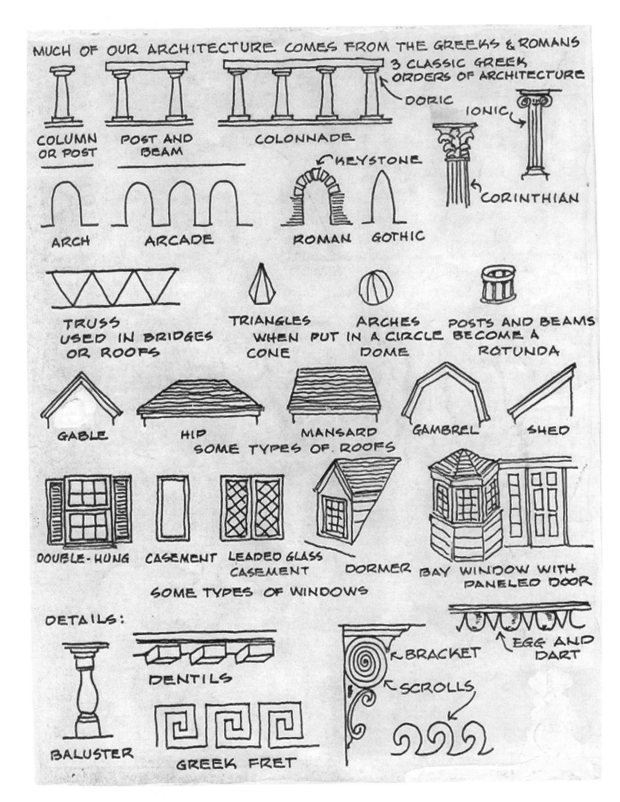

MUCH OF OUR ARCHITECTURE COMES FROM THE GREEKS & ROMANS

COLUMN OR POST

POST AND BEAM

COLONNADE

3 CLASSIC GREEK ORDERS OF ARCHITECTURE

DORIC

IONIC

CORINTHIAN

ARCH

ARCADE

KEYSTONE

ROMAN

GOTHIC

TRUSS USED IN BRIDGES OR ROOFS

TRIANGLES WHEN PUT IN A CIRCLE BECOME A CONE

ARCHES WHEN PUT IN A CIRCLE BECOME A DOME

POSTS AND BEAMS BECOME A ROTUNDA

GABLE

HIP

MANSARD

GAMBREL

SHED

SOME TYPES OF ROOFS

DOUBLE-HUNG

CASEMENT

LEADED GLASS CASEMENT

DORMER

BAY WINDOW WITH PANELED DOOR

SOME TYPES OF WINDOWS

DETAILS:

BALUSTER

DENTILS

GREEK FRET

BRACKET

SCROLLS

EGG AND DART

Architectural details for one- and two-point houses

The Exercise

HOUSE #1

Practice drawing the house first on drawing paper. Draw a horizon line across the middle of the paper. Place a dot for a vanishing point at either end of the line. Draw a vertical line about 3 inches below the horizon in the middle of the paper for the corner of the house.

Supplies

1. drawing paper
2. pencils
3. rulers
4. tagboard
5. tempera paints
6. palettes
7. paint brushes
8. water
9. rags or sponges

From the top of the line draw a diagonal line to the vanishing point on the right. Move to the bottom of the line and draw another line to the vanishing point on the right. Repeat with two lines to the left vanishing point, creating the other side of the house. Finish forming the building with lines at the back of the house.

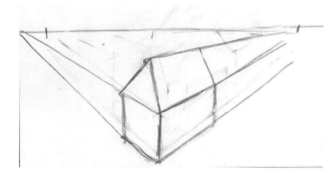

Two-point drawing of a house

ROOF

Draw a point over the front of the house under the horizon for the peak of the roof and draw a line from the peak to each front corner of the house. Draw a line to the vanishing point on the right for the top of the roof and frame the roof with a line at the back edge.

WINDOWS

The windows fit between a top and bottom line drawn to the vanishing point. Their sides are vertical lines.

THINGS TO WATCH OUT FOR

1. The house will look odd if students place the vanishing lines too close to the drawing. The vanishing points should be at either end of the horizon line and at the edge of the paper.

2. After the house is drawn, adjust the angle of the lines to make the house sit on the ground better.

HOUSE #2

Draw the front of the house first with vertical and horizontal lines. In this drawing the students can do more with detailing the house and less with landscape. In addition, page 102 has house parts students may copy or work from.

HOUSE #3 (DRAWING HOUSES ABOVE AND BELOW THE HORIZON)

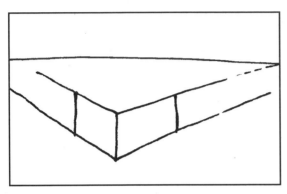

Diagram I

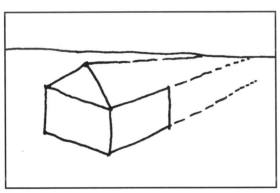

Diagram II

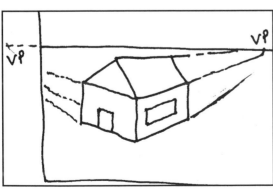

Diagram III

Draw the horizon line through the middle of the paper. Draw a vertical line across it in the middle. Lines above the horizon vanish down. Draw a line from the top of the line across the horizon to the left vanishing point on the horizon. Repeat on the right with a line from the top of the vertical line to the vanishing point on the right (Diagram I).

Lines below the horizon vanish up to the horizon. From the bottom of the vertical line draw a line up to the left, then the right vanishing points on the horizon. Add a vertical line between the vanishing lines on both sides to create the back wall of the house. For the roof find the midpoint of one of the sides, draw a point 2 inches above it, and draw a diagonal line from the point to the top corner on each side to frame the roof. Draw a line from the top point of the roof to the vanishing point and add a line for the end of the roof. Add any number of boxes to represent a garage or out building.

To Paint

Draw a large house that fills the paper. Let the students use rulers. Put the paints out and let them take their palette or ice cube tray to the paint to select the colors they need. They will need water and rags, sponges, or paper towels near them while painting.

Often times the outline of the house gets lost in the paint. To avoid this give the students a black felt-tip pen and have them outline the house first.

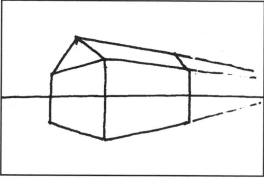

Diagram IV

Holly McNeill, house drawing, Art for Teachers, Oregon State University.

Students need to make value changes in their paint to paint the house. Each side of the house is a plane and, to separate the planes, they must change the value of the paint. The exercise in Section One on mixing and using tints and shades will come in handy here.

Windows can be blackened, which helps them to show up. Have the students frame the house with trees, bushes, grass, or walkways. Put the sky in the background.

Goals

- To increase visual awareness. To see space depends on following light and dark. Students must manipulate light and dark in paint to create a sense of space.

- Students practice creating a three-dimensional space on a two-dimensional paper.

Resources

Photocopy the page of architectural details on page 102 and give each student a copy. Home magazines that have house plans have drawings you can copy and share with the students for ideas. Let them copy a house if they like. Having something to look at is very helpful. This could also be an opportunity for the class to take a walk around the neighborhood and draw the houses they see.

Cultural Resource

In *A World of Art*, second edition (Prentice Hall, 1997), by Henry Sayre, pages 184 and 185 offer a two-page focus on the artist Beverly Buchanan, whose art is connected to the shack builders of the south. These houses are constructed out of found materials. The people who live in these shacks are poor, but proud and independent, preferring to live in their own homes instead of on the streets or on welfare. There is a 30-minute video available from Annenberg CPB that follows Beverly Buchanan making a drawing and a sculpture. It can be purchased for about $24 by calling 1-800-LEARNER.

Beverly Buchanan, Kingsland Georgia, 1994, oil pastel on paper, 60" x 60", photo by Adam Reich, private collection.

CREATING SPACE IN PAINTING

OVERVIEW

The painting is built up by layering one section on the one before it. The sky is painted first with the hills or mountains painted over the wash for the sky. Each section of the painting must overlap the section behind it. Each section must change in value and/or color from the one before it.

If the sky is light blue, for example, the hills might be orange and the ground in front of them medium to light purple. The trees could be red, purple, or light to medium green. The buildings are painted last along with the trees in the foreground. They are painted the strongest and darkest colors. The sides of the buildings must change in value in order to be distinguished. If the house is painted all red, for example, it will look flat. Instead, paint one side red and one side red-orange or go darker and use brown. The trees must also be manipulated with light and dark sides to show their volume.

In the end the painting should be light in the background and dark in the foreground. Moving from dark to light, from front to back in a painting creates space and depth.

The Exercise

Begin with the HB pencil and make a light outline drawing of the house, trees, mountains, and whatever else you want in the picture.

Mix blue and white with water and make a light wash over the entire sky. Use another light color, such as orange, for the hills. Paint the hills over the end of the blue wash, covering the edge without leaving any gaps between the sky color and the hill color. The two will mix a little but, being washes, they will blend together nicely.

Use two values of the color for the ground. Start with a light wash and add more paint to the mixture as you move toward the front edge of the paper.

Paint the tree trunks over the ground wash with light and dark values on either side, add light and dark strokes for grass, and use small strokes for leaves.

Select a color for the house and mix two values of that color. Paint the sides of the house different values.

Continue to add light and dark strokes of paint to complete the picture. The forms in the foreground are the darkest values in the picture while the background is very light and very soft, making it seem far away. A dark foreground and a light background give the impression that the mountains and clouds on the horizon are far away and faint in the distance.

Goal

- Students control the values in a painting front to back by working from light to dark, overlapping each section coming forward. The final picture has the darkest values in the front and the lightest values in the back, creating a sense of space. The students practice using tints and shades.

Chris Higashi, Landscape, oil on canvas, Painting I, Oregon State University

108a

BUSHES, GRASS, LEAVES, AND FLOWERS: DEVELOPING DETAILS

OVERVIEW

Early in my painting career I was trying to paint a landscape and getting more and more frustrated when Morris, my painting instructor, strolled by and said, "Use a dirty brush if you want it to all blend together." It works! A brush with a little yellow, a little red, and a little orange will create various earth-tone values. By adding a little purple or blue on the tip of the brush, the dark values blend right in next to the light values, making the change in light seem more natural. Strokes of paint can be placed side by side or the paint can be stamped on, dabbed on, and overlapped a little at the edges.

Value change is important in creating a sense of volume to leaves, grass and bushes. Even small blades of grass have a light and dark side. They cast a shadow as tiny as it is and the field they grow in can't be all one value; otherwise, it would be one big, flat blob instead of a textured ground representing a field of grass.

In one of Van Gogh's paintings he painted the shadows purple while the field was yellow-orange. By using opposite colors, he created an exciting visual vibration.

Nature changes color with the light of the sun. At sunset the colors will look different than at high noon. When the sun goes down and the sky is orange and red, the mountains in front of the sky will appear blue and sometimes purple. Water will reflect the colors around it. Water can be pink or yellow or green or black if there is no light.

The Exercise

Practice creating details in nature out of brush strokes. Every tool makes a different mark. Begin by rolling denim fabric into cigar-size tubes and taping the roll together in the middle. These tubes can be dipped in paint and wiped or stamped across the surface to create different effects.

Supplies

1. tagboard
2. tempera paint and acrylic medium
3. brushes
4. sticks
5. rolled pieces of cloth (heavy fabrics)
6. water and rags
7. photographs or magazine photos

Have students make their own painting tool out of a 6- to 8-inch square of fabric and then experiment with it on the tagboard. The tool may be rolled up on the diagonal or directly across. When the tools dry with paint in them, they are still useable but will make a different mark at first until they loosen up. Display the experiments and have each student share their process by telling the other students how they made the marks.

Let the students trade tools and use both ends. Put paint out on a flat plate or palette, making dipping easier. The paint will get mixed and at a certain point it will be too brown to use. At that point wash it down the sink.

The paint will dry rapidly. When it's dry students can take a small brush and add light sides to the dark marks and dark marks to the light marks. Layering light and dark improves the realistic effect. Have them add more light to one side of the form and more dark to the bottom.

The size of the stroke is important. Make marks from dots to larger heart shapes. Length is another consideration. How long or how short should the stroke be? Stack the strokes in a pile and then go back, even while it is wet, with light marks on top and dark marks on the bottom of the stack.

Sometimes it helps to take a field trip and observe how light falls on form.

Jennifer, Grade 5, landscape, tempera with acrylic medium on paper

Painting Clouds and Skies

Paint the sky a light blue, then dip a clean brush in white. Paint the white over the wet blue with a few quick twisting strokes. Set the brush with the bristles aimed as if on the side of the cloud, then rotate the bristles in a semi-circle, making a white arc of paint. If students continue to paint with this brush and continue making strokes, the blue paint will take over and the white will be mixed to light blue. If students make one stroke, only a tiny amount of blue will mix in, tinting the clouds just a little. Dip the tip of the flat bristle brush in the white and make one stroke at a time to construct the clouds over the blue ground. Students may also sweep a stroke of paint across the sky. A white stroke can cross a red and yellow sky, for clouds over a sunset.

Use brush strokes to construct and form details in the landscape. By cleaning the brush after every stroke, students can control the balance and clarity of the color. If they continue to paint with a dirty brush, the contrast will be less and the areas blend together more.

Goals

- Students improve painting skills and their understanding of light on form by practicing.

- Students develop a larger painting vocabulary.

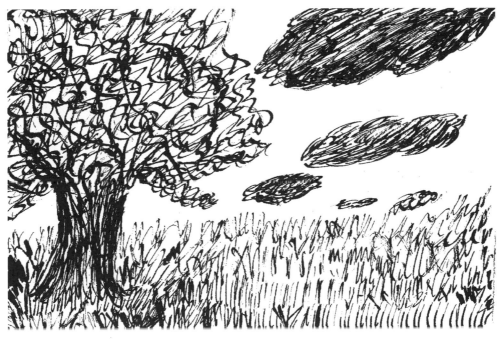

Heidi Veeman, pen and ink, Art for Teachers, Oregon State University

WORKING ON LOCATION: THE FIELD TRIP

OVERVIEW

Sometimes it helps the students to clear their heads by taking a walk around the block. Being outside in the fresh air just feels good, but equally important is having students experience and study the future subject of their art work.

Before you leave the classroom have the students construct small traveling paint kits for themselves. Staple or clip together four or five pieces of tagboard cut down to 4" × 5". Then back them with a small piece of cardboard. Attach a set of watercolors with a rubber band around the paper. In a plastic bag place a rag, a small plastic dish or jar lid to hold water, and one brush. One or two people need to carry the water supply for everyone. A plastic tote works well to carry a quart of water (or a plastic thermos® with a handle will also work).

Observation is the focus of the trip. You will be asking the students to look carefully and closely at the trees, bushes, ground, sky, and anything else you encounter on the walk. They are looking for light and dark areas on leaves and buildings. They are looking at details on trees, bushes, houses, and all the natural and man-made forms they encounter.

The Exercise

Try to take this walk before 11 A.M. so that the light is coming at the Earth from lower on the horizon, which creates a greater difference in light and dark, thus creating longer shadows.

Discuss the purpose of the walk with the students and then set out to find a tree or a bush about which to make a study. When you locate the subject, the students can sit on their carpet piece and get out their dish or lid into which someone needs to pour a little water. (The water is for diluting the paint and rinsing out the brush between colors.)

Sitting in

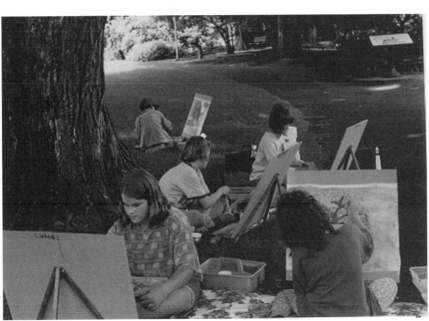

Students painting outside in Corvallis, Oregon

front of the tree or the bush, have the students make notes with their watercolors on the tagboard as to where the light is on the tree and whether it is dark on or under the tree.

113

Use dots of paint and map out the light and dark. Don't bother painting an outline, but try to use strokes to build up the form in light and dark instead of filling in an outline. The students shouldn't worry about blending the values. By just placing light values next to dark values, they will create a modeled form in high contrast. They should be able to see a volume forming.

Spend 15 minutes to one hour observing color and light. Then, back in the classroom, hang all the studies for the students to share their observations. Ask them to talk about their experience. What surprised them? What didn't they expect? What do they know now that they didn't realize before? What did they like best? What color were they surprised to find? What was hard? What was easy?

Goals

- Students broaden their awareness of the world around them.
- Students widen their color vocabulary. This improves their visual memory.

Megan Macke, pen and ink, Art for Teachers, Oregon State University

Wade Mroczko, landscape, oil on canvas, Painting 1, Oregon State University

114a

Section 5

OTHER MEDIA

1. Acrylics

2. Watercolor

3. Watercolor Technique: Working Wet on Wet

4. Watercolor Technique: Working Wet on Dry

5. Overlaying Colors

ACRYLICS

OVERVIEW

Acrylics were developed in the 1950s first as an experiment by students who mixed ground pigment and Rhoplex acrylic emulsion. Using a hand-powered eggbeater, they mixed titanium dry pigment, whiting, and Rhoplex to make an acrylic gesso. Under equally primitive conditions, they ground dry pigments with water which they sorted in jars. Then just before they wanted to use the colors, they would add the Rhoplex® medium with a pigment dispersant. Their colors were vivid and intense.

Acrylics proved to be revolutionary in the arts of the 1960s. They could be poured, dripped, spread, dragged, and pulled across raw canvas. You could never do this with oils, as oil will rot raw canvas. Acrylics made translucent stain painting possible which appeared fresh and direct. The acrylic hues stayed brilliant even when diluted with water or dispersant, a wetting agent that helped disperse the watered-down color evenly. Acrylic paints tend to have a matte surface when applied directly without additives. Acrylics without medium additives are opaque. An acrylic surface may look seemingly textureless, and even the colors tend to stay bright.

The Color Field painters of the 1960s used acrylics to develop a style of painting that came to be known as "hard-edge painting." Helen Frankenthaler, though not a minimalist painter, lead the way. She taught Morris Louis and Kenneth Noland how to pull acrylics across a canvas with a squeegee and how to pour acrylic. Frank Stella was another of the minimalist painters who produced large hard-edge paintings.

Qualities of the Material

Acrylics are fast drying, allowing the artist to make constant changes. That, along with masking tape which kept the edges of the forms neat and uniform, contributed to a new way of painting.

With acrylics the artist can pour wet color into wet color to create an earthen texture with cracks or fissures. Thickening agents increase the paint's viscosity. Nylon brushes were designed for acrylics, and synthetic bristles are excellent for acrylics, as opposed to the white bristle used in oil painting.

All of the exercises in this book can be done with acrylics. Acrylics are more expensive than tempera paints and are of higher quality. The acrylic medium I suggest you add to the tempera gives the tempera many of the qualities of the acrylics.

The amount of pigment that is used in making a paint determines the quality of the color. Paints with high percentages of pigment are richer, deeper colors, colors that mix together well to make true mixed colors. Colors that are low in pigment will muddy or haze when mixed creating inferior secondary colors.

In both acrylic and tempera painting, the paints dry fast. Using a mister bottle like the one you mist plants with will slow down the drying time. Lightly mist the surface of the painting as you work on it. After misting the surface, wait a minute for some of the water to evaporate. If the surface is too wet, the next layer of paint will slide around, so by waiting for some of the water to evaporate, you can reduce the slipperiness of the painting surface.

Storing Acrylics

Acrylics can be kept in plastic containers. If the container is misted weekly, the paint will not dry out. For a palette, acrylics may be placed directly into a plastic box like the type used in storing cookies. A paper palette can be placed under the paint or it can sit directly on the plastic bottom of the box.

Acrylics may be kept in individual small plastic storage containers. The paint should be mixed with a little water and acrylic medium to the consistency of light whip cream. This makes a "tub" of paint for the artist to use.

In addition to a difference in drying times, a major difference between oils and acrylics is that acrylics cannot be blended as oil medium inherently does.

WATERCOLOR

OVERVIEW

Watercolors are fluid and transparent. The fresh and spontaneous appearance of watercolor depends on planning and understanding a few basic techniques. In pure watercolor, the artist can't make "mistakes" because you can't correct by overpainting. For a young student, this attitude is too much pressure. Approach watercolor as a painting process that once completed, if doesn't meet the artist's expectation is simply repeated. Perhaps the next painting will be better. All painting is a process of putting paint on and sometimes taking your chances. It is hard to completely control paint. Some painters capitalize on the happy accident: a splash or a glob of color or colors running together that create a sky or a mountain, creating an effect that appeals to the painter. If it is unappealing, take a tissue and lift the paint out by blotting. Then paint over the same area again. If you want the color firm, wait until the area dries.

Qualities of the Material

Watercolors come in solid pans and look like a block of color. The better the watercolor, the more pigment is placed in the pan. One of the nice things about watercolor is it reconstitutes with water. While you are using the watercolor, you control the light and dark of the color by adding different amounts of water directly to the color cake or pan. More water than paint makes a light wash, while continually mixing the paint in the pan and the water deepens the color. When the pan dries up, it dries hard but can be renewed by adding water when you are ready to paint again. Neither tempera, nor acrylic will do this. There are hard cakes of tempera available, but they are opaque, not transparent. The transparent quality of watercolor allows the painter to overlap the washes and build up a color. It is best to work from light colors to dark colors.

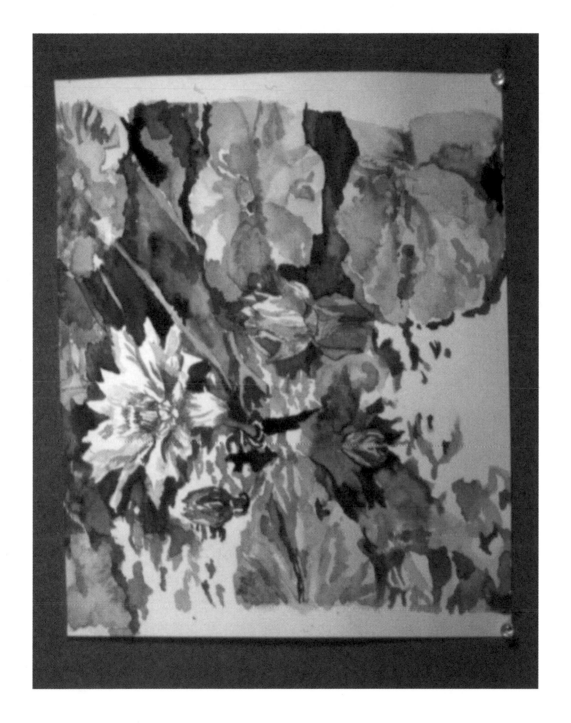

Kristin Grimba, watercolor, Oregon State University

118a

Watercolor Technique

Leave the white of the paper in the light areas or highlight areas on the forms in the painting. To lighten areas you can use Chinese white but generally white isn't used in watercolors. The more water you add to a pan, the lighter the value of the color will be. By adding less water and working into the color with the brush, the color will be deeper and stronger. To maintain the stronger color, add water slowly to the pan a drop at a time. Watercolor brushes are generally small which also helps control the water in the pan.

Watercolor depends on building up the washes and leaving a little of the underpainting showing through. For example, foliage may be painted yellow first, then tiny dots of green and green-black added over the yellow, letting some of the yellow remain framed by the green and black.

Skies may start as light blue washes with the white of the paper left for clouds. A light gray may be used at the bottom of the clouds to establish their volume. A hill can be painted over the bottom of the sky in red and purple; when the hill is dry, the branches of the trees can be painted over the top of the hill.

Paintings usually start in the background with the sky painted first, then the mountains, the hills, the roads, the houses, and the trees. Each section is added on over the one before it, which avoids gaps in the picture. Painting around the object or a form later, flattens the space and can result in brush work that doesn't blend in with the rest of the picture.

Tints in watercolor are highly diluted colors. Shades are overlays of color or various color mixes.

WATERCOLOR TECHNIQUE: WORKING WET ON WET

OVERVIEW

Mixing colors while they are wet results in them running together or marrying. This process depends on chance, not planning. The art work generated in this exercise may be used in the next exercise, "Working Wet on Dry." By saving this work, you don't need to repeat the exercise; instead you can extend these paintings one step further.

This is a watercolor technique to help the painters create a complete painting front to back. Some abstract painters, however, use this technique in composing an abstract painting.

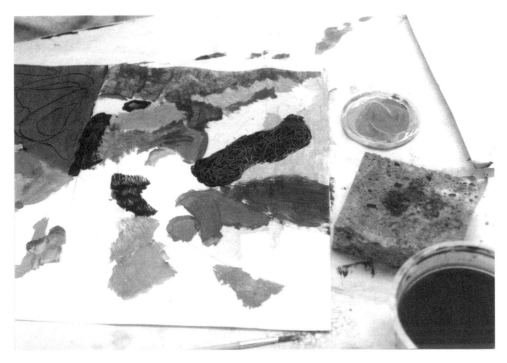

Student working on a painting

The Exercise

Tape the paper to the desk or a board before starting. A wet paper will warp and wrinkle making it difficult to work on. Mix the watercolor with a little water in the pan. Put a few drops of water on the pan and brush the color a few times to release the color into the water. The more you mix with the brush, the deeper the color will be. For liquid watercolors in a tube, use a small dish or cup, place a drop of watercolor on the dish and add water. By creating a small pool of color, the students can dip the brush in to paint.

PAPER #1

Paint a yellow shape on the paper, and clean the brush in water and on the paper towels. Next dip the brush in red and touch the end of the brush into the wet yellow, letting it run into the yellow. As this first color spreads, add more red by dipping back in the pool and touching the end of the brush a second time into the yellow. Don't brush the color together; just let it run together. Try another shape and, while it is wet, add a second and different third color to it.

A third approach is to paint a red area and, while it is still wet, dip the brush in yellow. Then brush the two together.

PAPER #2

If the paper is on a board, using a couple of big strokes, wash on a color with a large flat brush across the top. While it is still wet, lift up the board and let the color run down the paper. Lay the paper down and brush several rows of another color over the top edge; then pick it up and let it run again. Let it dry.

PAPER #3

Dampen the entire sheet of paper. Paint a large, thick stroke of red across the top. Using a damp to wet brush, paint into the first red stroke, pushing it down the entire page with the brush. Add a little more red if it gets too light. Clean out the brush.

Pick up yellow as a second color and brush it into the paper from the middle of the paper to the bottom. Clean the brush, and blot out the water.

Finally, dip a clean brush into the blue wash and start at the bottom of the paper, brushing it over the two previous washes while wet. Move up the paper a line at a time. These three colors, layered and overlapped, are a ground for a landscape painting with the color moving from light to dark down the page.

Hint: If you work the paint over the paper too much, it will turn muddy. Watercolor muddies quicker than tempera. It is probably better to stop and make another painting using what you learned than try to change the one you feel isn't feeling successful.

Goal

- Students practice using watercolor techniques, gaining experience in painting.

WATERCOLOR TECHNIQUE: WORKING WET ON DRY

OVERVIEW

Use the papers from the previous exercise, "Working Wet on Wet." For this exercise the students need a previously painted dry ground to work on.

When you build on a watercolor ground, you should paint in quick, rather than belabored brushstrokes. Watercolor is water-based, so the under layers will fade together with top layers if the students brush too much. Some blending and mixing is good and can be superior in building a color. The second coat should be planned and placed on the ground with a few strokes of paint.

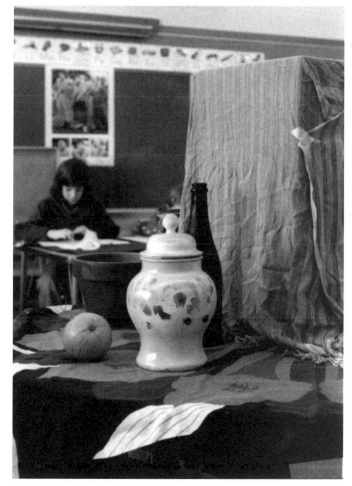

Student working on a still life

123

The Exercise

Select one of the previously painted papers. Using a pencil, *lightly* draw the outline of trees, mountains, clouds, and cars for a landscape, or roof lines for a cityscape. The choice for the drawing is up to you and your students; these are just suggestions. Keep the drawing simple. One animal and a bush or tree is plenty. Ask the students to paint their images over the ground.

The students can also draw with colored pencils on the dry wash and then fill in with either the colored pencils, or watercolor washes. Crayons or felt-tip pens can also be used over this ground. They may combine materials. They could draw an animal in colored pencil and then paint a wash around it, changing the sky and ground colors.

Subject matter for the painting may be in another subject they are studying. A particular history unit could provide a focus out of which the students could create a scene. Each student could draw one part of the scene, and then all the papers could be composed together in a mural. For example, draw on one paper a horse or a wagon. Continue through the list of necessary subjects to complete the story on the mural.

Goals

- Students practice painting and improve their skills to develop a greater knowledge of the possibilities of painting.

- They practice improving hand-eye coordination and increasing the concentration and focus of their eyes.

- It is a no-stress, no-fail activity in which everyone succeeds and learns something by doing.

- This exercise is more a foundation lesson, which is a building block for other focused exercises..

OVERLAYING COLORS

OVERVIEW

As watercolors are transparent, it is impossible to make them lighter by layering. Once you put a color on top of another, it will be darker. Depending on which colors you choose, the dark values will vary.

Layering color is used on small areas of the painting because adding wet color to dry color will loosen the under color and mix it with the second layer. Too much mixing will look muddy. Try to work quickly using as few brush strokes as possible. Four layers of color is about maximum on one area before it muddies.

The Exercise

Add a brush full of water to each pan, dip the brush in the water, and transfer the water to the pan, by gently squeezing the bristles as you slide your fingers down the brush releasing the water. The water can sit on the pan and begin dissolving the color.

1. Paint 3 separate squares of color, starting with yellow. Mix the water and the color together in the pan, and paint a 2″ × 3″ rectangle of yellow on the paper. Let it dry. Clean the brush and wipe it off. Now paint a red rectangle on the paper. Let it dry. Clean the brush, blot it, and paint a blue rectangle beside the red one.

2. Build up a color on top of itself. Paint a second square of red over the bottom corner of the dry square of red. Let it dry, and then paint another square of red across the lower corner of the second red square. Where the red overlaps, it will be deeper; where it remains untouched, the students will see a lighter value. Try green, yellow, or blue overlapping squares painted in the same way.

Diagram 1—
Overlapping colors

3. Paint three squares of blue in a row with 2 inches of space between them. Let them dry. While you're waiting, clean out the brush and paint three squares of red and three squares of yellow. When they are dry, paint over half of each square with a different color. On blue, paint red over one, yellow over one, and green over one. On the red squares, paint yellow over half of one, blue over half, and green over half of one. On the yellow squares, paint red over one corner, blue on the next square, and green on the last yellow square.

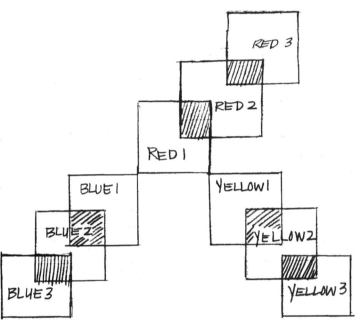

Diagram 11—Overlapping colors

Another watercolor texture you may get is a speckled, granular effect when layering colors. It's called precipitation and considered good by watercolorists. Watercolor papers encourage this granular effect by their makeup. The paper is uneven so the paint will flow into the tiny pockets and the peaks of the paper will show through the color.

Line-and-Wash Exercise

Line and wash is an older watercolor technique historically used to put flat tints over drawings. Illustration work still uses it today. There are a few different approaches.

1. Start with a *light* pencil drawing and loosely define the areas of the painting. Use a light wash in the sky and then over the mountains or buildings. Let it dry. Using a waterproof pen, draw the outlines of the trees, stone buildings, brick walks, or flowers over the ground washes. Add another layer of wash here and there to darken the shadows or add a darker value to the picture.

Richard Diebenkorn, *Untitled*, 1945-46, gouache watercolor, and graphite, $10^{7}/_{8} \times 13^{3}/_{4}$ in. San Francisco Museum of Modern Art: Gift of Jermayne MacAgy.

2. You may draw with water-soluble inks and then take a wet brush and wash over some of the ink on the painting. The ink will run, darkening the area around the line. Trees respond well to this technique. Draw the trees with branches to the top of the paper, then run the ink outlines to make a wash around them which will blend the branches softly into the sky. Remember to leave the white of the paper for air or cloud spaces in the sky.

3. After practicing this technique, ask students to think about and plan the location of the lights and darks, figuring approximately where things will go in their painting. Start with loose overlapping washes. When the washes are dry, they will draw their picture across the wash but not necessarily in the wash lines. They may draw across the washes enclosing different values and colors.

Creating a Backrun

Backruns happen when two colors are placed next to each other on the paper and allowed to run into one another wet on wet. A third color may be added to the wet wash by tipping a paint-loaded brush at a wet spot in the run. This third color will run into the other two. A backrun will take a minute or two to begin, and will continue to spread for as long as the paint is wet.

A further backrun is made by working into the center of the still-wet paint with clear water. Just touch the tip of the wet brush into a wet paint surface and watch the color run. The backrun is also called a cauliflower because of the round flowering appearance of the run.

You can use a backrun to create a cloudy sky. Make one on the horizon and draw the trees over and around it. Or start with one on the foreground area of the painting and then draw the houses and sidewalks over it.

Vassily Kandinsky, Russian (1866-1944) *Little Painting with Yellow,* oil on canvas 1914, Philadelphia Museum of Art, The Louise and Walter Arensberg Collection.

128a

Section 6

WORKING ABSTRACTLY

LAYERING: PAINTING ON PAINTING

OVERVIEW

In this exercise the students will create an abstract painting. The focus of the exercise is color and how that color is applied. Students will make decisions about layout and then color placement. Their technical problems will include in addition to choice of color, whether to mix a color, how thick to apply a color, or would a thin layer be better. Once a color is placed students decide if they should leave it or paint over it, and when the painting is done.

Paint prepared for other painting exercises and stored in plastic containers can now be used again. The room set up as in Section One will also work for this exercise. Containers of paint that stay clean and true in color but are empty can be refilled; offer the students a choice of paints and colors. If a color gets badly contaminated with too many other colors, toss it and start over with a new container of the original color.

In landscape painting, dirty colors are often perfect for rocks, trees, grass, and other areas. In this exercise students may actually want to use them to get some variation in their color choice. A mixed color is fine to use in layering paint. Students should stand to paint.

130

The Exercise

Select an old painting that is dry. The students will redesign the old painting, using it for a base on which to work. Ask the students to make a composition out of an arrangement of lines, linear shapes, and solid shapes using lengths of masking tape over the dry ground. Press the tape on the painting where the lines should go. Then choose shapes and configurations that are constructed out of lengths of masking tape laid side by side on the ground. Cover the painting top to bottom and side to side with a line design.

Students can make lines of tape, boxes of tape, triangular shapes with tape, or outlined overlapping sections with tape. Basically any geometrical arrangement they can think of—whether symmetrical or asymmetrical—is fine.

Depending on your budget, it is helpful in designing the layout or composition of this painting to use different widths of masking tape. If you can't afford different widths of tape, have the students use scissors to cut 1-inch tape into halves or thirds. The tape will stick to the scissors as you slice through it, so just go slowly and remove the tape off the scissors as you cut along. A 4-inch piece of tape should be plenty. Once students have all the areas they want taped off, they should burnish both sides of the tape on the paper by running the end of a paint brush firmly down the edge of the tape to make sure it is flat on the paper. They can also use a spoon to press the sides of the tape down. Students should not put the tape on any sections of the painting that were not originally painted. The tape will rip the paper if it isn't covered with paint.

The paint to overpaint with should not be watery but rather a more buttery, thicker consistency. The acrylic medium will alter the paint's consistency and make it more transparent.

Supplies

1. a dry painting from an earlier exercise
2. tempera paint mixed with acrylic and stored in a plastic container
3. brushes (small and large)
4. sponges and rags
5. water cans
6. masking tape (1/2″, 3/4″, 1″)

Using a medium to large (1/2″ to 1″) brush, paint over the tape choosing various colors to completely cover the painting. Select a painting color that is different from the color under the tape. Every section of the painting can be a different color. The edges where the colors meet can be brushed together to create an atmospheric space over the surface.

As the students paint over the tape, it is best not to push paint back against the edge of the tape, but to paint down and over the edge of the tape. In this way the paint has less chance of getting under the tape. The tape will provide a hard edge line through the atmospheric space. If paint gets under the tape, it creates "bleeding" which is a fuzzy line instead of a hard edge line. The students can take a small brush and paint over the fuzz if it is bothersome.

Let the painting dry, which will take about 10 to 15 minutes. Then remove the tape by pulling it off slowly. Pull the tape at a slight angle (45 degrees to the paper), rather than directly back over itself. Gently lift one edge and slowly remove it several inches at a time. Don't pull the entire piece off in one long stretch; rather, lift up sections of the tape 1 to 2 inches at a time. That will help avoid the color on either side of the tape edge from ripping up. The tape should be removed directly after it is painted. Letting it sit overnight sometimes weds the tape to the painting so strongly that some areas will pull up and rip when the tape is removed. If this happens, paint over the ripped areas.

Goals

- Students increase hand-eye coordination, decision-making skills, and technical knowledge of painting.

- Students experience the process of painting on a dry colored ground.

- They develop different lines of thought in creating abstract painting.

132

Sandy Brooke, All that Glimmers, acrylic on paper, 22″ × 30″, 1988

132a

RHYTHM AND REPETITION

OVERVIEW

The composition of this painting depends on the students doing a drawing lesson first. A line drawing exercise is included on the following pages. After the students are familiar with drawing objects in simple outline form, they will use those skills to draw their composition. There is now wrong way to draw a form and they do not need to erase, as each drawing will contribute to the overall painting—even if it is warped or shriveled. Each time the students try an exercise, they will improve because practice is how you get successful in the arts, especially in drawing.

Student painting a rhythm drawing at Holley School

Warm-up Exercise

Before students start to draw, have them hold their selected object in one hand in front of themselves. Have them follow the shape of the object with their fingers in the air. They should look at the object for changes in texture, shape, or material.

Then have them make a simple line drawing no smaller than their hands with felt pens anywhere on the drawing paper. Students should continue to look at and feel the object, while drawing a line that follows the outside contour of the object. Take into account the grooves and bulges changing the line accordingly. When finished, have them select a new object for an outline drawing.

Remind students not to cross out or erase any drawings they don't like. Once they start, they continue to the end. If they are not satisfied with a drawing, have them draw the same object again on the same piece of paper right next to the one they don't like. Each line drawing helps students improve their skills.

Sarah Dubrasich, Grade 5, Outline Drawings of clothespin, compass, scissors and wrench

Supplies

1. 12″ × 18″ white drawing paper
2. 18″ × 24″ tagboard
3. pencils
4. felt pens
5. simple objects (light bulbs, tennis balls, spoons, wrenches, hammers, toothbrushes, sunglasses, electric plugs, screwdrivers, utensils, and nails)
6. tempera paints or watercolors
7. quill paint brushes
8. water, sponges for tempera

The Exercise

Each student now selects one object to draw. Draw the object on the tagboard. Draw a second outline overlapping the previously drawn outline. The outlines can overlap on the end, on the side, on the top—wherever. They can draw the outline vertically, horizontally, or diagonally. The objects must cover the entire page and run off three sides. They can be laid out in a circle, run from the top to bottom of the page, or go from side to side across the page. They can be all the same size or start small and get larger, whatever the students decide as long as they cover the page and run off on three sides while overlapping each other.

To paint the composition, use the rule: Any color may be used within an outlined area, but you must *change the color when you cross a line*. The objects and the areas around the objects should also be painted. The quill paint brush will be the most precise to paint with. The areas can often be small and hard to fill in with flat paint brushes.

The illustrations on the next page are four examples of tool compositions for the next lesson, but they are good examples of how to paint by changing color at a line.

Goals

- Students build hand-eye coordination and critical-thinking skills. With each outline the students are making decisions first for placement, then for color.

- Students' painting skills increase because of the care and precision involved in painting the outlines.

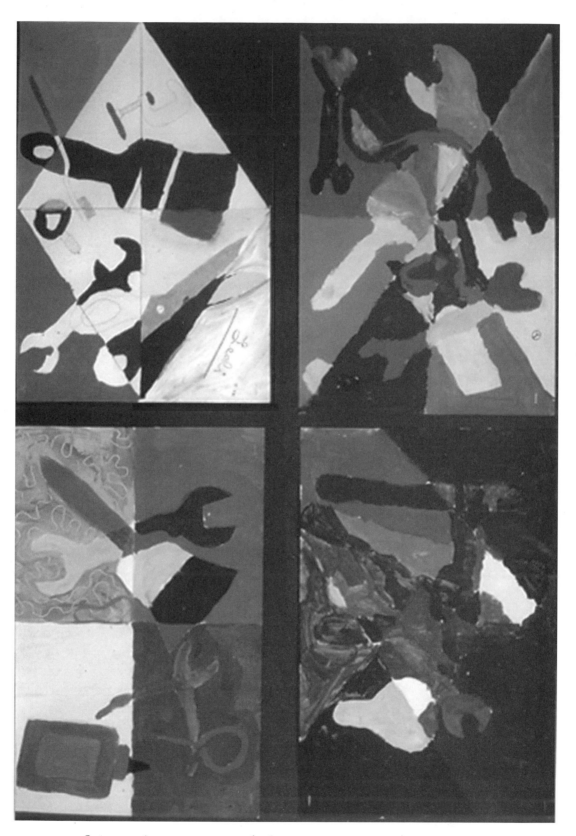

Four student paintings of the geometric composition exercise

MATH AND PAINTING: GEOMETRIC COMPOSITIONS

OVERVIEW

The math involved here is in the form of measuring to divide the paper space. Students will practice using a ruler as they plan the composition. First, they divide the space in half, then into quarters. The quarters must be divided in half by diagonal lines.

Students should use a large piece of paper and draw the forms large. The students must listen and follow instructions to compose their painting.

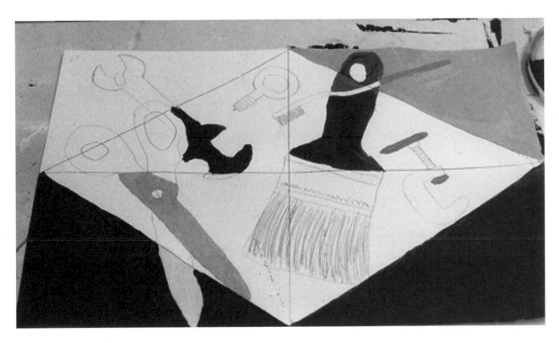

Student starting a geometric composition at Holley School

The Exercise

STEP 1

Each student selects four or five objects to draw on the paper in *light* pencil outlines. The goal is to fill the page with objects. Draw one object touching the top and bottom edge of the paper, one going off the edge and one diagonally across the paper. Don't bother erasing misshapen drawings; all distortion adds to the painting and will hardly be noticed when the painting is completed. The drawings of the objects may overlap.

After students have all the objects drawn on the paper, let them erase lines that are too dark to be covered (Diagram I).

STEP 2

Using the ruler, divide the paper in fourths with light lines. Next, divide each quadrant with a diagonal line from the center to the corner or from corner to corner (Diagram II).

STEP 3

Paint the sections of the drawing by following the rule: Use one color within any surround lines. Never cross a line with a color. The line can be either a division line or an outline of a tool.

Areas side by side or adjacent should *not* be painted the same color (Diagram III).

Supplies

1. pencils
2. tagboard
3. brushes (quills for small areas)
4. tempera paints
5. water
6. rags and sponges
7. tools (wrenches, screwdrivers, hammers, light bulbs, scissors, hand saw, pliers)

Diagram I

Diagram II

Holley School student's painting, geometric composition

Goals

Diagram III

- Students develop critical-thinking skills, increase perception, and reinforce basic learning skills of listening.

- When finished, students see how color affects our perception of space. Ask the students, "What colors seem to recede and what colors seem to bounce out at you?"

Evaluation

FOR AN A

1. The student drew four to five large forms, some overlapping, on their paper.

2. The student divided the paper correctly.

3. Each section was painted a different color; adjacent areas were not painted the same color.

FOR A B

1. The student drew fewer than four objects.

2. The lines of measurement were not exact or were curved, not straight.

3. Some adjacent areas were painted the same color.

FOR A C

1. The student drew three or fewer objects.

2. The student did not complete the page divisions.

3. The craftsmanship was poor because of lack of attention to detail.

4. The color was applied without attention to line or space.

FLATTENED PERSPECTIVE: WORKING AS A CUBIST PAINTER

OVERVIEW

You can expect different responses to this exercise from your students. Some will love making the decisions; some will think it's dumb; others will be frustrated as they worry whether or not they are doing it right. It seems to be a controversial lesson.

A little background on the history of art will be helpful. Art history books and art survey books, such as *A World of Art*, second edition by Henry Sayre (Prentice Hall, 1997), discuss the development of cubism and modern art. Examples from books or photos from magazines and calendars help the students to see what cubism looks like.

Cubism took the modeled form and flattened it. The renderings of the objects in the still life were drawn distorted and outlined in black line. The artist might stack the outlines on an oval, circle, or rectangle that represented a table. Cubism had the feeling and look of a collage. Sometimes the forms were cut in half and shifted in the composition to sit up to four inches apart. A violin, for example, could be drawn with the neck in one square, the body in another, with the strings off to the left side to leave it all completely unattached.

Texture played an important role in the compositions. Pablo Picasso used real wood and pieces of a cane seat in one collage. Georges Braque drew wood grain and marbling on some places of this work. Dots, lines, hatching, gradations on a square, and wallpaper patterns appear in the background as well as on the shapes in the painting.

The Exercise

Georges Braque once said, "Picasso and I both liked to use the mandolin in our compositions, but I don't think either of us ever had the instrument in our studios."

Some of the imagery for cubist work came from the artist's visual memories and imaginations. Some came from objects they had used in still life. A mirror, a vase, a table, a table cloth, a rug under the table, a bowl, pears, bottles, pitchers, and words from the newspaper were the shapes they used in their compositions.

Start by drawing a large oval on a piece of tagboard. Draw legs on either side of the oval to the edge of the paper. Draw a violin or guitar on the table. Overlap the instrument with a rectangle of sheet music. Create notes and lines of texture on the rectangle to represent sheet music. Select a headline out of the newspaper and glue it on. It can overlap and cover some of the forms already drawn on the paper.

A second option is to draw a bowl of fruit or other still-life objects of the students' choosing. Let the drawings overlap. They can be drawn on the diagonal as well as vertically and horizontally. Cut the drawings in half vertically and paste them on a new backing. Shift the drawing so the lines no longer meet. Introduce a rectangle of texture between the halves. Weave the texture in and out of the objects or overlap the objects.

Supplies

1. 12" × 18" tagboard or cardboard
2. sticks and brushes
3. tempera paint (black, white, plus blue or red)
4. newspaper
5. wallpaper samples
6. shelf paper
7. glue
8. water
8. rags

Georges Braque, *Vase, Palette and Mandolin*, 1936, oil. 32″ × 39⅝″. San Francisco Museum of Modern Art: Gift of W. W. Crocker.

To Paint

Using small brushes and sticks, paint sections of the drawing in white, black, and one other color. The cubists used light blue, light brown, or red most often.

Balance the painting with three tones. Select and add textures between the forms and behind the objects. Instead of painting an area a solid color, dab the color on or dot it on. Paint wood-grain rectangles or geometric patterns in the background. Create patterns in mosaic for the rug or use geometric patterns on the drape in the background.

Dip the sticks in paint to make lines and textures. Select a different color or texture within each shape. A shape may be created by overlapping forms as much as by outline. To strengthen the composition, use a black outline around the table and around the rug as well as on some of the objects.

Goals

- Students learn to think abstractly.

- The students must make each decision based on what they think intuitively will look good. This builds confidence in making decisions and thinking critically.

- Students are introduced to modern art and the problems those artists faced. It may build some understanding of different approaches and qualities of art.

Megan Macke, continuous line, Art for Teachers, Oregon State University

CONTINUOUS-LINE COMPOSITIONS

OVERVIEW

Make a drawing from a large still life arranged in the middle of the room on a long table. The students can sit around the table to draw and then move back to their desks to paint. Or the desks could be grouped together to paint. Once students have the outline, the painting has nothing to do with the drawing or with modeling the forms. It comes out of their imaginations; all painting decisions are made by the painters as they work on the composition.

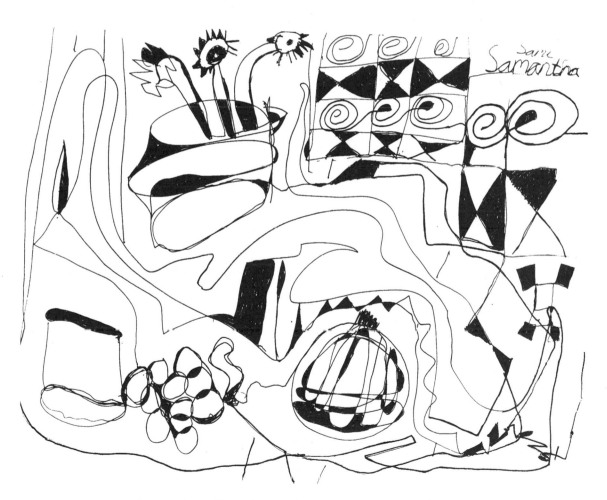

Smantha Polfus, Grade 4, continuous line drawing

To Draw

The students will draw the objects in the still life with one continuous line. The line can go around the contour of the object, across its surface, and up and down the volume to define it. Ask the students to start on one side of the paper and move across the paper to the other side.

Pick a starting point on the still life and start, continuing to draw around the outlines of the objects with one continuous line. The line may go across the surface of a bottle, for example, to reach the other side. The line may also go across the surface of the table to connect the second object to the first object. The line can go from the front object to an object behind it to an object beside it.

Once students are across the page, they may return with the line to objects in the background they missed and add them into the composition. Keep the pencil on the paper, drawing a line to each object as it is added. Draw around the pattern on the table, and around anything they can see in the background, including any floor patterns. There is no need to erase anything as all lines will contribute to the painting whether intentional or accidental in nature. The line creates not only shape and contour but also volume.

The Exercise

Use the lines drawn to guide the choice of colors to paint on. If students would like the outline to be part of the finished painting, outline the pencil lines in felt-tip pen or crayon. If they use crayon, push firmly on the crayon to cover the line. There is a lot to cover here, so allow enough time for the students to be precise and careful.

Supplies

1. 12″ × 18″ tagboard
2. pencils
3. tempera paints (all colors)
4. brushes (small and medium)
5. felt-tip pens or crayons
6. water, rags, palettes
7. paper towels

OPTION 1

Use one color plus its tint and shade to paint areas on one object. If a vase is drawn with overlapping lines, dividing its surface, use red for one section and red plus white in another section, plus red darkened with green in another section.

Each object in the composition can be painted with value changes of a single color.

OPTION 2

Select all the smallest areas in the outline and paint them black. Then paint the larger areas different colors, for example, red, yellow, or orange. Try to avoid placing the same color in two shapes that touch.

OPTION 3

Stay within the lines of the shapes created by drawing with this one continuous and overlapping line, paint each section a different color.

Goals

- Painting this drawing takes time and patience, so students improve their painting skills in manipulating the brush. They won't realize what they are making until they step back and look at it. It is a very alive painting, full of visual bounce.

- Students improve their ability to concentrate and focus.

ABSTRACT COMPOSITIONS: A COLOR PROBLEM

OVERVIEW

The students will need to draw the composition with a ruler, making mathematical decisions first to establish the composition. This composition is made up of circles inside squares, diamonds inside squares, and circles inside diamonds. The paper should be square to start with. A rectangle will work but, instead of circles, you would create ovals. The diagrams at the end of the lesson explore several possibilities for layouts.

Student Painting of an Abstract Composition

Shanna Ann Reagan, Grade 5, Foster School, Sweet Home, OR

148a

The Exercise

To Draw

1. Divide the paper in half by making a mark at 9 inches down each side. If the ruler is a 12-inch one, measure 9 inches down from the middle of the top of the paper to make a mark. Draw a horizontal line across the paper through the three marks.



Supplies

1. pencils
2. rulers
3. 18″ × 18″ tagboard
4. tempera paints (all colors)
5. acrylic medium can be added to paint
6. sponges, rags, water
7. brushes (small and large)



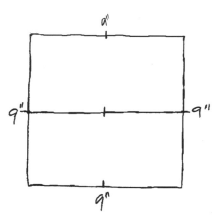 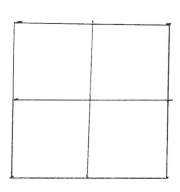

Next, divide the paper in half vertically by making another mark at 9 inches from the side on the bottom line. Draw a line through the middle mark to the marks on the top and bottom lines.

2. The square is divided by a diagonal crossing through the center. Or, using diagonal lines, divide each quadrant in half by drawing a line from corner to corner across the square.

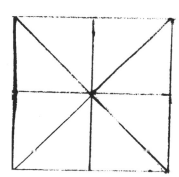

3. Continue to divide the square by finding the midway point on each diagonal and connecting those points. These measurements center a square in the square.

4. (Optional) A circle may be constructed in the square by drawing an arc across each quadrant.

To Paint

Use the lines to guide the selection of colors for painting. Use any color paint in each section without placing the same color side by side.

A second choice for painting is to rotate the color from light to dark by shape. For example, if the circle in the middle is painted blue, purple, and red-purple, then the square around it could be painted yellow (one color), light yellow, and yellow-orange. The diamond or next shape would be in dark values.

A third way to paint is to paint each shape gradually, lightening or darkening the colors as you move from the outside shapes to the center shapes. First, use values of yellow; on the next shape, values of red; then values of purple; then light and dark green; to finally dark blues in the center. You can also reverse this and use light values in the center, gradually darkening the colors in the shapes as you move to the outside edge.

Painting Reminder:

Remember to ask the students to clean their brushes before dipping in a new color and to wipe the water out on the rags or paper towels before picking up more paint.

Goals

- This exercise is for the experienced painter. It demands time, patience, and planning to be successful. Students improve their control of paint with the brush.

- Students develop thinking skills in organizing and planning the execution of the painting. This is purpose in this painting.

- Students must carefully measure the surface to lay out the painting. Measuring and planning have been an important part of art throughout history. The artists of the Renaissance drew their figures on a measured grid to proportion the composition.

GROUP PAINTING:
THE EXQUISITE CORPSE

OVERVIEW

The Exquisite Corpse (le Cadavre exquis) was a game designed by the Surrealists in France about 1934. In this game a sentence or a drawing was made up by several people working in turn, none of them being allowed to see any of the previous contributions. They would string the images or the words together, fragment to fragment. It was up the players to find and add more charm, more unity, more daring to this collective work. There were no losers and each player wanted the next player to "win."

The first player would draw one section of the body and pass the paper to the next player. The game was not played with any negative feelings or thoughts. No image was directed as an insult to any person playing.

The major artists at these evening sessions were Max Ernst, Pablo Picasso, Andre Breton, Jean Arp, Man Ray, Joan Miro, and, perhaps, Paul Klee.

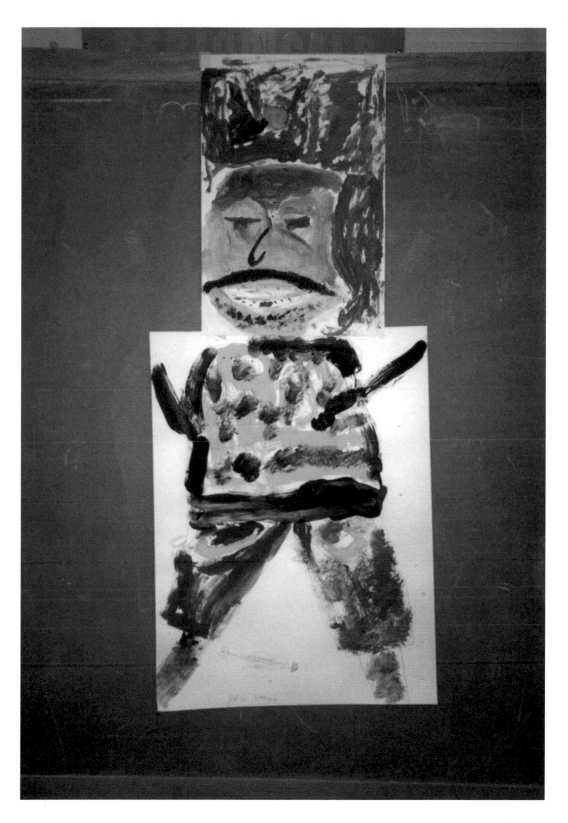

Student assembled figure at Cloverridge School

The Exercise

Originally, the artists took a piece of paper and folded it in three sections. The first person drew a head and folded the drawing over, putting it out of sight to reveal only the area for the second section. The second artist drew a body from the neck to the waist, adding the arms. The drawing was then rolled over so the next artist could not see it. The third artist drew the legs and the feet. The paper was then unfolded and all the parts seen. A few touch-up lines could then be added at this point to bring it all together.

TO DRAW

Start by taping three pieces of paper together in the back. One extra piece can be added as a cover. Divide the class in thirds. One group starts with the head. Another group starts with the body, and the third group starts with the legs and the feet. The students must fold their drawing under and leave the section for the next student to draw. Each student must tell the next student what section he or she is to draw. **Or** assign the drawing to move from "John to Christen and then to Sydney," for example. No peeking!

Students can draw human or animal parts. The figure could have a duck head on a tiger body with horse legs. Or, they could draw a robot body or legs, while someone else drew a human head. It's open construction.

TO PAINT

Make a composite drawing for each student in the class. When they are done, give each student one complete person and have them paint it. Painting will be more detailed than usual. Quills and small brushes should be used, as these are easier to paint with when filling in small areas. An outline in crayon or felt-tip pen will preserve the drawing.

Watercolor is more transparent and perhaps easier to use than tempera paints. Acrylic medium can be added to tempera to keep it flexible and make the tempera a little more transparent.

Goals

- Students develop and improve visual thinking.
- Students work as a group and cooperate on the drawings.
- Students are challenged by the number of possible images.

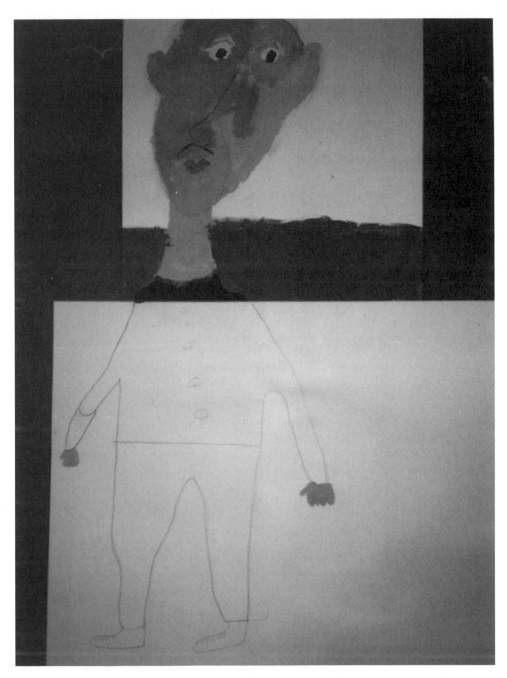

Student beginning an assembled figure at Cloverridge School

PAINTING NEGATIVE SPACE

OVERVIEW

Negative space may also be referred to as empty space or interspace. It is the space between two positive spaces, also identified by the terms *form* or *object*. Negative space is the space around the objects in a still life. It is the air space between the rungs on a ladder. It is completely necessary as it separates one positive space from another, which allows us to distinguish one object from another.

In a still life, the space between a vase and a bowl is negative space. Drawing negative space is hard because we see the outline of a shape much easier than the outline of the space between two shapes. It will be easier for the students to make this drawing if you set up a collection of large objects that have holes in their form. Objects such as chairs with wooden slat backs, stools, ladders, deck chairs, or camp tools with the triangle base are all possibilities.

Negative space drawing, student at Oregon State University

The Exercise

Supplies

1. pencils
2. tagboard
3. one color of tempera paint for each student
4. water and brushes
5. rags or paper towels

1. Set up an arrangement of large objects: a stool next to a ladder with a table behind it and a chair beside it, a bucket with a handle on the table, and another object a few inches from the bucket. The students may draw the outlines of the objects, leaving the space between the objects. Draw the space between the handle and the top of the bucket. When the paper is covered, paint the space between the objects and leave the objects the white of the paper. If desired, paint all the objects one color, which will make them appear as silhouettes on the paper.

2. Fifth- and sixth-grade students who have done at least a half year of art projects may be visually mature enough to try and draw the negative space. Stack several chairs on top of a table with a board sitting from one chair seat to the other. Put a stool on the board, and sit the ladder on one side. Try to arrange a pile of things that have holes in their form so the students can draw one open space after another across the paper.

Ask the students to pick a starting point at the top or the bottom of the paper and draw the first negative space (an empty space) framed by the sides of the chair or inside the rungs of the ladder or between two chairs. Move across the chair itself, leaving the space of the chair, and draw from the outside edge of the chair to the next outside edge of whatever object is sitting next to it. Fill the paper side to side, top to bottom with the negative spaces. Let the drawing run off the sides of the paper.

Goals

- Students see and understand spatial relationships.

- Students translate three dimensions into two dimensions with better accuracy.

- Students develop awareness and ability to think spatially.

Jessica Nunley, negative space drawing, ink, Design I, Oregon State University

Section 7

PORTRAITS AND FIGURE STUDIES

1. Mixing Skin Tones

2. Separating the Planes of the Face

3. Drawing and Painting the Face

4. The Cut-Paper Mural: After Matisse

5. Drawing and Painting People

6. Health Lesson and the Body

7. Continuous Line and the Figure

8. Caricature

9. Completing a Face

MIXING SKIN TONES

OVERVIEW

The trick to painting in flesh tones is to mix four or five different values of skin tones on the palette, and then work between them to build up the facial planes from light to dark. Layer paint to darken sections of the face instead of using a very dark value directly.

Flesh tones should be mixed on the palette to create light and medium values, as well as yellow and pink tones.

With a number of mixes on the palette, the painter can go back and forth between them, picking up a little light yellow, then adding a little light rose tone over it which will darken the flesh tone.

Patience is important. Value change on the face is subtle, so you must tint and shade in rather close values. All skin tones are made of the same combination of red or magenta, yellow, and white. To paint dark skin tones, you only darken this mixture.

Your students may be surprised that black and brown skin tones are made from the same base as white skin tones. Black people have rosy cheeks as do brown and white people; they are just on a dark-value skin tone instead of tan or light-value skin tone.

Maria Larsen, portrait, oil on canvas, Advanced Painting, Oregon State University

The Exercise

Don't mix huge amounts of paint. Face colors are various tints of red, yellow, and white. Magenta may be used instead of red; it is sometimes easier to control and manipulate into a rich flesh tone. Place a little red and a little yellow on the palette an inch apart. Put out some white a few inches from the red and yellow. Mix the red and yellow mixture together, creating a teaspoon of orange.

Dip the tip of a small brush in the orange and slowly mix this orange into one side of the white. It will make either a peach, pink, or yellow flesh color depending on how much of each color is in the mix.

With a clean brush pick up some of this red/yellow/white mixture and move it to the other side of the white. Mix it into the white, keeping it in a separate spot. This will make a lighter tint of flesh.

Put a touch of green on the palette. Add a little green with a small brush to one side of the first orange. It will turn a brown. This is what you use to shade flesh tone and darken it.

DRAW A FACE

Draw a circle; halfway down, add two almond eyes, and place a nose of two vertical lines between the eyes. Use a **V** or a **U** shape for the end of the nose and use **C**'s on either side for nostrils. Add a heart-shaped mouth. Draw two lines off the circle for the neck and curve them out for the shoulders. *Hooked on Drawing* has a complete drawing exercise on faces.

Using the lightest flesh tone, paint the forehead, cheeks, and chin. Select a little darker flesh tone and paint over the first layer at the sides of the head, under the eyes, and below the cheeks to under the chin. Use a mixture that has more yellow than pink and less white than the first mixture.

Continue to work on the face by shaping it with light and dark skin tones. Add a little pink to the cheeks. Use value change on the neck: darken one side and lighten the other. Be sure to clean the brush when you want to change value. A dirty brush will blend everything together, which will eliminate the individual values necessary to see the planes of the face change.

Choosing Light and Dark Planes

Areas of the face that recede should be darkened as well as the planes on the sides of the head. Darken above and under the eyes, under the nose, on the sides of the nose, and below the cheeks. To darken, use the mixture of green with flesh tone over the first layer of flesh tone.

The top place of the nose, the cheeks, and the center of the forehead are light planes.

Goals

- Students practice creating a face with light and dark values of flesh tone.

- Students push and pull the paint back and forth to create a modeled face.

- Students increase technical skill in painting and develop a better understanding of chiaroscuro through paint.

Student creating a figure at Cloverridge School

SEPARATING THE PLANES
OF THE FACE

OVERVIEW

The head and the face are composed of a number of small planes, a plane being a flat, level surface. This translates in modeling form to each small surface on the face.

For example, there is a small plane above the eye and one under the eye, there is a larger front plane for the cheek and side planes on the cheeks. The forehead is a front plane with side planes turning towards the back of the head. As the planes turn in and out across the face, light and dark skin tones follow the planes, changing the structure.

To get a sense of the planes of the face, it is helpful to ask the students to examine their own faces with their hands. Have the students start in the middle of their foreheads and move gently across the forehead to the sides of the head. They should be feeling the roundness and curve of the skull. Continue, starting again from the middle of the forehead, and move down the bridge of the nose to the end of the nose. Feel the sides of the nose going down into the crease between the cheek and the nose. The side of the nose is a plane, as is the side of the cheek. To locate the ears ask the students to place their fingers at the back edge of their eyes and run on an imaginary line towards the back of the head. They should run into their ears. From the ears follow the jaw line to the chin, noticing the connection. Return to the bottom of the ear and note where the side of the neck starts.

Now they should have a better idea of the form of their face.

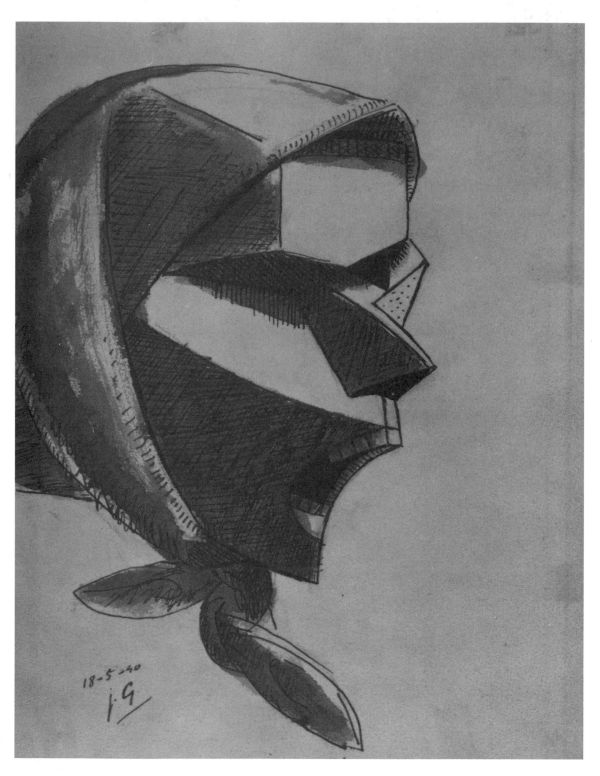

Julio Gonzalez, Spanish (1876-1942), *Screaming Head*, pen and black ink, with brush and gray wash, over graphite, on off-white laid paper, 1940, 31.6 × 24 cm., McKee Fund, 1957.358. Photograph © 1995, The Art Institute of Chicago. All rights reserved.

The Exercise

To draw the face start by drawing two eyes three-fourths of an inch apart. Place the ears on either side of the eyes. Add a nose with two vertical lines and a **V** at the end. Use a **C** shape next to the **V** and draw a line up to the eyes, making the side plane of the nose. Add a heart-shaped mouth or a flatter vertical line mouth. Draw and shape the jaw line from the bottom of the ears to the chin. Add a neck from the bottom of the ears and add shoulders. Within this simple framework, map out the planes of the face.

Supplies

1. pencils
2. tagboard
3. brushes
4. tempera paints (red, yellow, white, magenta, and green)
5. acrylic medium for paint
6. palettes (plastic coffee can lids)
7. water
8. rags and paper towels

Illustrations for drawing a face

Use a medium flesh tone to paint the darker sides and planes of the face. Let the first layer dry. Then mix a light flesh tone and paint the light tone over the areas and planes that will be lighter. Mix another flesh tone more yellow or more pink to adjust the planes or the areas connecting the planes. Model the face with different values of flesh tone to shape it. When the light flesh tone is painted over the medium tone the planes will flow together. The dark layer of paint underneath will darken the light second layer, separating the planes a little.

Goals

- Students understand the volume of the face and head.
- Students practice modeling the face and head with value changes in flesh tone.

DRAWING AND PAINTING THE FACE

OVERVIEW

It helps to look at large portraits done by such artists as Henri Matisse, Vincent van Gogh, Pablo Picasso, Paul Gauguin, and Piere Bonnard. They are good artists to copy because their color choices were interesting and their use of modeling more understandable for students.

Make black-and-white or color copies of their work and let the students study the use of color in terms of where they placed it as well as which colors they chose to use. Examine the different values across the face. Copying a master was the way art was taught for centuries and still is an excellent way to improve technique.

There are no lines on the face to follow. The changes of light and dark that will shape the volume of the face follow the planes of face. Modeling can also result from a change of color as well as a change of value. Usually light values visually come forward and dark values recede.

Three portraits by students at Holley School, Grade 4

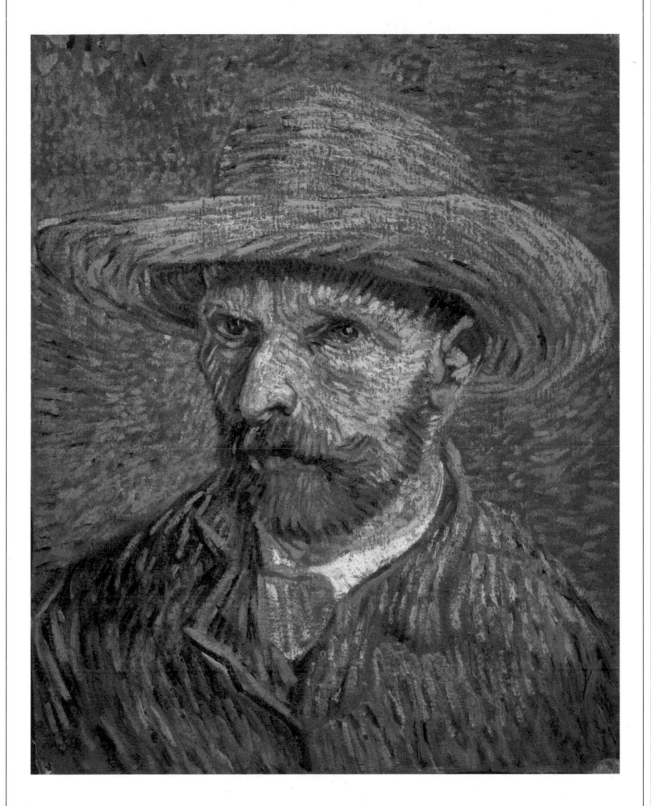

Vincent van Gogh. Self Portrait with a Straw Hat, oil on canvas, 16 × 12¹/₂ in. (40.6 × 31.8 cm.) unsigned. The Metropolitan Museum of Art, Bequest of Miss Adelaid Milton de Groot (1876-1967), 1967. Photograph © The Metropolitan Museum of Art.

The Exercise

Start by drawing the face and the shape of the head. Add the neck and shoulders along with the shirt or dress on the model. Map out on the face where light and dark values change or where the color changes with light pencil outlines.

On the palette, set out the light colors in the portrait. Use a small brush. Start with light and medium washes, blocking the planes out and dividing light areas from dark areas. Use water to dilute the first layers of flesh tone or other colors that the artist used. Let the wash dry.

Put the darker colors on the palette. Paint a second layer of the darker colors. Paint the dark planes of the face, painting next to or over the first layers. Leave the light areas to paint next.

Select the other colors on the face and add them. One side of the face may be darker than the other. Look at the background and paint behind the head. Follow the artist portrait you selected. If it is in black and white, interpret the color by value using light and dark values of one color or light and dark colors to compose the background.

Goals

- Students translate from black and white to color and read the value change on the face that creates volume.

- Students translate color by area if the reproduction is in color.

- Students interpret information and find both the subtle and major plane changes on the face.

THE CUT-PAPER MURAL: AFTER MATISSE

OVERVIEW

Henri Matisse (1869-1954) was a great innovator in collage, along with Pablo Picasso and Georges Braque. At the end of his career, in his eighties Matisse—while bed-ridden and forced into a wheelchair—invented a process he described as "carving with color." He refused to quit working. Instead he had assistants paint papers with gouache for him out of which he cut shapes to be glued down in large collages. He directed the placement of his cut-out shapes from his bed or wheelchair. To form the shapes he worked from memory, cutting shapes by how he felt about them as much as how he remembered them. He based one collage on a trip he had taken to the South Seas. He remembered the ocean and the life in the ocean and recreated from memory the shapes and forms. He made a collage of swimmers, a snail, and people dancing.

These collages are in the Museum of Modern Art as well as in the Metropolitan Museum of Art, both in New York. You might want to look at one of the books of Matisse's collages, called *Jazz* (by Henri Mattisse. NY: George Brazillier, Inc., 1983. [Translated by Sophie Hawkes from the original 1947 edition.])

The Exercise

I have recommended adding the acrylic to the tempera to make the paint more flexible and prevent the tempera from cracking off the paper, but you can paint with tempera alone.

Start by painting sheets of paper solid colors. Use any color but black, because the background will be black. Students may also texture the paper with stripes, dots, and drips. Let the papers dry.

Flatten the papers, stack them, and cover with textbooks overnight. You will need a lot of papers for this cut-paper mural.

Discuss with the students the possibilities for a theme of the mural. I have used The Circus, a Parade, The Ocean, The Forest, Dancing, and Flying. A theme involving movement is fun to do.

After deciding on a theme, divide the students into groups. One group will take a few papers and cut out head shapes, one group will cut out legs, one will cut out arms, and one will cut out shapes to be torsos.



Supplies

1. 18" × 22" 80-lb drawing paper
2. tempera paint (no black)
3. acrylic medium to mix in
4. large brushes
5. water and containers
6. rags, sponges, or paper towels
7. scissors
8. glue
9. 10 feet of black posterboard (butcher paper)



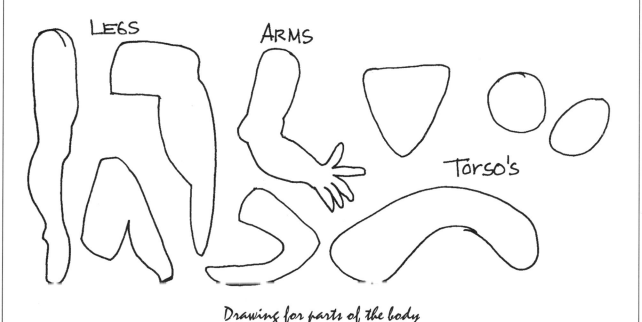

Drawing for parts of the body

169

Example: The Circus

Hang a large black piece of poster paper on a wall. Start by placing and gluing a curved torso or body on the black paper horizontally; glue on the head. Now select two straight arms for either side of the head and glue them to the mural's ground. Select two legs for the other end of the torso and glue them on. Ask the students to be careful putting the glue on the pieces. They should wipe the glue flat so it doesn't drip when they bring the piece to the mural and the glue must go to the edges to keep the pieces flat on the ground.

Now construct another such figure 6 inches away; you now have two trapeze artists reaching for each other. Construct other figures to complete the composition of the scene.

Cut out accessory pieces from the scraps and remaining papers. Ask the students to cut out swings and bars for artists to walk on, rings for people to perform in, balls to stand on, and stars for the sky. Construct an acrobat doing a handstand or a clown rolling a ball. The performers may be at the top of the paper, in the middle, and near the bottom. They can overlap, which should look like one performer is in front of another. Continue adding to the mural, making decisions with the students as you move across the paper. Have them name all the people and things that could be in this mural. Make a list on the board and then create as many as possible.

NOTE: Save the scraps and leftover papers for the collage and painting lesson in Section Eight.

Goals

- Students develop an understanding of how the parts of the body go together.

- Students increase their understanding of the proportions of human form.

- Students improve their abilities to construct two-dimensional space in the likeness of three-dimensional space.

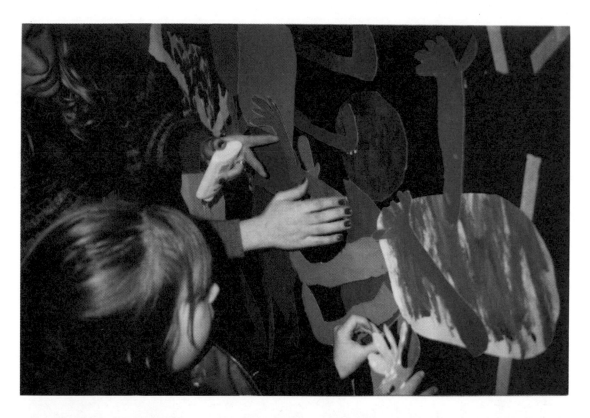

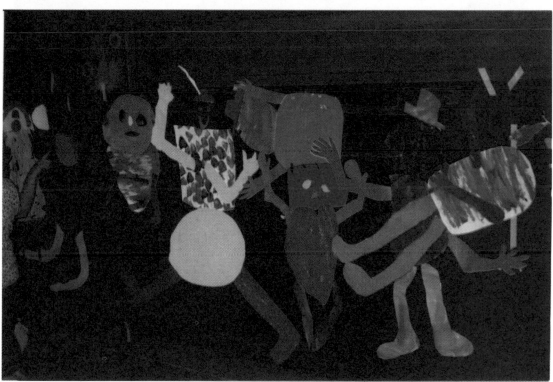

Teacher helping a student glue pieces down
Cut Paper Murals at Foster School

DRAWING AND PAINTING PEOPLE

OVERVIEW

This exercise combines painting and construction. It will probably take 2 to 3 hours. This is another approach in forming a complete human body: from the head to the shoulders to the waist to the knees to the feet and arms.

The Exercise

Students start by drawing a portrait of a person they admire or they invent. Examples include a cheerleader, a politician, a pirate, and a rock-and-roll star.

Draw the portrait on the 12" × 18" tagboard and paint it. Discuss the person with the students. What does this person wear? Next give them the larger piece of tagboard and tape the head to the top. Now they can draw the body, adding it to the head.

Have them paint the clothing. They can also paint a background on the paper around their figure. They could also cut the figure out if desired.

Display the figures so students can study each other's technique. Some bodies will be large and some will be small.

Supplies

1. 12" × 18" and 18" × 22" pieces of tagboard
2. pencils
3. tempera paints
4. brushes
5. palettes
6. paper towels
7. sponges
8. water and containers

Goals

- Students increase their spatial awareness.

- Students determine the scale of the body.

- Students practice painting and designing with paint.

HEALTH LESSON AND THE BODY

OVERVIEW

Working on poster paper is difficult with paint because the paper is thin. Ask the students to wipe the water out of the brush before painting. It would also help to put on a first coat and let it dry. The acrylic medium in the tempera will strengthen the paper and allow students to paint over areas again without the paper warping too badly.

Tape the paper down to a table or the floor to keep it flat.

The Exercise

Have two students work together as a team. Cut two pieces of white poster paper, long enough to accommodate the height of each student. Either tack the paper to a wall, or lay the paper on the floor. Have the first student lie on the paper or stand against the paper attached to the wall. They can hold their arms out or at their sides. Have one student draw an outline of the other student's body with a pencil, and then switch places with his or her partner.

Now the students have an outline of themselves. Using the pencil, map out all the internal organs. Find the lungs, the heart, the stomach, the connecting tubes, the kidneys, and the liver. Map out the sections of the brain and discuss what functions they control.

Once drawn, outline the parts in felt-tip pen and label, if desired. Dilute the tempera with acrylic medium and a little water to thin the color to a wash. The wash will be more transparent, allowing everyone to see color through color. Have the students paint the drawings of their bodies.

Supplies

1. one piece of white poster paper 5 feet long for each student
2. health book showing internal organs
3. black felt-tip pens
4. pencils
5. tempera paint mixed with acrylic medium
6. water container
7. water to clean brushes
8. brushes
9. rags or paper towels

172

Assembled figure by a student at Cloverridge School

Goals

- This project is art as illustration, whereby students use their skills as artists to render prescribed images.

- Students are judged by how accurate and clean the presentation is constructed.

- Students plan and understand scale, perspective, looking, and interpreting.

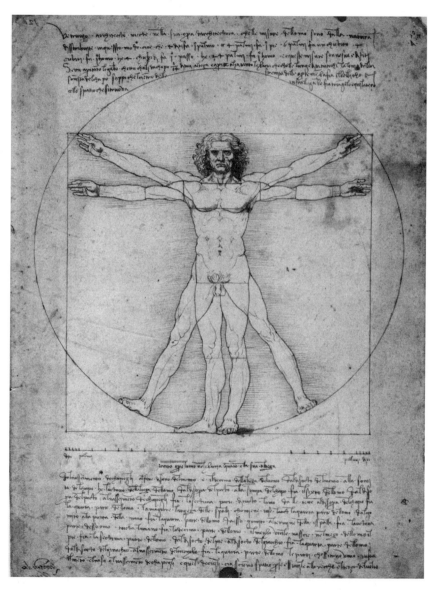

Leonardo daVinci, (1452-1519). *The Vitruvian Man*, Ca. 1492. Drawing. Accademia, Venice, Italy. Scala/Art Resource, N.Y.

CONTINUOUS LINE AND THE FIGURE

OVERVIEW

You need a volunteer to do this exercise. If you can't convince a parent to come in and sit for 20 minutes, use your students.

POSE #1

The first model sits on a chair in front of the class with his or her body and legs to the side.

Have the students stand to draw. Give them a large piece of paper (18″ × 22″ would be good). They are to draw not only on the outline of the figure but also across the figure from side to side. That will help them proportion the figure and create a sense of volume, with the lines wrapping around the figure.

In this drawing the pen is kept in constant contact with the paper, moving continually back and forth, from up to down or down to up the figure, and adding one section of the body to the one before. Have this first model sit for 5 minutes.

POSE #2

Now change to another student. Give the students another piece of paper for the second drawing. Change the pose for the second drawing: have the model stand leaning on the chair.

POSE #3

In the third drawing have the model sit sideways with the back of the chair to the room and resting his or her head on his or her arms, which are resting on the back of the chair. You could have two students model at one time, as some angles are very hard to draw. Two models can give all students a better view.

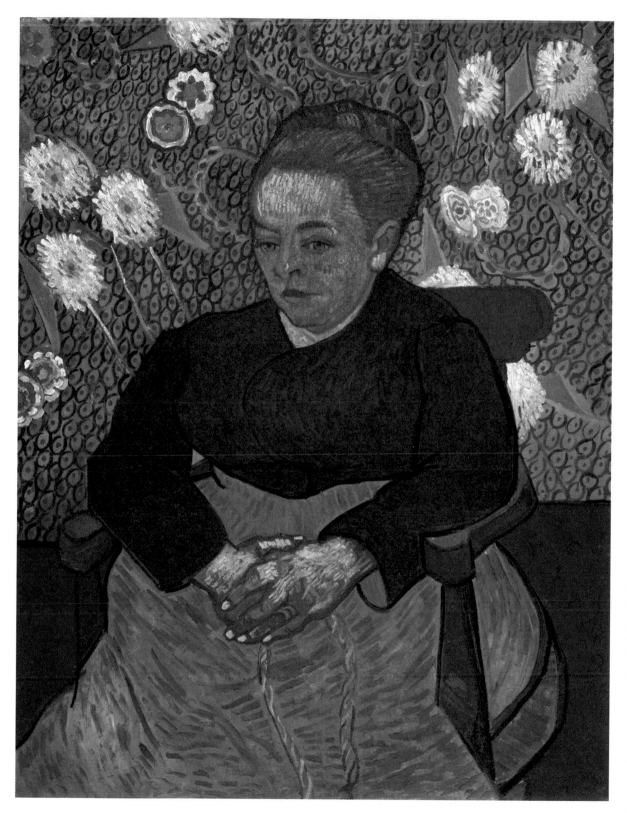

Vincent van Gogh, Dutch (worked in France) 1853-1890, Lullaby: Madame Augustine Roulin Rocking a Cradle (LaBerceuse), oil on canvas, 1889, 92.7 x 72.5 cm. Bequest of John T. Spaulding, Courtesy Museum of Fine Arts, Boston.

174a

The Exercise

Have a student sit in a chair as the model. The pose will only last 5 minutes. Someone will need to be the timer. Give each student a large piece of white paper and ask students to stand to draw. They may lean on the hand they are not drawing with. The drawing hand should be kept free, with the elbow loose, so the hand can make big flowing lines.

Supplies

1. 18″ × 22″ 80-lb drawing paper (60 lb is too light; 150 lb is even better)
2. thin felt-tip pens
3. tempera or watercolor paints
4. small brushes
5. water and rags
6. paper towels
7. palettes for tempera

Have the students pick a starting point on the figure and begin drawing with a continuous line that encircles the figure, thus creating form and volume. For example, start with the arm closest to the front. Draw down the sleeve, then across the elbow to the other side so they can come back to the cuff and the hand. Then move from the hand to whatever it is touching—perhaps the face? Draw around the parts of the face, down the neck, back and forth across the T-shirt, down one side of the jeans, and over the chair to the other leg.

There are no mistakes and students can't erase. If they draw a line they feel is wrong, merely move the pen over to where they feel the line should be and redraw the line. They need to work quickly and make rapid decisions. The chair can be part of the drawing. It is always easiest to draw front to back. The artists start with the form closest to them, drawing it, and then adding the next form on to the front form.

Now change to model #2 and pose #2. This way the model will get to draw also. Start on new paper. Follow the same rules.

Change to model #3 and pose #3. When completed, the students will have three drawings to choose from. The drawings are made up of overlapping lines in black ink.

TO PAINT

Using the watercolors or the tempera, paint the drawing by painting inside the sections outlined in black. Students may change the color completely in every section. They may change the value of one color section by section within one part, such as for pants. Change the value within one color for the face and T-shirt. In this way, the painting will have the look of a mosaic. Painting by following the drawing avoids learning a lot of rules for modeling the figure. Drawing and painting the figure is a "10" in difficulty in art projects. By painting the sections, the students may enjoy the project more. If they prefer, they could paint over the lines and model the figure in a more traditional manner.

Goals

- Students increase hand-eye coordination.

- Students improve visual literacy and increase their understanding of proportions.

- Students make decisions rapidly, deciding where to go, how much line to use to get there, and whether or not they need to make adjustments.

- Students reinforce critical-thinking and decision-making skills.

- Students develop a strong sense of achievement and success.

CARICATURE

OVERVIEW

Cartoon would be the modern word for caricature and probably the word most students recognize. By exaggerating the features of the face, students learn to draw and organize facial features.

Political cartoonists attack our political figures every day in the newspaper. Ask the students to look at the section of the paper with the political cartoons. You may want to discuss what the cartoon means and what current event the cartoon is pointing out.

Claude Monet, the famous impressionist, drew cartoons early in his career. Leonardo da Vinci drew incredibly interesting portraits of people who had very unusual features. Honoré Daumier depicted actual current events from the early 1830s until his death in 1872. Daumier was employed by the French press as an illustrator and political caricaturist. Recognized as the greatest lithographer of his day, Daumier exposed Paris life and political outrages. The lithograph "The Dangerous Children, 1848" depicts the first street gangs of children in Paris. The library may have books and more information about Daumier's and da Vinci's drawings.

Ask the students to bring in cartoons or photos from magazines to which they can refer in addition to the copies you can make out of books and newspapers.

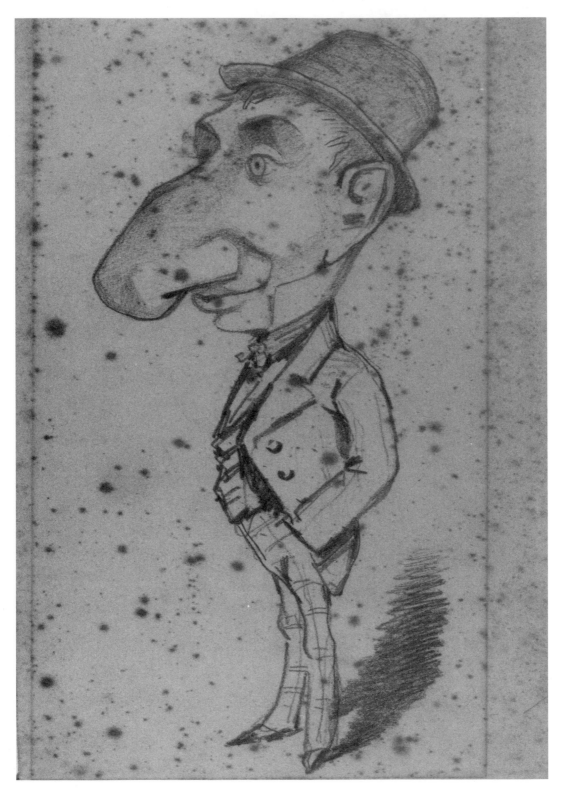

Claude Monet, French, 1840-1926, *Caricature of a Man with a Large Nose*, graphite on tan wove paper, c.1855/56, 24.9 × 15.2 cm. Gift of Carter H. Harrison, 1933.895. Photograph © 1995, The Art Institute of Chicago. All rights reserved.

The Exercise

Have the students select a photo or photocopy of a photo to draw by copying. Have them follow the drawing with their pencil on the tagboard, making the cartoon larger. They can add a background. For the background, ask where the figure should be located. In a landscape? In a room? Would a prop help us understand the point of the drawing?

To Paint

Based on the information in the "Mixing Skin Tones" lesson in this section, paint the face, clothing, and background. Since the photos will be in black and white, the students will need to interpret the values on the face and work from previous knowledge gained from the earlier exercise, "Separating the Planes of the Face." Caricatures often have only two values on the face. They rely on outline more than value change across planes to define the facial features.

When the paint is dry, the students can go back into the painting and outline the facial features with felt-tip pen or pen and ink. If they have good control of small brushes, students can outline in black tempera paint.

Supplies

1. tagboard
2. pencils
3. photos and cartoons
4. small brushes
5. palettes
6. tempera paints
7. water
8. paper towels

Marco Rico, Italian (1676-1729), pen and brown ink, wash, *Caricatures of Bandits*. The Frederick and Lucy S. Herman Foundation, Muscarelle Museum of Art, College of William and Mary in Virginia..

Goals

- Students develop skills in looking, seeing, and interpreting visual information.

- Students transfer information and increase hand-eye coordination.

- Students are successful and feel accomplished. They like the unusual and tend to stay with the exercise to the end.

WOMEN IN ART

From the Middle ages through the Renaissance and up until 1900 artists trained by copying the art of Masters. Guilds trained young men and women to be painters and sculptors. In the Renaissance young artists apprenticed to such artists as Leonardo da Vinci and Michaelangelo. Many famous frescos and murals were first drawn on the wall by apprentices. The master would then complete and finish them.

We know of three women who painted during the Renaissance. One was Sofonisba Anguissola (1532-1625), who came from a wealthy Italian family and was well educated. She created a new type of picture that focused on people in scenes of everyday life. In addition, she painted self-portraits. King Philip in Spain invited her to paint at his court.

Lavina Fontana (1552-1614) achieved success as an artist during the Renaissance. Her father taught her to paint. She became the first woman to make paintings for large public places. Many fashionable and rich people commissioned her to paint portraits because she was very skilled at rendering their finery (clothing) and jewelry. At the same time, the Pope commissioned her to paint religious works in Rome.

Artemisia Gentileschi (1593-1652) may have been the greatest Italian female artist. Some of her paintings were more than 6 feet high, depicting powerful and courageous women from ancient myths, the Bible, and history.

COMPLETING A FACE

OVERVIEW

To make this exercise more interesting, rather than using magazine photos, use color photocopies of paintings by artists. Some of the artists you might look up are Vincent van Gogh, Henri Matisse, Paul Cezanne, Pablo Picasso, Paul Gauguin, Chuck Close, and Andy Warhol. They all created portraits that vary in color and complexity.

Supplies

1. glue
2. pencils
3. tag board
4. photocopies
5. palettes
6. tempera paints
7. small quill and flat brushes
8. water
9. paper towels
10. magazine photos of faces or color photocopies of portraits by artists

The Exercise

Cut the photos in half vertically from the top of the head through the nose and lips. Give each student a bissected photo.

Glue half of the photo onto the tagboard. Students recreate the other half of the face with a pencil line drawing first while looking at the half not glued down. Paint the new drawn half following the values and changes on the color copy or photograph.

Goals

- Students practice drawing the parts of the face.
- Students increase their visual composition skills.

Completing a face

Section 8

TEXTURE

Georges Braque, French (1882-1963), *Collage*, composed of charcoal, graphite, oil paint and watercolor on a variety of cut laid and wove paper elements laid down on dark tan board, c.1912, 35.1 × 27.9 cm. Gift of Mrs. Gilbert W. Chapman, 1947.879. Photograph © 1995, The Art Institute of Chicago. All rights reserved.

COLLAGE AND PAINTING: A STILL LIFE

OVERVIEW

Georges Braque and Pablo Picasso together invented the collage form. In his youth, Braque was trained by highly skilled French house painters. As an apprentice house painter, he watched his teachers working in oil paints produce remarkably convincing marble veining on a wooden facade. Braque retained a sensitivity to the illusionistic play of textures. His collages involved cutting and gluing papers with printed designs and imitative textures in combination with actual textures.

Collage depends on overlapping pasted paper to create a spatial construction. The artist's consideration must be with the interaction of shape, line, and color to transform the materials into a piece of art. Collage can expand the artist vocabulary of interlocking and overlapping shapes.

To produce lines, the edges of the shapes can be coated with a dark color that stains the edges. The stained edges create a line softer than a drawn line but a definite division in the collage. Materials for collage range from fabrics, like lace and burlap, to sandpaper and textural surfaces. Corrugated cardboard, painted papers, wallpaper samples, self-stick vinyl paper, and construction paper are useful materials to consider using in collage.

Supplies

1. glue
2. scissors
3. still life
4. pencils
5. paper or tagboard
6. tempera paints
7. palettes
8. rags
9. water

The Exercise

Collect a number of painted papers. These can be unsuccessful paintings, practice or warm-up paintings, leftover paintings, and painted papers from "The Cut-Paper Mural: After Matisse" in Section Seven. You can use fabric, cardboard, sandpaper, wallpaper samples, and construction paper.

Set up a big still life in the center of the room with bottles, pitchers, guitars, violins, sunflowers, bowls, and fruit. Ask the students to take a piece of tagboard or heavy drawing paper and make an outline drawing of five or six shapes in the still life. The shapes do not have to stay in the order they are on the table. The students may manipulate the shapes by placing them on their papers side by side, overlapping, front and back; or they may draw one half of the shape on the right and one half of the shape on the left. Draw the objects from the middle of the paper out. Fill the center of the paper. Draw around all the objects, framing the outside edge with an oval.

Select a material and cut the shape of the drawn still-life object out of it. Glue the material on the drawing. Students may also cut one part of the shape out of one material and the rest of it out of another material.

Chris Higashi, cubist collage painting, oil on canvas, Painting I, Oregon State University

188a

The new shapes may overlap. Add painted shapes. Select one of the outlines and use tempera paint to develop it. Continue to compose the collage, balancing paint with cut-outs, textural areas against solids, and texture next to texture.

Mount the entire collage on cardboard, railroad board, or foam core as a frame. The frame material can be painted, textured, or covered with fabric before mounting the collage on the surface. Old picture frames from the second-hand store can be gessoed or painted with white latex and then repainted, or covered with newspaper or fabric to use around the collage for a more finished appearance.

For a final glaze, use the acrylic medium thinned with a little water and paint over the frame. The medium will adhere the newspaper to the frame.

Goals

- Students must make constant critical and creative decisions in creating the composition. Their knowledge and understanding of balance, color, line, and shape must come into play to complete the work.

- Students use technical skills in cutting and pasting.

- Students make judgments about size and scale in creating the cut-outs to go in the collage.

MAKING TOOLS TO USE FOR PAINTING AND CREATING TEXTURE

OVERVIEW

The first painting tool was the hand, followed by a stick, and a piece of charcoal out of the fire. The brush is a rather late invention in the history of image making. This exercise does *not* use brushes.

The Exercise

Collect a box of found materials: shipping foam, styrofoam "popcorn," fabrics, wood, sticks, cardboard, and whatever else the students can find around home.

When you have a large selection of materials, make your own tools. Use a heavy fabric, such as denim, to cut out squares of cloth 4 to 5 inches square. Tightly roll the cloth on the diagonal. Use masking tape to wrap around the roll and hold it together. Continue rolling different fabrics and securing them. This tool will be different if it is loosely rolled or tightly rolled, as well as whether the strings are cut off the fabric or left on.

From the collection of materials, ask the students to construct other tools they can imagine being able to paint with or make marks with.

Ask the students to think about what their favorite thing to do on the weekend is and what it looks like. Design symbols to represent the outing. With the symbols, marks, and pictographs, ask the students to depict their favorite weekend in a painting on the tagboard in one or two colors. The best colors would be red, black, and brown. These are the colors of the cave paintings of Lascaux in France.

Ask students to draw a map of the route they take to school every morning. What are the landmarks they pass? What is involved in getting to school? The purpose is to get them to visualize an event and then symbolically—without language—depict it. In addition, they are limited by their tools. Let them use their hands; you could give them charcoal if the tools are too hard to draw with. (Students should save the tools to use in other painting projects.)

Supplies

1. 12″ × 18″ or larger tagboard
2. tempera paints
3. heavy and thin fabrics
4. sticks from the ground
5. collected packing materials
6. pieces of wood
7. masking tape
8. glue
9. scissors

Goals

- Students improve their visual memory.

- Students experience what communication was like before language. The Aborigines today communicate about their landscape through art maps. Their paintings tell stories and recreate their history of creation.

ADDING OTHER MATERIALS TO A PAINTING

OVERVIEW

The cubists may have been the first group of artists to add things other than traditional painting materials to their artwork. Georges Braque often added sand to an area of the painting to add a texture. This form of texture is physically real as opposed to created or drawn.

The Exercise

It would be best to work on thick cardboard, foam core, or heavy tagboard. When the students add some of the above items, the picture will become quite heavy.

A piece of white paper can first be glued to a cardboard backing. Then ask the students to make an overlapping outline drawing of the items you have set up loosely in a central still life. They should arrange the objects in a cubist manner with some things drawn horizontally, some diagonally, and others vertically.

The students are to construct a composition following the divisions in their drawing. Each outlined area can be dealt with differently.

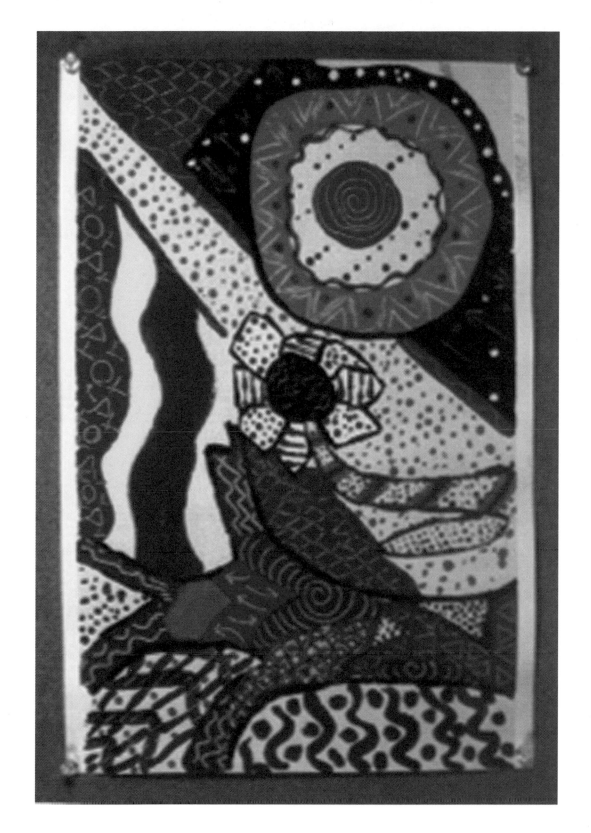

Mandy Bewley, painting based on aborigine art, Art for Teachers, Oregon State University

192a

Begin by selecting one outline and paint it. Gently sift the sand into the area of the wet paint, letting it stick to the paint. Use the glue in another area. Pour the glue over the entire shape, then press string, sand, buttons, or lace into the outline of the shape. Rubbing wax on the paper first will create a resist texture. Use the wax first in a section and then paint over the wax with tempera.

Tempera paint that has acrylic medium added to it will dry hard and will not rewet with a second layer of paint over it. You can paint a shape one color, let it dry, then paint a lighter or darker color over it. With a stick or the end of the paint brush, scratch a line or pattern through the wet top layer to expose the underpainting.

Words from the newspaper may be added in part or whole. Balance the composition among painted areas, textured areas, and areas of added textures that are cut to fit the area of the shape.

Goals

- Students experiment with real texture in their art work to create a relief.

- Students develop planning and critical-thinking skills.

PAINTING WITHOUT A BRUSH: A LANDSCAPE

OVERVIEW

Painting wind, sunlight, leaves, bushes, grass, snow, rain, water, waves, sand, and all the other textured surfaces in nature is sometimes easier if it's created by a tool instead of painted with a brush. By pushing, shoving, pressing, dabbing, dripping, and swishing paint across the surface, the textures of nature can be created.

Paint has a certain mind of its own. You plan paintings and think you know where you are going—then suddenly the paint does something you did not predict. At that moment, you learn a new way to paint. Paint teaches as you use it. In this exercise, you provide the students an opportunity to experiment and build new skills.

The Exercise

Have the students select a landscape or combine parts from two landscape photos to make a drawing of the mountains, water, rivers, trees, or fields.

THINGS TO TRY:

Supplies

1. tagboard
2. photos of landscapes
3. pencils
4. tempera paint
5. water
6. rags or paper towels
7. palettes
8. tools from earlier exercise
9. wax, crayons

1. Paint the sky orange. Then as it dries, sweep red and yellow through the orange. When it is all just about dry, with one stroke drag a little white midway through the sky.

2. Select a tool to pounce with. Rub some wax or green crayon on the ground. Dip the tool in yellow or brown and pounce it across the wax surface.

3. Pick a small roll of fabric with a flopping tip. Dip the tip in paint and make small stabbing strokes for leaves. Use a light color and a dark color. Continue experimenting with short and long strokes, thick and thin, light and dark strokes as well as different tools dipped in paint.

Goals

- Students discover texture by inventing it.

- Students make decisions and choices about tools, marks, and paint colors in creating the landscape.

- Students learn by doing.

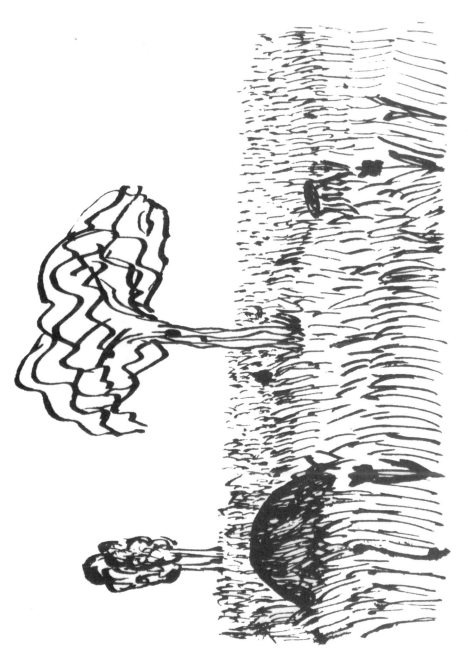

Heidi Veeman, pen and ink drawing, Art for Teachers, Oregon State University

WAX-RESIST PAINTINGS

OVERVIEW

Painting with wax layers is often rewarding for students because they can control and keep the outline of their drawing. So often in painting the paint takes over and we lose ourselves in the color, only to find at the end that the definitions of edges and the planes are not very clear. Sometimes it makes a better picture, sometimes an unexpected picture, and—once in awhile—a disappointment in the final picture. The cure for the latter, of course, is to return with black ink or tempera and add outline to separate areas.

Working with wax allows the lines to remain and get a little washed out so they aren't hard; instead, they create a value change and the wax supplies the form with texture.

By using thin color washes, the wax will show through. The paint tends to fit in around the wax, soaking into the paper. Waxing again over the first wash adds another layer of color or value and enriches the surface. At first, the wax resists the water by having the color bead, but if you wait a minute and put another layer of color over the same area, more of the wax will be covered.

The direction the wax is applied is also important. Often the strokes will show through exactly as they were applied. The last thing to think about is pressure. The harder the wax is rubbed on, the more it will remain in the end and show through the washes. Don't use water-soluble crayons; although they will work, they wash out easier.

The Exercises

A STILL LIFE

Set up a simple still life of oranges in a bowl. Have the students fill their paper with a drawing of the fruit and the bowl. They should be sitting within 4 feet of the still life to draw it. Start by drawing with crayons the outlines of the fruit, the bowl, the fabric pattern underneath, and the wall pattern behind the bowl. Students can probably make up both patterns.

Select a color for the dark side of the fruit and the bowl, and color the areas that are dark. Probably any blue, purple, or green would be good to start with. Starting in the shaded areas with dark colors first, use the dark crayon on the bottom or one side of the oranges. Then use purple crayon on the bowl. If you put a light wash of color over dark crayon the marks will usually show through the paint. Use a light yellow crayon on top of the oranges. Remember to use the crayons to create patterns. The wall behind the bowl could be striped, the bowl, decorated, and the table cloth pattern drawn in with crayon patterns.

Put a thin, light wash of orange watercolor over the fruit and a light yellow wash over the bowl. Choose colors for the table top and the background. When it dries, return with the crayons for a second layer over the first wash here and there. Rub the crayons on for texture and line. Then add a second wash to strengthen the color of the oranges, the bowl, and the table top. Paint red over the dark side of the oranges. *Let each wash dry* before adding crayon.

If the students get too much water in the wash and it's running, use a rolled-up tissue to dip into the wet color and lift it out.

Ryan at Holley School, landscape

198a

A Landscape

Landscape is another good subject for wax resist. Have the students use the crayons in the drawing for the ground, clouds in the sky, one side of the mountain, leaves, the roof of the house, or other selected areas they feel should have a texture.

The amount of pressure is important. The harder the pressure, the more of the crayon will remain after painting.

Select the colors using a light to medium wash. Paint them one by one onto the paper over the crayon. Paint the blue or red of the sky over the wax and the area of the sky. Wash over the ground, the mountains, and the trees in different colored washes. Let dry.

Return with other colors of crayons over the wash. Darken under branches and leaves. Add wax over the wash on the side of the house or the ground.

Then make a second wash. In a blue sky, you might add white or purple. In a red sky, you might add yellow or orange. A house painted yellow, then waxed, might get a red wash over the yellow. The ground could be green, yellow, and brown crayon marks over which first a green wash is laid. Students could use a little blue wash over areas in shadow and a yellow wash over other areas in full sun. Move back and forth between crayon marks, outlines, or hatching to watercolor washes. Think about layering the colors from light to dark.

Goals

- Students practice layer washes and line to build up the surface.
- Students develop patience.
- Students plan light to dark.
- Students develop decision-making and critical-thinking skills.

Reference Lessons

See Section One for foundation lessons. Also see "Chiaroscuro" and "Cylinders and an Imaginary Bowl of Fruit" from Section Three.

SEURAT'S DOTS AND POINTS OF LIGHT

OVERVIEW

Georges Seurat (1859-1891) invented Pointillism in which countless points of color in the tiniest dots of paint were placed in close proximity to each other to create an optical dazzle. Part of the theory was that if you put yellow and red dots in an area with white spaces, the eye would create orange.

The other part of the approach was to use complementary hues and tints side by side. Visual color mixing didn't actually work out very well, but by using complements, the paintings were very electric and vibrant.

The paint is placed one dot at a time. The primary and complementary colors used are placed with tiny white spaces between them. Unlike the Impressionists before him, Seurat was scientific and not romantic in his approach to painting. The Impressionists were intuitive and spiritual; Seurat was formal and technical. Gauguin nicknamed him, "The Little Green Chemist."

Benjamin D. Kaiel, Pointillist Painting, Painting I, Oregon State University

200a

The Exercise

OPTION 1

Make a *light* pencil outline of the forms to be in the painting. Draw from still life, calendar photos of artists' paintings, portraits of famous people, or scenes from the movie *Star Wars*.

Place a little tempera paint in the ice cube trays. Use red, blue, yellow, and white. Test the paint with a brush on a scrap piece of paper, dipping in the paint and then placing a dot of paint off the tip of the brush on the paper. If it doesn't come off easily, add a drop or two of water to the paint and stir the water in. Then try the test again until the paint drops off easily, but is not runny. Ice cube trays are good to use because they hold the liquid tempera in a little well, making it easy to dip the brush in. Decide what color each area will be and have students lightly map out the beginning and end of each color area.

Use dots of paint side by side to create the color of the areas. If orange is needed, place yellow side by side with red. Balance between more red or more yellow in the areas depending on whether students want light orange or dark orange. Let the white of the paper show through. If the white should get lost when the paint is dry, return with dots of white to break up the color areas.

Experiment with putting yellow on and, while it is wet, adding a little red to it. Reverse by putting the red down first and adding yellow into it. Don't use any brush strokes—only dots of paint. There are no outlines—only the beginning of one set of dots and the end of the other.

When students are done, the picture will look fuzzy up close. But as the viewer steps back, it will focus at a distance.

OPTION 2

Using orange, green, purple, red, blue, yellow, and white tempera, create a painting out of dots placed together to create the forms of the picture. There are no outlines. Line in this type of work is implied. We are led by the change of color around things, feeling it could be a line although there is no actual line.

To model or shade areas, use the complement. On a red dress, for example, use green for shadows; on yellow, use purple; on orange, use blue. Select a primary color and its complement to form the shapes in this painting.

Goals

- Students learn to control the paint, plan the painting, and experiment with color mixing.

- Students cannot use line, to they must plan the beginning and end of color areas to create an implied line.

- Students develop an awareness of Art History.

VAN GOGH'S LINES AND MARKS

OVERVIEW

Vincent van Gogh was basically a self-taught artist. He developed a style of painting that was active, not passive; vibrant, not quiet. It was intuitive, romantic, emotional, expressive. The colors are often high in contrast and rather electric at times.

He was obsessive and dedicated to his art. In the last year of his life, from 1888 to 1889, in Arles in the south of France, he created around 100 drawings, 200 paintings, and wrote 200 letters.

Van Gogh's cross-hatched drawings of the orchards around Arles are terrific. He used the cross hatching to develop volume in a drawing and translated it to painting. Stacking strokes of paint side by side, he spiraled them up into the sky, building them in row upon row up on top of each other. He created paintings of tremendous energy. His work captures the wind and the air as well as the light all around us.

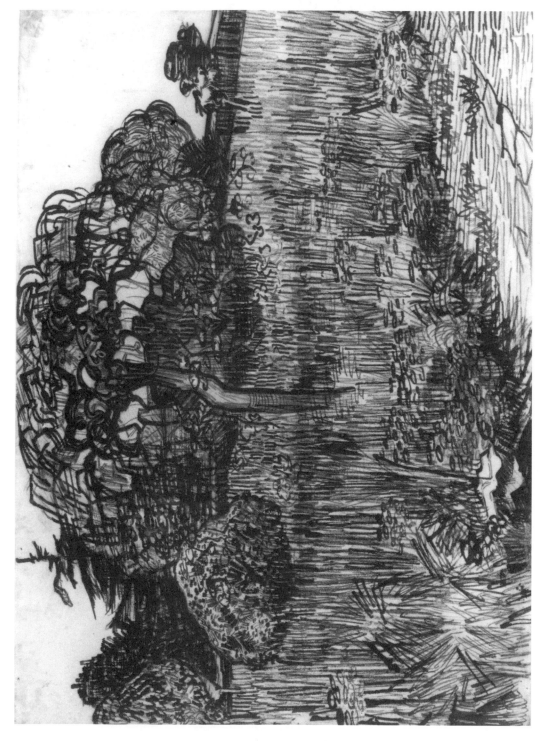

Vincent van Gogh, Dutch (1853-1890), *Corner of a Park at Arles (Tree in a Meadow)*, red pen and black ink over charcoal, 1889, 49.3 × 61.3 cm. Gift of Tiffany and Margaret Blake, 1945.31. Photograph © 1995, The Art Institute of Chicago. All rights reserved.

The Exercise

Van Gogh painted rooms, land-scapes, portraits, and still life. Students choose a subject to paint and make a *light* pencil line drawing on the tagboard to map out the space. Van Gogh tended to use complementary colors. On one of his portraits the flesh tones of the face were shaded with green. The background behind the head was also in green values showing reflect-ed light.

In a landscape with yellow fields, van Gogh would place strokes of purple and lavender beside them and under them for the shadows. A cityscape or landscape may well be the more exciting subject for students to paint because van Gogh's style lends itself well to trans-lating light, air, wind, and waves into paint.

When painting, rather than bleeding colors together, place the paint by strokes. Use small lines of paint to construct a surface, and *don't* outline areas. When the first layer is dry, add another layer of strokes next to the first ones, under them, and over them—changing and altering the color and increasing the complexity. If the paint is dry, it won't muddy. The acrylic medium adds a little transparency to the paint and to the strokes allowing some of the underpainting strokes to show through.

Work on the entire painting at once. Paint all the light areas first. When it's dry or almost dry, add medium values and dark values. Ask the students to construct out of paint strokes the way light streams out onto the street at night or the way the sun radiates light to the earth. Paint the pattern of star light and the movement of wind! Use strokes of paint diagonally, vertically, and horizontally to construct the painting.

Have students paint from the examples in this book, from *Hooked on Drawing*, or any other art book you may have available. Color photocopies are a great way to get copies of paintings by Vincent van Gogh. Let the students have a copy of the art at their desks.

Goals

- Students translate the forces of nature and light into paint.
- Students plan the space, select the color, place the color, and wait to add color after it is dry.
- Students follow the style of an artist and think about translating space and the forces of nature.

Reference Lessons

See "The In's and Out's of Color Mixing" and "What Is a Tint and What Is a Shade?" from Section One; "Painting with Complementary Colors" from Section Two; and "Chiaroscuro" from Section Three.

Heidi Veeman, drawing, Art for Teachers, Oregon State University

ASSEMBLED PAINTINGS

OVERVIEW

The art work entitled *Tongass Trade Canoe*, 1996, by Jaune Quick-to-See Smith, is assembled and composed of both two-dimensional and three-dimensional objects. The work is a mixed media piece of acrylic and collage on three canvas panels. It measures 60″ × 150″.

The Tongass is the last remaining natural rain forest in Alaska. A wildlife refuge for plants and animals, it is the country's biggest wildlife refuge and calving ground for 150,000 migrating caribou. There have been attempts to log the region, which environmentalists and Native Americans fear would displace native life forms.

In *Tongass Trade Canoe*, Smith draws upon Native American traditions of humor and irony. Her Pop Art approach is meant to direct our attention to stereotypical images. The image of the caribou moving across the work reflects her respect for nomadic sensibilities. The newspaper clippings she has added over the surface relate a broad range of feelings and beliefs about the rain forest: We move from a chart of oil reserve rights, political, industrial, and environmentalist positions, to a poem, the child's nursery rhyme, "rain, rain, go away . . ."

Perched above the canvas is a shelf made of unfinished plywood, a product of the timber industry. The brightly colored plastic laundry baskets sit lined up a reminder of traditional baskets used in trade by the Native Americans. These baskets are products of the oil industry. They have replaced traditional Native American baskets of natural materials and are a reminder that a consumer culture affects all of us, regardless of color or ethnicity.

The canoe is a stereotype image that mainstream culture uses to identify Native Americans. The canoe traditionally provided transportation for trading. The canoe is transparent, a painted outline, a ghost hovering on the surface. It is grounded in the wet paint dripping over it like the wet lands of the Tongass.

The philosophy of Native Americans considers the Earth as the source of all life. Native Americans respect all living things and the spaces in which all living things live. We are dependent on the Earth to survive.

The Exercise

Art and environmental science combine in this painting. While you plan an art project, you can also be studying the environment. Use science lessons as the subject of the painting. Consider any natural park or preserve in your area. A discussion of habitat for plants and animals could precede the art exercise.

Ask the students to bring in articles and newspaper clippings about the environment. If there is a crisis in South America or Africa, for example, you may want to focus on what the problem is and what each side wants and why. Then, using their knowledge of the environment or an environmental problem, have each student plan and construct an assembled painting.

Students should have completed many previous lessons developing technical skills and a knowledge of painting before doing this exercise. Sections One, Three, and Six will help students organize space.

Supplies

1. pencils
2. felt-tip pens
3. newspaper clippings
4. tempera paint with acrylic medium
5. brushes
6. 18″ × 24″ tagboard
7. collected collage materials
8. photocopied images
9. glue
10. water
11. palettes
12. paper towels

Goals

- Students learn to understand the work of a contemporary Native American artist.

- Students develop critical-thinking and decision-making skills.

- Students improve their abstract-thinking patterns, and learn to plan and think on many different levels.

Jaune Quick-to-See Smith, Tongass Trade Canoe, 1996, 60" × 150" tritych, acrylic and collage on canvas with mixed media, Courtesy of SteinBaum Krauss Gallery, New York. On permanent loan to Yellowstone Art Museum, Billings, MT.

Section 9

APPENDICES

I. Glossary

II. Handles and Spouts

III. Art Suppliers

APPENDIX I

GLOSSARY

abstract Art that is concerned with essential form and color to the extent that color and form may be the subject of the work. Realistic details may be absent; imagery may be simple, exaggerated, or distorted. Abstraction often relies on inner vision and feelings. Willem de Kooning said, "Content is a glimpse." Wassily Kandinsy (1866-1944) established Abstract art in a unified style of expression. He dematerialized objects into symbols. His belief in pure form and pure color was extended to believing that form and color could make sounds that could reverberate into the human soul and lift the human spirit. He wrote *Concerning the Spiritual in Art* (1912).

Abstract Expressionism A term coined by Harold Rosenberg to explain the work of New York Artists in the late 1940s and early 1950s. They were also known as "action painters." Arshile Gorky, Willem de Kooning, Milton Resnick, Franz Kline, Phillip Guston, Jackson Pollock, William Baziotes, Robert Motherwell, Mark Rothko, Elaine de Kooning, Hans Hofmann, Lee Krasner, Pat Passlof, Bradley Tomlin, Joan Mitchell, and Helen Frankenthaler were just a few of the artists who developed a new way of painting in the late 1940s, making New York the new center of art. There is no one style or form for Abstract Expressionism. The field may be large or small brushstrokes, flat color, or layered color. There may be no reference to form or form may be distorted. It is concerned with individual expression. The expressive content of the painting was generally nonobjective.

acrylic A clear plastic used as a medium for pigments. Acrylic paints can be used on almost any painting surface without painting a ground first. They dry quickly in glossy or matte finishes.

actual texture The literal tactile quality or feel of a thing as opposed to visual texture.

aesthetic The study of the creation, appreciation, and critical thinking of art. A philosophy whose term is attributed to Aristotle. In Greek it means "of or pertaining to things perceptible to the senses," instead of those things learned through intellect. Pertaining to the appreciation of the beautiful, as opposed to the functional or utilitarian and, by extension, to the appreciation of any form of art, whether overtly "beautiful" or not.

analogous colors Pairs of colors, such as yellow and orange, that are adjacent to each other on the color wheel.

Art Deco A popular art and design style of the 1920s associated with the 1925 exposition Internationale des Art Décoratifs et Industriels Modernes in Paris and characterized by its integration of organic and geometric forms. A modern, streamlined look, rhythmic in spiral arrangements. The Chrysler Building, The Empire State Building, and Rockefeller Center in New York City—plus more than 400 other buildings—are classic of its architecture.

Art Nouveau (1890-1914) The art and design style characterized by undulating, curvilinear, and organic forms that dominated popular culture at the turn of the century, and that achieved particular success at the 1900 International Exposition in Paris. Tiffany lamps and stained-glass windows reflect Art Nouveau's styling of flowing lines.

assemblage Combining and assembling disparate or unrelated elements. The artist Dubuffet used the word to describe the combining of ready-made or found objects with art. Various and diverse elements and objects are combined in an additive sculptural process.

asymmetrical balance A composition is balanced where neither side mirrors the other.

atmospheric perspective A technique, often employed in landscape painting, designed to suggest three-dimensional space in the two-dimensional space of the picture plane, and in which forms and objects distant from the viewer become less distinct, often bluer or cooler in color, and contrast among the various distant elements is greatly reduced.

automatic drawing A technique practiced by Surrealist painters in which they allowed ink to run down a page and then guided it by blowing on the ink. They wanted to get rid of preconceived ideas about art.

Automatism A main theme of Surrealism. Using spontaneous sketching and automatic drawing, they relied on free association and their intuition to find subconscious imagery.

avant-garde Those whose works can be characterized as unorthodox and experimental.

background The area furthest away from the subject of a composition when the subject is placed most frontal. The background is behind the middle ground and the foreground.

binder The substance that holds pigment in suspension, creating paint. There are oil, acrylic, and watercolor binders.

bristle The type of animal hair from which a paintbrush is made. Hog hair, squirrel hair, ox hair, camel hair, and sable are all used for brushes.

brush The tool used to paint with as opposed to a hair brush or other brush.

canvas A heavy woven cloth used with wooden stretcher bars and prepared with gesso for oils and acrylics, or rabbit skin glue and lead white for oils.

cartoon In common usage it refers to a drawing with humorous content. A cartoon may convey a message hidden beneath the surface; political satire uses cartoons. In the tradition of art it is a full-size preparatory drawing on paper that is transferred to the working surface from which a painting or tapestry is made. Honore Daumier (1808-1879) was an early political satirist in Paris. W. McCay was an early master of the comic strip (1871-1934). Comic-book heroes were the subject of Pop artist Roy Lichtenstein's art in the 1960s and 1970s.

cast shadow In chiaroscuro, the shadow cast by a figure is darker than the shadowed surface itself.

cave art Wall paintings or drawings discovered at Lascaux in Dordogne, France in 1940 and in Altamira, Spain in 1879. The figures are of animals, deer, bulls, and other herd animals. They are drawn in red, black, and ochre. They are before language and thought to be forms of early attempts to communicate. They may also be spiritual in that the hunter draws on the walls what he wishes to find the following day on the hunt. The pictographs found in 1994 in Southern France have been dated at 30,000 years old.

chiaroscuro In drawing and painting, the use of light and dark to create the effect of three-dimensional, modeled surfaces. Developed in the Renaissance it referred directly to light into dark.

classical line A kind of line that is mathematical, precise, and rationally organized, epitomized by the vertical and horizontal grid as opposed to expressive line.

classical style The style of the 5th century B.C. Greek art, characterized by its emphasis on balance, proportion, and harmony; by extension, any style that is based on logical, rational principles.

collage Art work that is composed of various materials, such as cloth, wire, string, photographs, and paper that are pasted together.

color wheel A circular arrangement of hues based on one of a number of various color theories.

complementary colors Pairs of colors that are directly opposite to each other on the color wheel; primarily, Red and Green, Yellow and Purple, Blue and Orange.

composition The organization of the formal elements in a work of art. The formal elements are line, color, texture, plane, volume, and value. Balance, harmony, and clarity define a unified artwork.

contour line A line accurately following the border or outside edge of a figure or form in space.

craft Expert handiwork, or work done by hand.

creativity The ability to bring to fruition, or produce, whatever is imagined or envisioned.

cross-hatching Two or more sets of roughly parallel and overlapping lines, set at an angle to one another, in order to create a sense of three-dimensional *modeled* space. Also called *hatching* when laid down in one layer.

Cubism The term was coined by the French critic Vauxcelles. Cezanne (1839-1906) is considered the Father of Modern Art and forerunner of Cubism. His attention to the planes of the surface and delineating the planes influenced Pablo Picasso and Georges Braque who pioneered this art form in the first decade of the 20th century. Cubism is noted for the geometry of its forms, its fragmentation of the object, and its increasing abstraction.

Dada An art movement that originated during World War I by artists, poets, and writers in a number of world capitals, including New York, Paris, Berlin, and Zurich. It was so antagonistic to traditional styles and materials of art that it was considered by many to be "anti-art." The mediums of collage, typography, photography, cinema, constructions, paintings, and posters were primary to the artists who ridiculed human activities and feelings. Making use of chance effects or capitalizing on the *happy accident* arose out of Dada.

diagonal lines, receding lines In perspective, when the lines recede to a vanishing point to the right or left of the vantage point.

Expressionism An art form that stresses the psychological and emotional content of the work, associated particularly with German art in the early 20th century. There was also Abstract Expressionism later in New York.

expressive line A loose, gestural, and energetic line epitomized by curvilinear forms. It seemingly springs directly from the artist's emotions or feelings.

Fauvism An art movement of the early 20th century (1904-1908) characterized by its use of bold arbitrary color. Its name derives from the French word *fauve* meaning "wild beast."

ferrule The silver to metal band on a paintbrush between the bristles and the handle that holds the bristles to the handle.

figure-ground The relationship and balance between the objects or figures in a painting to their surrounding field or ground.

figure-ground reversal Term used in a two-dimensional work, in which the relationship between a form or figure and its background is reversed so that what was figure becomes background and what was background becomes figure. M. C. Escher was a master of these compositions.

fixative A thin liquid film sprayed over pastel or charcoal drawings to protect them from smudging. (For the classroom Blair No-odor™ is less toxic than most.)

focal point In a work of art, the center of visual attention, often different from the physical center of the work.

foreground The area of the composition visually most in the front. Generally the objects and figures or forms fill the foreground. In landscapes or cityscapes the lower portion of the painting appears closed to the viewer and as things move further away, they move slowly up the paper towards the top, getting smaller the further back they are viewed.

fresco Painting on plaster, either dry (fresco secco) or wet (*buon* or true fresco). In the former, the paint is an independent layer, separate from the plaster proper; in the latter, the paint is chemically bound to the plaster, and is integral to the wall or support.

Futurism An early 20th century art movement, characterized by its desire to celebrate the movement and speed of modern industrial life.

gesso Traditionally a sizing with plaster of Paris and glue water for priming wood surfaces. Gesso was composed of a white coating substance composed of chalk or whiting mixed with a glue-and-water solution. This sizing was too brittle for canvas. Canvas was primed with rabbit-skin glue first; then when it was dry, lead white was spread over the glue. In the 1950s an acrylic gesso was developed as a ground. Synthetic emulsion gesso, usually called acrylic gesso, is flexible and will bend on canvas or paper without cracking.

gouache A water-based painting medium that is opaque rather than transparent, like watercolor.

gradation Refers to the grades of value. To move from light to dark through a number of grays in chiaroscuro.

grid A number of horizontal and vertical lines that cross each other to make uniform squares or rectangles.

ground A coating applied to a canvas as a gesso. In two-dimensional space the area around the figure (figure-ground relationships).

hard pans Blocks of dry watercolor. When you add water to them, they dilute to liquid color.

hatching Closely spaced horizontal, diagonal, or vertical lines used in drawing to create value or to model a surface to seem three-dimensional. See *cross-hatching.*

highlight The area of the lightest value in modeling form. It is where the light strikes the form first; also known as the hot spot.

horizontal A line drawn parallel to level ground and at right angles to the vertical. Parallel to the horizon.

hue A color, usually one of the six basic colors of the spectrum: the three primary colors of Red, Yellow, and Blue, and the three secondary colors of Green, Orange, and Violet.

implied line A line created by movement or direction, such as the line established by a pointing finger, the direction of a glance, or a body moving through space.

impressionism A late 19th century art movement centered in France, and characterized by its use of discontinuous strokes of color meant to reproduce the effects of light.

intensity The relative brightness or dullness of a color's hue and its relative purity in color.

key Refers to lightness and darkness, or value change. Used in preference to value, which directs light as good, and dark as bad; or light as up, and dark as down, scale wise. Key avoids confusion with skin color and light and dark.

linear perspective A system for depicting three-dimensional space on a two-dimensional surface developed during the Renaissance. It depends on two related principles: that things perceived as far away are smaller than things nearer the viewer, and that parallel lines receding into the distance converge at a vanishing point on the horizon line.

local color As opposed to optical color and perceptual color, the actual hue of a thing, independent of the ways in which colors might be mixed or how different conditions of light and atmosphere might affect the color.

mass Any solid that occupies a three-dimensional volume.

matte As opposed to gloss, a flat finish on a surface.

medium (1) Any material used to create a work of art; plural form, *media*. (2) In painting, a liquid added to the paint that makes it easier to manipulate.

Minimalism A style of art, predominantly American, that dates from the mid-20th century, characterized by its rejection of expressive content and its use of "minimal" formal means.

mixed media The combination of two or more media in a single work.

modeling In drawing and painting the rendering of a form by means of hatching, chiaroscuro, or value change to create the illusion of a three-dimensional form.

Modernism Generally speaking, the various strategies and directions employed in 20th century art—Cubism, Futurism, Expressionism, etc.

narrative art Art that tells a story.

naturalistic art Synonymous with representational art; more specifically, meaning "like nature;" descriptive of any work that resembles the natural world.

negative space Empty space surrounding positive shapes. Sometimes referred to as interspace, the area between an object and the object beside it or the wall or floor behind or below it.

nonobjective art Art that makes no reference to the natural world and that explores the inherent expressive or aesthetic potential of the formal elements—line, shape, color—and the formal composition principles of a given medium.

one-point linear perspective Linear perspective in which there is only one vanishing point. The entire composition can vanish to one point. Individual forms in a composition can vanish to one vanishing point and that one point can be specific to each building, form, or object.

outline The edge of a shape delineated by an actual line drawn or painted on the surface.

overlapping By placing one object behind another, space is created on a two-dimensional surface.

palette A plastic or glass surface upon which artists mix their colors and may store their paints for painting. A restricted palette employs a given number of colors (six is common), and an open palette utilizes the full range of hues or colors.

pan In painting, the name of the storage container for individual watercolors.

perspective A formula for projecting the illusion of three-dimensional space onto a two-dimensional surface. See also *atmospheric perspective, linear perspective, one-point linear perspective*, and *two-point linear perspective*.

picture plane It is conceived as an imaginary piece of glass that sits between the artist and the subject. The three-dimensional space is translated through the flat plane and transferred to the artist's paper or canvas. The plane of the paper or canvas is the same as the picture plane.

pigment A dry insoluble substance, usually pulverized, which when suspended in a liquid vehicle or medium becomes a paint or ink. Pigments are natural elements or can be manufactured.

Pop Art A style arising in the early 1960s characterized by its emphasis on the forms and imagery of mass culture. Its subjects were common objects, a soup can, a hamburger, and a comic book. It attacked the concept of high art.

primary colors Red, blue, yellow. They are primary because there is nothing that can be mixed together to make them, but when mixed together they will make secondary and tertiary colors.

proportion The relationship between the parts of a composition to each other and to the whole.

realism Specifically in the 19th century, the desire to describe the world in a way unadulterated by the imaginative and idealist tendencies of the Romantic sensibility. In modern painting, the artist renders the subject as accurately as possible, resulting in recognizable subject matter.

Renaissance The period in Europe from the 14th to 16th century characterized by a revival of interest in the arts and sciences that had been lost since antiquity.

representational art Any work of art that seeks to resemble the world of natural appearance.

rhythm An effect achieved when shapes, colors, or a regular pattern of any kind is repeated over and over again.

Romanticism A dramatic, emotional, and subjective art arising in the early 19th century in opposition to the austere discipline of Neoclassicism.

secondary colors Hues created by mixing two primary colors together; specifically, Green, Violet, and Orange.

shade, shading The effects of chiaroscuro, to move from light to dark on a form to create the sense of three-dimension on a two-dimensional surface. A shade is made when the color's complement is added or when black is added to the hue to darken the value of the hue.

still life An arrangement of objects for drawing or painting. Traditionally, a painting of objects with flowers or cylinders or fruit. To the French, "Nature Morte."

tempera A painting medium made by combining water, pigment, and traditionally egg yolk. Can be stabilized and made flexible by adding acrylic medium.

tertiary colors Colors resulting from mixing a secondary with a primary in a ratio of 50/50; thus, Yellow-Orange and Red-Orange, Blue-Green and Yellow-Green.

texture The quality of the surface: hair, fur, dents in metal, or the uneven qualities of a surface.

three-dimensional space Any space that possesses height, width, and depth.

tint A color modified by the addition of white resulting in a lighter value.

two-dimensional space Any space that is flat, having height and width but no depth. Paper is two-dimensional.

two-point linear perspective Linear perspective in which there are two vanishing points in the composition and/or for the subjects in the composition or the whole composition.

transparent A material that one can see through.

trompe l'oeil A form of representation that attempts to depict the objects as if it were actually present before the eye in a true three-dimensional space; literally "to fool the eye."

value See *key*. In painting the light and dark of a color. There are light, medium, and dark values.

vanishing point In linear perspective, the point on the horizon line where parallel lines appear to converge.

vertical Located in a direction perpendicular to horizon; upright.

visual literacy The ability to recognize, understand, and communicate the meaning of visual images.

visual texture A texture on the surface of a work that appears to be actual but is an illusion.

wash Large flat areas of paint, watercolor, or ink that are diluted with water and applied by brush.

watercolor A painting medium consisting of pigments suspended in a solution of water and gum arabic; often stored in pans that separate each color.

weight An important element in creating balance in a composition. As opposed to actual weight, which is the physical weight of material in pounds, visual weight is the apparent "heaviness" or "lightness" of a shape or form.

APPENDIX II

HANDLES AND SPOUTS

Foundation Exercise

Once the students have the idea of constructing a cylinder by making rows or a series of ellipses, they will need some additional help with handles.

To draw a pitcher, first construct the body with a number of half ellipses, remembering to make pairs. Each part of the pitcher has a top and a bottom ellipse. Make a full ellipse for the top to represent the opening (Diagram I).

The handle is made from two lines drawn from the top ellipse which at one point meet and cross each other as they form the handle on the side of the pitcher. See Diagram II. Next bring one of the lines down to where the handle meets the body of the pitcher. Now draw a second line inside the first one for the inside of the handle, as shown in Diagram II.

Diagram I

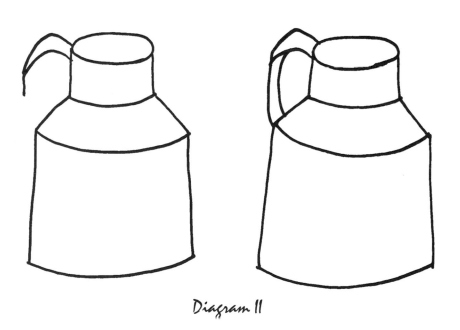

Diagram II

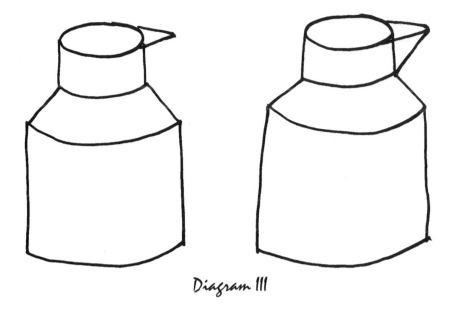

Diagram III

There are two types of spouts. The spout shown in Diagram III is constructed by drawing a triangular shape off the top ellipse and then connecting the outside tip with a curved line to the pitcher's neck. The other spout is shown in Diagram IV. Draw two ellipses the same size, one on the pitcher and one above the pitcher where the spout ends. Connect the outside curves of the ellipses.

Plates are constructed of two ellipses, as shown in Diagram V.

Diagram V

Diagram IV

Appendix III

ART SUPPLIERS

Sources for Ordering Art Supplies

1. **DISCOUNT SCHOOL SUPPLY**
 Order 1-800-627-2829
 Fax 1-800-879-3753
 WEB: www.earlychildhood.com
 Free Freight over $297

2. **LAKESHORE LEARNING MATERIALS**
 Headquarters: 2695 Dominguez Street
 Carson, CA 90749
 Call 1-800-421-5354
 Fax 310-537-5403
 Local 310-537-8600
 Customer Service Department 1-800-428-4414

3. **NAPA VALLEY ART STORE**
 Call 1-800-648-6696
 Fax 1-707-257-1111

4. **ROCHESTER ART SUPPLY, INC.**
 Call 1-716-546-6509
 Fax 1-716-546-5028

5. **ART EXPRESS**
 Call 1-800-535-5908

6. **DANIEL SMITH**
 An Art Store and Catalog of Artist's Materials
 Seattle, WA
 Call 1-800-426-6740
 Fax 1-800-238-4065
 Customer Line 1-800-426-7923
 e-mail: DSARTMTRL@ AOL. COM